IRINA BARONOVA

and the

BALLETS RUSSES

DE MONTE CARLO

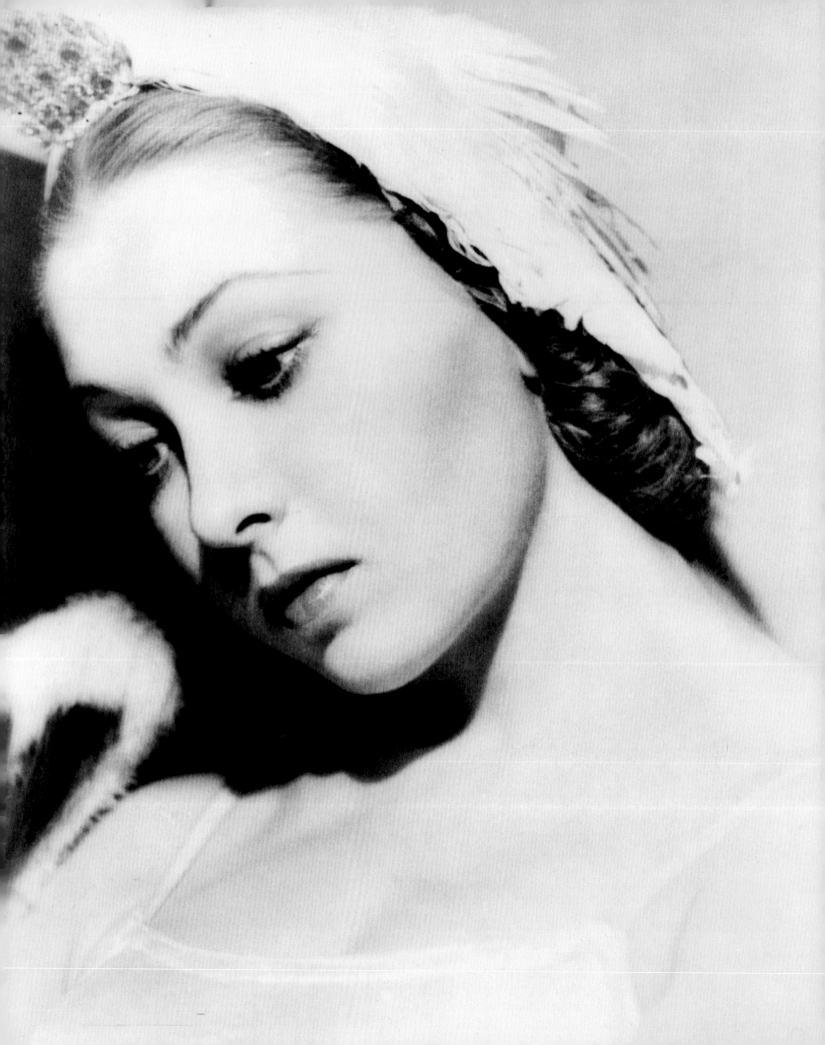

IRINA BARONOVA

and the

BALLETS RUSSES
DE MONTE CARLO

VICTORIA TENNANT

UNIVERSITY OF CHICAGO PRESS • CHICAGO AND LONDON

VICTORIA TENNANT played the title role in her first film, *The Ragman's Daughter*, in 1972 and since then has worked in film, television, theater, and radio, receiving Emmy and Golden Globe nominations. She lives in Los Angeles.

The University of Chicago Press, Chicago 60637
The University of Chicago Press, Ltd., London
©2014 by Victoria Tennant
All rights reserved. Published 2014.
Printed in China

23 22 21 20 19 18 17 16 15 14 1 2 3 4 5

ISBN-13: 978-0-226-16716-9 (cloth)
ISBN-13: 978-0-226-18630-6 (e-book)
DOI: 10.7208/chicago/9780226186306.001.0001

Library of Congress Cataloging-in-Publication Data

Tennant, Victoria, 1950– author, editor of compilation.
 Irina Baronova and the Ballets Russes de Monte Carlo / Victoria Tennant.
 pages cm
 Includes index.
 ISBN 978-0-226-16716-9 (cloth : alkaline paper) — ISBN 978-0-226-18630-6 (e-book)
1. Baronova, Irina—Pictorial works. 2. Ballets russes de Monte Carlo—Pictorial works.
3. Ballerinas—Biography. I. Baronova, Irina, author. II. Title.
 GV1785.B3475T46 2014
 792.802′8092—dc23
 [B]
 2014005254

Digital Imaging by Curatorial Assistance, Pasadena, California
Design by Karen Bowers, Altadena, California
Title page: Irina Baronova, *Swan Lake*, 1933

Publication of this book has been aided by a grant from the Neil Harris Endowment Fund, which honors the innovative scholarship of Neil Harris, the Preston and Sterling Morton Professor Emeritus of History at the University of Chicago. The Fund is supported by contributions from the students, colleagues, and friends of Neil Harris.

♾ This paper meets the requirements of ANSI/NISO Z39.48-1992 (Permanence of Paper).

For my mother, Irina Baronova,

with admiration, respect, and, most of all, love

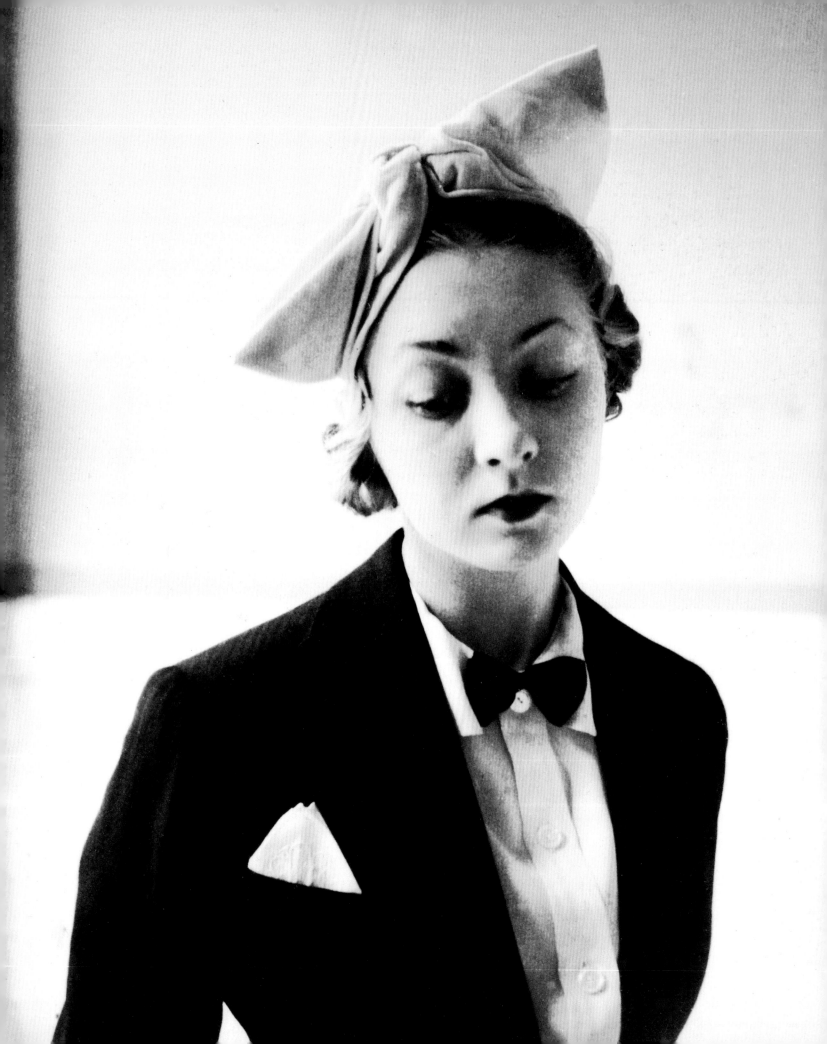

Acknowledgments

My thanks to Jan Schmidt, Curator, New York Public Library for the Performing Arts, Jerome Robbins's Dance Division, for her most generous help, interest and advice.

My thanks to Alice Standin, Photographs Assistant, Jerome Robbins Dance Division, New York Public Library for the Performing Arts, for her invaluable research assistance.

My thanks to Lee Christofis, Curator of Dance, National Library of Australia, for his generous help.

My thanks to Norton Owen, Director of Preservation, Jacob's Pillow Dance Festival, for allowing me to use the Hans Knopf photographs.

My thanks to Ron Seymour for so generously allowing me to include the photographs by his father, Maurice Seymour.

My thanks to Graham and Susan Nash for introducing me to Graham Howe and Curatorial Assistance in Pasadena.

My thanks to Graham Howe and his staff at Curatorial Assistance for his help with editing the photographs and their outstanding digital imaging work, and to their graphic designer Karen Bowers for her sensitive and beautiful book design.

My thanks to Takaaki Matsumoto for his generous advice.

My thanks to Edmund De Waal for early words of wisdom and encouragement.

My thanks to Theresa Sackler for giving me her home in New York to research and write in.

My thanks to Susan Bielstein for calling me and then giving me excellent suggestions while I was writing. My thanks to the whole team at University of Chicago Press.

My thanks to my sister, Irina Tennant, without whom this book couldn't have been made at all.

My thanks to my husband, Kirk Stambler, for his technological assistance, his insightful editorial comments, his continual support and advice, and most of all, for loving my mother.

Foreword

The last time I saw my mother, I spent a week with her at her home in Byron Bay, Australia. Each day, after breakfast, she lay on the sofa in her sitting room while I sat in an armchair next to her, reading her autobiography aloud. You see, she had spent four years writing her book, which had been published to great acclaim, but because she had macular degeneration she had never been able to read it. Together we went on the journey of her life. A month later she died. I knew it was coming. I knew that when the call came it would be my sister's voice on the phone, that the call would come in the afternoon, and yet, when it happened exactly like that, I was devastated. I had held on to the hope that we would be together for her ninetieth birthday. Then, the packing boxes arrived at my house containing all her papers. I opened them and pulled out plastic garbage bags of loose papers, photographs, letters, scrapbooks and albums: almost ninety years' worth of her life. I upended everything into piles on the floor and looked at it. It was an impossible jumble. What was in there? What the hell was I going to do? One piece of paper at a time, I thought, one piece at a time.

It took me five months. There were over two thousand photographs, the earliest taken in 1915 in St. Petersburg. There were

piles of letters, going back to 1926, and I read every one. There were crumbling press clippings and posters. There was a small silk bag with a frayed zipper that I carefully pried open. In it was a small pair of pale pink toe shoes. Inside the lining of one shoe, in my mother's handwriting, were the words I R I N A B A R O N O V A , and inside the other shoe, M Y L A S T P E R F O R M A N C E . I sat on the floor and sobbed.

By the end, I had identified everything: three binders of letters, seven huge binders of photographs, manuscripts, newspaper clippings, bits of costumes. Sleuthing through the diminishing piles of paper, I had journeyed through her life again, only this time without her. At last it was done. All the binders and folders, labeled and wrapped, were boxed up and standing next to the front door, ready to ship to the New York Public Library for the Performing Arts Dance Division. I felt a wave of loss and grief: my mother was leaving me again.

However, over the course of the five months, I had come to realize that the rare and beautiful photographs told my mother's story in pictures. I saw another book. I'll just write a few words, I thought, just enough words to put the photographs in context. Just for the family. Once again I found myself on her journey.

— **Victoria Tennant**

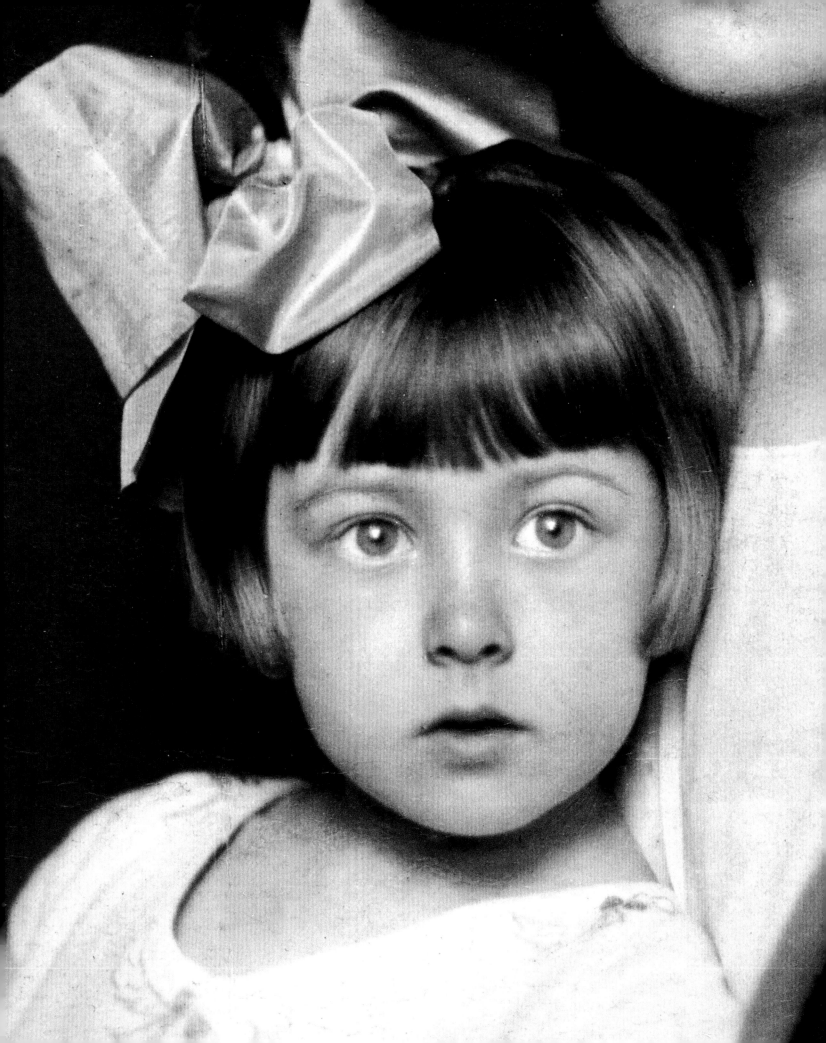

St. Petersburg, 1916–1919
Letter to My Children

I decided to start by dividing the photographs into the years they were taken. The first pile was easy. The oldest photographs were taken by my grandfather and were very small with frilly white edges. They were taken in St. Petersburg and the Crimea, and among them was a photograph of Tsar Nicholas II. I got out a box where I keep old letters and there was one, dated October 1984, that my mother had written to my brother, sister, and me. It was all about a conversation she had had with her mother, our Granny:

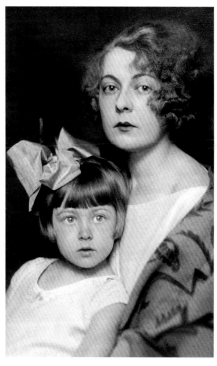

Irina Baronova, aged 4, with her mother, Lydia (my Granny)

Granny fascinated me today at lunch. She suddenly started talking about her youth and reminiscing about things she had always avoided discussing, especially with me. I had a feeling that the reason was that her hurt was too deep to be able to talk about it. Why now did she spontaneously, with no prompting, burst out with it, I do not know. But I have noticed that people who are nearing the end of their lives start to live in the past and get the urge to talk about it. I sat listening to her, occasionally asking a question, transported into the world of my country, that I never got a chance to know, and my family, of whom I know so little. Where my soul and heart and roots are from, and from which I was always cut off, making me the incomplete person that I am, longing to belong and finally belonging nowhere.

Today Granny talked of her school days in the First World War, her parents and her home life. They lived in St. Petersburg, in a fashionable street near the River Neva, across from the Mikhailovsky Palace and the Summer Garden. She went as a daygirl to a school that taught all its classes in German called "Annen Schoole" for children of

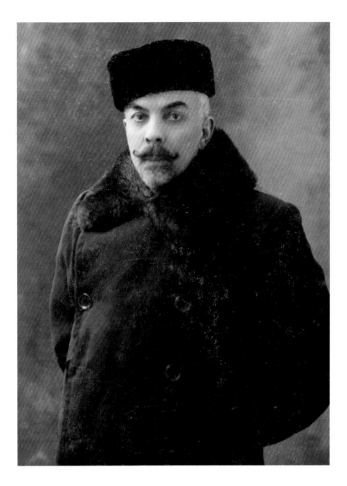

General Wishniakov

the aristocracy. The school building was immense and beautiful. It had two entrances, as half of the building was for girls, the other half for boys. They were totally separated from each other except for one central staircase that led to an immense gymnasium that was used by both sexes, of course, at different hours. Although the school was close to where they lived, her parents' coachman would take and fetch her from school in the carriage; only when she was fifteen years old would she sometimes be allowed to walk.

In those days in Russia it was fashionable to speak perfect German and French. It was a must to go abroad for the winter months, to the South of France or Italy or to take the waters in Baden Baden or spend time on the Swiss Riviera where our dowager Tsarina had an estate called Villa D'Este on Lake Como. Granny's parents went every year in January and February to the South of France while Granny remained at home with her governess, maids, butler and cook.

Granny's father, Alexander Wishniakov, was tall, with a proud head and a great big moustache. He was a general in the Imperial

"Granny would be allowed to watch her mother being helped into her ball gown in her boudoir and wish for the day when she too, would be grown up."

Guard, open, gay and warm. Granny obviously adored him. She tells me that he was her pal, her friend, she would run to him and hug and kiss and sit on his lap. Granny's mother, Evgenia, was a very prim and proper lady; it gave her an aura of being cold. She would kiss my mother on the forehead "good morning" and "good night" and there was no other physical touch, no cuddling or show of any emotion. I was listening to Granny and thinking to myself how similar our relationship is, strained in showing outward affection, and how my Papa was my pal, my friend, my teddy bear.

Granny described the huge, beautiful ballroom in their house. Her mother entertained a great deal and was a wonderful hostess. On the nights when there was to be a ball, Granny would be allowed to watch her mother being helped into her ball gown in her boudoir and wish for the day when she, too, would be grown up and join in the magic of the grown ups' world. Poor, poor darling — it was all gone, gone forever before it even began.

When the First World War was declared our Tsarina and the princesses all went to work as nurses in military hospitals. Later as the wounded poured in, in the thousands, some of the palaces were transformed into hospitals. It became fashionable for young ladies to follow suit. Granny was no exception. Her mother was terribly against it, it was unheard of, indecent that little Lydia should be exposed to naked men. However, the General had the last word. Granny went on a short nursing course and obtained a place at one of the hospitals as a nurse's aide. School days were over — it was 1916. Granny was telling me today how brave the wounded soldiers were and how much suffering the untrained nurses must have inflicted upon them with their clumsy hands. Granny's job was to change dressings and peel off infected scabs.

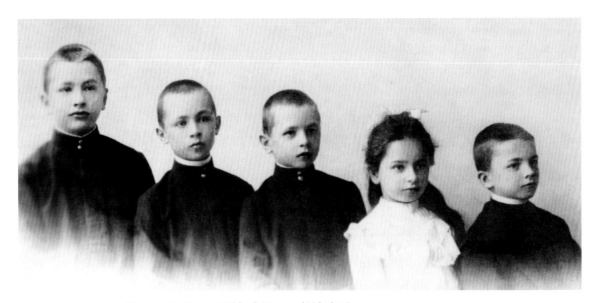

Konstantin, Sergei, Mikhail, Vera and Nikolai Baronov

The sight of those terrible wounds would give the young ladies the vapors. Their hands would shake, tears would roll down their faces, fear of hurting the men would paralyze their movements. But the Russian moujiks always tried to cheer them up. "Go on, Barishnia (Miss) go on, pull, pull — I will stand it don't you worry, I will stand it."

Soon after this Granny got married to Grandpa, Mikhail Baronov; they had known each other since childhood. The Baronov family had a country house next to the Wishniakovs' country house on the River Neva, twenty-five miles outside St. Petersburg, and the two families were great friends. There were four Baronov brothers and a sister. The brothers were a wild lot — each day they would disappear into the countryside and reappear for dinner, always with torn clothes and scratches. It was a happy, gay household full of noise, pranks and laughter. But the end of that life came swiftly, plunging the entire country into horror, bloodbath and starvation. It was 1917, the start of the Russian Revolution.

By the time Granny got married, aged seventeen, Grandpa had become a young lieutenant in the Imperial Navy and Flag Officer to Admiral Kolchak. They were married on Grandpa's battleship in the Crimea during World War I, between sorties into battle. The honeymoon was short. Grandpa would leave her, his ship disappearing over the horizon, she never knowing if he would return.

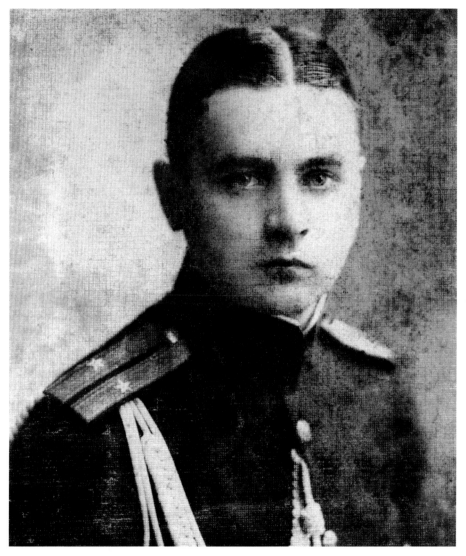

Mikhail Baronov, 1916, Flag Officer to Admiral Kolchak, Russian Imperial Navy

Lydia on her honeymoon in the Crimea, 1917

As soon as I was born, in 1919, we went to join Granny's parents at the country house. It was called Otrodnya, "A happy place to be." Although they had been thrown out of their city house, somehow they had not yet been thrown out of their country house. In the renamed Petrograd there was nothing to eat, but in the country the Bolsheviks allowed them to keep one cow. All the servants, of course, were gone. Granny's mother's personal maid of many years married a Commissar, helped herself to the jewelry and disappeared. There was no one in the country except a very old peasant woman from the farm who could hardly walk. It was my father who took care of the cow, milked her and looked after her, in his one and only naval uniform.

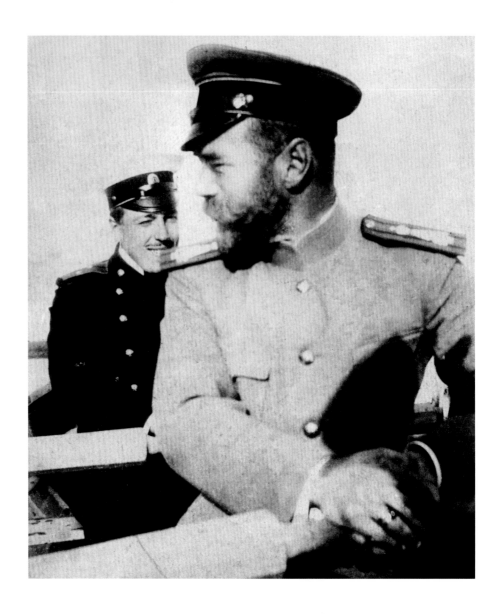

Rowing from battleship to battleship on inspection. Behind Tsar Nicholas II is Grandpa's best friend, Sabline. Photo taken by Grandpa, 1914–1915.

One evening, soon after we arrived, the General's dead body was brought back to the house. He had been shot on the train on his way to the country, shot by drunken soldiers. Although he had removed the epaulettes from his great coat, the red lining denoted his rank; the soldiers saw it and shot him in the head. Granny was telling me how her mother became an old, old lady overnight. She, herself, prostrate with grief, developed a high temperature and couldn't go to the burial at the village church.

Your grandpa was posted from the Crimea to the Baltic, and Granny and I, just a baby, went with him. When the White Russian Army closed in, we were evacuated by train with the rest of Naval Headquarters, in cattle wagons back to Odessa, on the Black Sea.

"One evening, soon after we arrived, the General's dead body was brought back to the house. He had been shot on the train on his way to the country, shot by drunken soldiers."

Grandpa's best friend, Sabline, also a Naval Officer, was engaged to Grandpa's sister, Vera. He was tortured and shot while Vera was made to watch. Fearing they would be killed, too, my parents decided to try and escape across the border into Romania. They left at 2:30 AM, traveling in a wooden cart for three nights, and hiding during the days. On the fourth night they waited until dark, then ran for a kilometer through the woods to a river, Grandpa carrying me, and Granny carrying his violin and some silver. My parents had agreed that if they got caught by the Red Army guards patrolling the riverbank Grandpa would shoot me, Granny, and then himself, because if caught, we would be tortured before being killed. A smuggler rowed us across the river, telling my parents that if I made a sound he would throw me overboard or they'd all get shot. Granny held a sugar lump for me to suck and somehow we made it.

Sabline on the street outside Grandpa's home. Note Grandpa's shadow holding the camera, 1915.

I sat on the floor holding the letter, thinking about the day I was clearing out Granny's room after she had died, aged ninety-three, and, there, pushed to the back of a cupboard shelf was a bundle wrapped in old newspapers. I reached in and pulled it out. It was heavy, and the paper crumbled in my hands. Inside the wrapping was silver cutlery, completely black with tarnish. I got some rubber gloves and polish and worked away at the forks and knives. Each elaborately worked piece had the letter "E" engraved on it. It was my great-grandmother Evgenia's wedding silver, smuggled out with the violin. All that was left of my mother's inheritance, all that was left of Russia. Too precious to sell, and too painful to use.

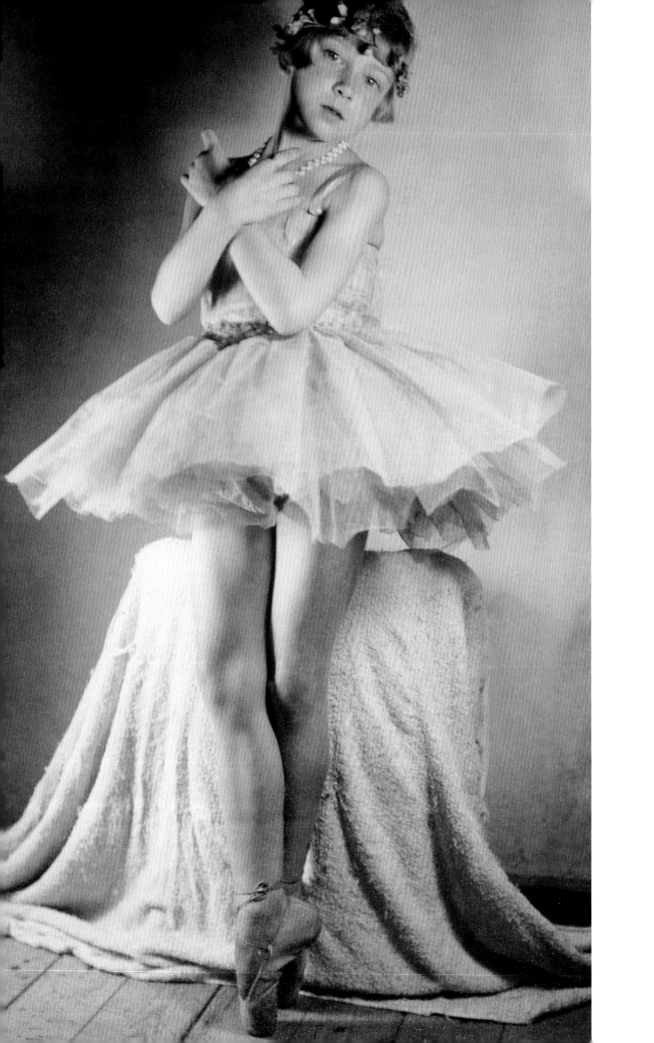

Romania, 1920–1927
Seeing a Ballet for the First Time

My brother, Robert, recorded a talk he had with Granny not long after our mother's letter. Granny describes her childhood; her voice is happy, laughing. She goes on to talk about her marriage and how thrilled they were to have a baby, and then, describing the moment when her father's body was carried into the country house, her voice breaks, "Oh my God . . . his face . . . " There is silence. Her voice continues, flat and quiet. In Romania, the first job they got was at the local cinema. She played the piano and Grandpa played his violin, accompanying the silent movies. They were destitute, but they thought that in a year or so they would be able to go home. They didn't realize they would never see St. Petersburg or their families again. Granny wrote to her mother, Evgenia, telling her that she was in Romania, and a couple of months later a postcard arrived from a family friend in Poland telling her never to write again, that it was too dangerous and had caused terrible trouble. And that was it: all communications to Russia, all information ceased. The Iron Curtain came down. Granny never heard of her mother again. Grandpa never knew what became of his family either.

Among the photographs and letters I found was the following transcript of an oral history interview my mother had made for the New York Public Library:

When we ran away from Russia in 1920 we found ourselves illegally in Romania, where we lived for seven years. We had no money so I never had toys or anything. I'd pick up a stick and my father would sharpen it into a point and I'd pretend it was a pencil

Irina Baronova, age 7, Romania, 1926

"Karsavina was so beautiful. I thought how could I ever possibly become this fairy?"

and draw in the earth. I'd go outside into the factory yard and invent my own fantasies. I remember the back yards of the factories where we lived. I remember the lice in my hair and a lot of bedbugs, my mother with a fire thing trying to kill them. Once she set fire to the mattress but had the presence of mind to throw it out the window.

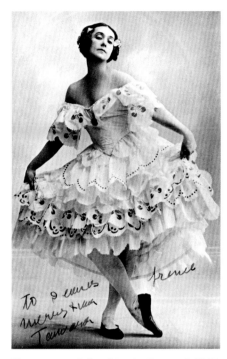

Karsavina as Columbine in *Carnaval*, 1910

When Granny was a young girl, she had been taken to see a ballet and had adored it so much that she had begged to have ballet lessons. In those days it was unthinkable that a girl from a good family should go on the stage, and her parents were alarmed enough by the degree of her enthusiasm that they forbade her to see a ballet again. Now that Granny and Grandpa were refugees, and there were no social considerations anymore, Granny decided that her daughter would take the ballet lessons that had been forbidden to her and started looking for a teacher. It wasn't my mother's choice at all; she had no idea what ballet even was. At that time there was no ballet in Bucharest, none, but that year the great ballerina Tamara Karsavina came to give some concerts, and even though it was a struggle to buy food, Granny insisted that Grandpa give her the money to buy two tickets.

It was 1926, I was seven then, and I can still remember moments of Karsavina on the stage, you know, like photographs — I don't of course remember the whole performance or anything, just bits, but it impressed me so much the memory has stayed with me my whole life. It was like being taken into a fairyland. Out of the ugliness of our lives. It was something extraordinary and Karsavina was so beautiful. I understood then what my mother had been talking about, but I thought how could I ever possibly become this fairy?

Irina Baronova, age 8, Romania

11

So Mama found a lady called Mme. Majaiska. She used to be at the Maryinsky Theatre in the corps de ballet, in the back row. She was living, like all of us, in one dingy room, where she slept, ate, and gave her lessons. There were three of us girls and we clung on to her dinner table, and she sat on the bed, like a Turk, smoking some brown, terribly smelly cigarettes and coughing because she was suffering from asthma, "Aach, aach, phph, phph." We started the pliés and all that awful stuff and I thought, "Oh, gracious! Karsavina didn't do that on the stage! What's all this!" I found it so boring I began to hate it. Then it came to little dances she tried to make us do which were always to a Delibes pizzicato from *Sylvia*. I thought, "How sissy." Because I was rather a tomboy, my idea of fun was climbing trees and throwing stones, so I didn't really like it very much. I did not go to these lessons with enthusiasm. But somehow Majaiska told Mama, "Look, I think she's got what it takes to make a dancer. But you must not leave her with me because I shall ruin her. Try to get away to France, to Paris, and take her to Preobrajenska." Which was an extraordinary thing to say, very honest.

So my father started working day and night to save enough money so that we could move to Paris. He did all sorts of things. He washed carriages. He worked as a bricklayer. My father had a talent for painting and drawing. He went to night school to learn how to make gravures, engravings, lithographs and things. Little by little he started working for advertising agencies designing posters, things like that. We moved from Orgeyev to Kishinev, from Kishinev to Bucharest, always living behind factories. Factories that printed posters, or factories that engraved things. We always lived in a factory yard somewhere. Father started taking on extra work. I remember waking up at night seeing my father bent over at the table with the lamp on, a magnifying glass stuck in his eye, engraving all night through. How he didn't collapse, I don't know. All to save enough money to get us to Paris to give me a chance.

Irina Baronova, age 8, Romania

Paris, 1928–1931

Ballet Class with Madame Preobrajenska

Not only was my mother living Granny's dream of dancing, but her parents were dedicating their lives to giving her the chance to make that dream come true. Small wonder that in later years Granny would feel that she and Grandpa were shareholders in my mother's career. At a certain point her life became their life too. It took Grandpa a year to earn enough money to buy three third-class train tickets to Paris.

In the spring of 1928, we left Bucharest for Paris. I was almost nine years old and I spoke Russian and Romanian. When I started school in Romania I adored our French teacher, so I tried very hard and was always first in class, so as a result I thought, "Oh, I speak French, you know." Of course, my French was not good enough when we came to Paris and I was absolutely stuck. I was amazed that even the woman in the dairy selling milk spoke French. I don't know what I was thinking. I imagined that only special people spoke French.

My mother was sent to a school where one didn't pay, the Ecole Communale, 42 Rue de Picpus, in the twelfth arrondissement. The directrice, Madame Bizet, happened to be an extraordinarily nice woman and she arranged for my mother to sit next to the teacher. While the other girls were doing their work the teacher took time to help her understand what was going on. Two months later she was speaking French.

Irina Baronova, age 10

Photo: Studio Iris (Paris)

"She said to Mama, 'I know you are penniless and I don't want your money. If she's good, . . . one day when she makes it you can pay me.' "

Then the terrifying day came when Mama took me to meet Madame Preobrajenska. She had her ballet studio on the top floor of the old Olympia Music Hall. The spaces there were huge. I had never seen anything like it in my life. I found myself in that huge studio with a mirror and a barre, and girls doing wonderful things, when all I had known was the tiny, poky room at Majaiska's, and holding onto the table. Unfortunately Preobrajenska was in a filthy mood: her husband had just run away with one of her pupils and her nerves were shot. She was shouting so I was afraid of her. Somehow, though, she decided to accept me. She said to Mama, "I know you are penniless and I don't want your money. If she's no good I'll tell you not to waste your time on her and if she's good, one day when she makes it you can pay me." She did that for Tamara Toumanova, and probably for other pupils too, because we were Russian girls without a sou in our pockets. That woman was an absolute saint.

There was one class for beginners and one which was a mixture of medium and strong dancers. I was pretty much zero. I knew the five positions and some barre exercises, but I was very thin, all knees and elbows. I was also petrified. I spent the whole time hiding behind the piano in the back row so she wouldn't see me. The way she was yelling at everyone terrified me. To this day if someone yells at me I get paralyzed, I can't respond. I was painfully shy, blushing all the time and going absolutely blank. For a few days she left me alone, but then she started telling me, "Come on out from behind the piano. Come here. Come here." It was agony. I didn't like it, I really suffered. Because I was shy and frightened. My body progressed, but with my face I could show

Irina Baronova, age 10
Photo: Studio Iris (Paris)

16

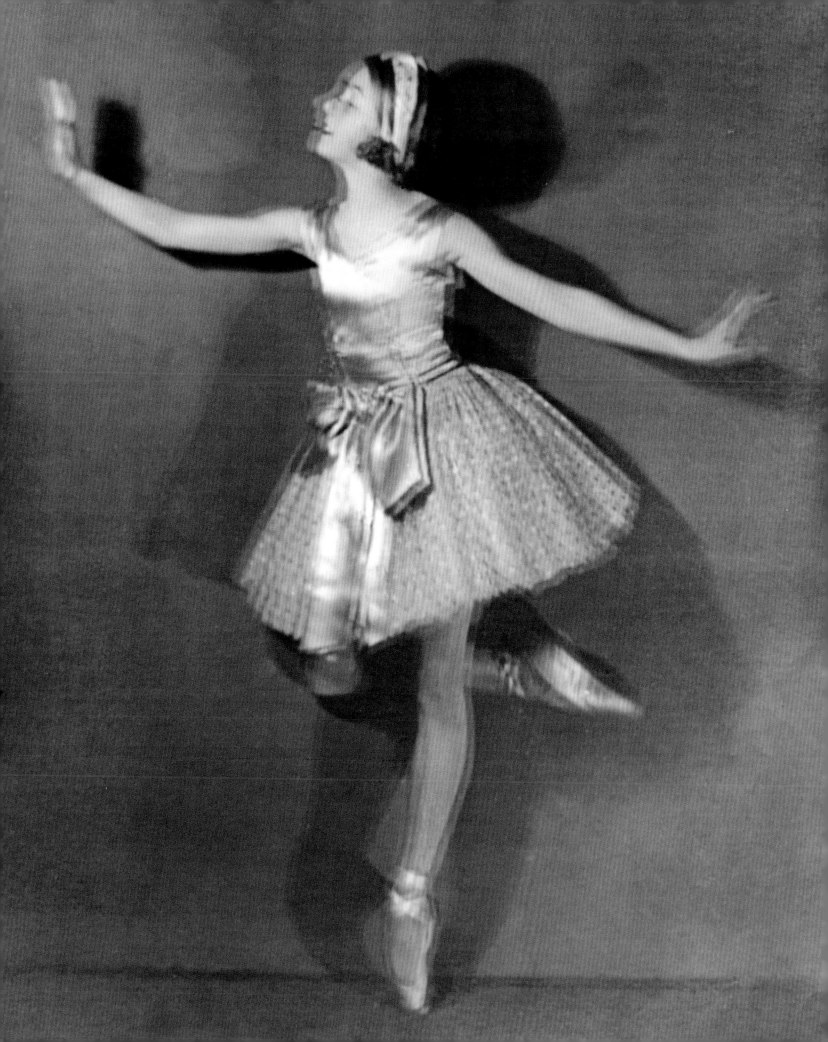

"Preobrajenska said, 'Why the hell couldn't you do that before? Why can't you dance like that every day?' I said, 'I'm scared of you.' From that day on she was gentleness itself. I started to relax and absolutely adore her."

Olga Preobrajenska in her studio, 1931

nothing. Nothing came out. Then Preobrajenska would yell at me and the more she yelled at me the less I could express. One day there was a benefit performance for the Russian Naval Officers Club. Every year they had a ball and all the White Russian refugees in Paris got together. It was always great fun, a big party. At that time in Paris there were three wonderful teachers: Preobrajenska, Kschessinska, and Egorova. One of them would be asked to provide entertainment, a cabaret, a little performance, a dance. This time it was Preobrajenska's school. She arranged some solo dances, a group dance, and Tchaikovsky's "Valse des Fleurs." The students' mamas were sewing the costumes. This was the first time I ever gave a performance — apart from one benefit performance in Romania with little kids — I was dying with fear. But when the curtains parted and we were on, the audience didn't exist, Preobrajenska didn't exist, I was so filled with pleasure and joy at what I was doing, I was having such a wonderful time that I just did it. When it was finished, Preobrajenska rushed to me and said, "Why the hell couldn't you do that before? Why can't you dance like that every day? What's the matter with you? You've got it!" I started crying and I said, "I'm scared of you." And from that day on she was gentleness itself. I started to relax and absolutely adore her.

In the autumn of 1931 Colonel Wassily de Basil and George Balanchine started to make the rounds of the three great teachers' studios.

They always came to the studio together, and we'd all go like jelly because we knew that this new company was being formed. They would appear at the door of the studio, embrace Preobrajenska and sit down to watch the class. We weren't told that they were coming to choose somebody; it was all very casual but we knew, of course. We were rather vague as to who de Basil was, but we knew who Balanchine was: he was from Diaghilev's company. He was the famous dancer and young, brilliant choreographer.

Col. de Basil was an extraordinary character, formerly a cavalry officer of a Cossack regiment who had escaped the Bolsheviks and was reinventing himself in Paris. He knew nothing about ballet but surrounded himself with people who did. He approached René Blum, an elegant, quiet intellectual who had been awarded the Croix de Guerre in World War I, who was in charge of providing ballet dancers and companies for the opera company of the Casino de Monte Carlo. De Basil proposed that they become partners; de Basil would find the dancers, ballets, scenery, and costumes and Blum would bring in the financial backing of the Société des Bains de Mer, which owned the casino, and provide the theatre. De Basil also said that he would find new patrons. Blum was interested,

Tamara Toumanova, Olga Preobrajenska, and Irina Baronova in Paris, 1931

but he had no intention of recreating Serge Diaghilev's company (he had already discussed forming a ballet company with Léonide Massine and had rejected that idea as unseemly); what was needed was something new. De Basil agreed and they engaged George Balanchine as ballet master and choreographer.

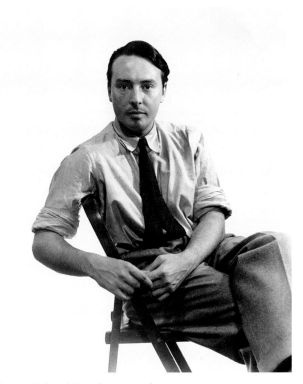

George Balanchine, choreographer
Photo: NYPL Jerome Robbins Dance Division

Blum and Balanchine wanted to build on the extraordinary success of Diaghilev's company, but to do it by making modern ballets with modern ideas. From 1909 to 1929 Diaghilev had presented lavish ballets, with gorgeous costumes and astounding décor variously taken from Old Russian folk tales (*Firebird, Midnight Sun, Les Contes Russes, The Rite of Spring, Polovtsian Dances, Chout*), classical myths (*Oedipus Rex, Daphnis et Chloe, Zephyr et Flore, Narcisse, The Triumph of Neptune, Apollon Musagète, Mercure*), fairy stories (*Sleeping Beauty, Cinderella, Le Chant du Rossignol*), *The Arabian Nights* (*Scheherazade*), the Bible (*Prodigal Son*), the Orient (*Thamar, Le Dieu Bleu, Les Orientales, Cléopâtre*), the Commedia dell'Arte (*Pulcinella, Les Femmes de Bonne Humeur*). However, these ballets cost a fortune to produce, and Balanchine wanted freshness, speed and youth. It was Balanchine's idea to have a lot of very young dancers in their new company. They started with dancers from Diaghilev's and Anna Pavlova's companies who had been without a company since Diaghilev and Pavlova died. The rest of the dancers were youngsters, like my mother and Tamara Toumanova and Tatiana Riabouchinska. From each Paris studio they picked the young girls Balanchine liked best.

When they picked my mother, Grandpa wasn't sure whether it was right for her to join this new company because she was not quite thirteen and still at school. My grandparents were trying to weigh up whether it was right or wrong. But de Basil could talk anybody into anything.

BALLETS RUSSES COMPANIES

1909–1929	BALLETS RUSSES DE SERGE DIAGHILEV
1932	LES BALLETS RUSSES DE MONTE CARLO*
	Director and Founder: René Blum
	Co-Director: Col. de Basil
	Artistic Advisor: Boris Kochno
1932–1933	Maître de Ballet and Choreographer:
	George Balanchine
1934–1937	Maître de Ballet and Choreographer:
	Léonide Massine
1937–1939	Choreographer: Mikhail Fokine

*Neither Blum nor Balanchine wanted the word "Russes" in the name of the company. De Basil persuaded them that it was necessary to attract audiences and finance. The name Les Ballets Russes de Monte Carlo underwent slight variations from city to city, until René Blum left over Col. de Basil adding his own name to it.

1932–1934	Before the Blum/De Basil split:
	LES BALLETS RUSSES DE MONTE CARLO
	BALLETS RUSSES DE MONTE CARLO (London)
	MONTE CARLO BALLET RUSSE (New York)
	BALLETS RUSSES DE COL. W. DE BASIL (London)
1934–1937	After the Blum/De Basil split:
	MONTE CARLO BALLET RUSSE (New York)
	BALLETS RUSSES DE COL. W. DE BASIL or
	COL. W. DE BASIL'S BALLETS RUSSES

More name changes ensued after Col. de Basil had to step aside to avoid a lawsuit and his second-in-command, Gerry Sevastianov, took over as Director, with Victor Dandre, Pavlova's husband, brought in for show. A final name change was made when Col. de Basil came back.

1938–1939	When Col. De Basil had to step aside for legal reasons:
	RUSSIAN BALLET
	(Directors Victor Dandre and Gerry Sevastianov)
	COVENT GARDEN RUSSIAN BALLET
	(Australia, where Dandre left, and London)
1939	Col. de Basil came back and Sevastianov left:
	ORIGINAL BALLET RUSSE
	(The company kept this name until disbanding in 1951)
1939–1941	Several choreographers presented their own ballets:
	Lichine, Fokine, Balanchine, Verchinina, Schwezoff
1936–1937	René Blum's company after the split:
	BALLETS DE MONTE CARLO
	Director: René Blum
	Choreographer: Mikhail Fokine
1938–1939	BALLET RUSSE DE MONTE CARLO
	Choreographer: Léonide Massine

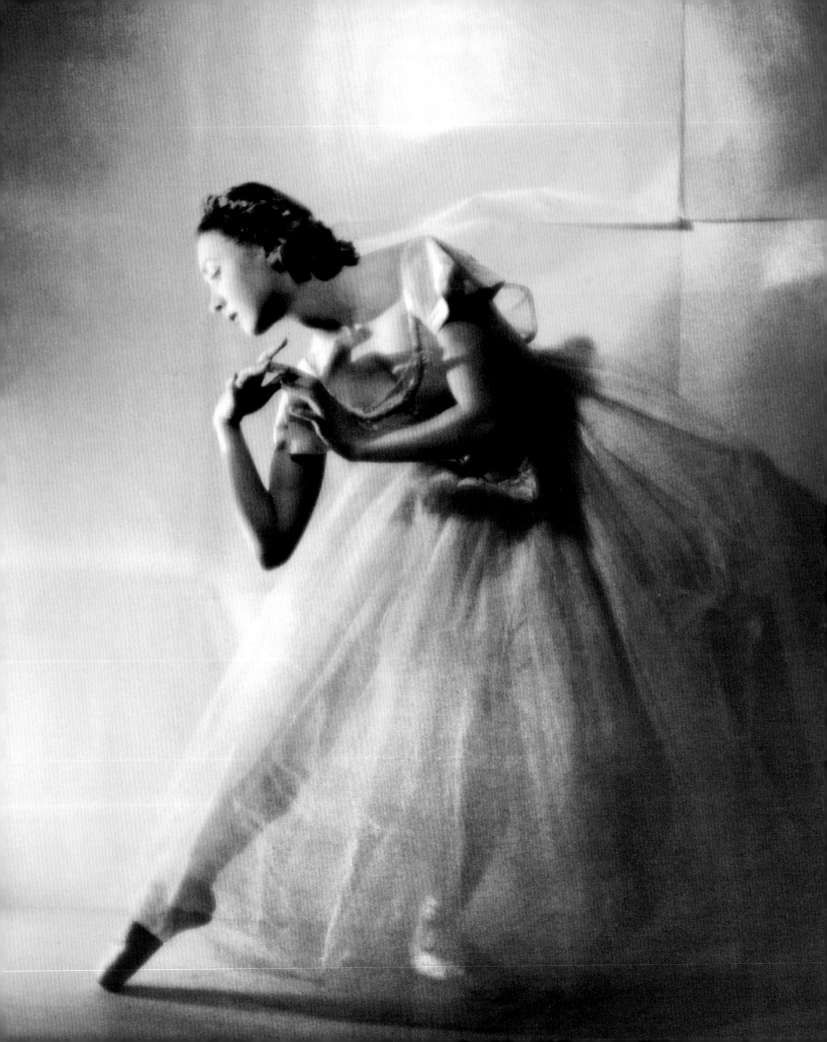

Monte Carlo, 1931–1932
Ballets Russes de Monte Carlo

So, my mother left school at the age of twelve. She always joked that she couldn't spell in any of the languages she spoke (Russian, Romanian, French, English).

The Ballets Russes de Monte Carlo was run by René Blum, the founder and artistic director, and Colonel de Basil, the administrative director. Balanchine was the choreographer, Lubov Tchernicheva the ballet mistress, and Boris Kochno the librettist and artistic advisor. Serge Grigoriev, the rehearsal director, supervised the ballets not by Balanchine and kept the performance records.

The first season would present five revivals (*Les Sylphides, Petrouchka, Pulcinella, L'Amour Sorcier, Chout*) and five new ballets: *Le Bourgeois Gentilhomme, Cotillon, La Concurrence,* and *Suites des Danses* by Balanchine and *Jeux d'Enfants* by Massine. Balanchine also reworked Act II of *Swan Lake*, removing the Diaghilev additions and restoring the original choreography.

De Basil hired an elegant White Russian refugee, Barbara Karinska, to make costumes for the new ballets. She had been working in Paris as a dressmaker. Karinska's first ballet was Balanchine's *Cotillon*. It was the start of her long collaboration with de Basil's company as wardrobe mistress with her team of Russian seamstresses. Her respect for the dancers and her understanding of their needs led her to devise new ways of constructing costumes that permitted them total physical freedom while translating the visions and ideas of the choreographers and designers into richly detailed works of art in their own right.

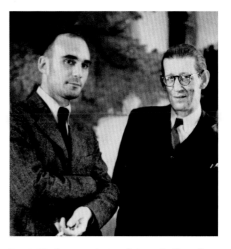

Boris Kochno, artistic advisor *(left)* and Colonel de Basil, administrative director

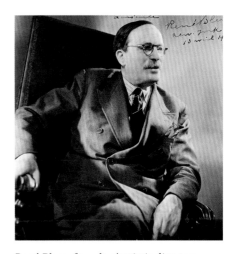

René Blum, founder/artistic director
Photo: NYPL Jerome Robbins Dance Division

LES SYLPHIDES

(Solo Waltz for Lifar Tour)

Choreography by Mikhail Fokine

Set by Prince Alexandre Schervachidze after Corot

Costumes by Olga Larose

Music by Frédéric Chopin

First performance by Diaghilev's Ballets Russes, Théâtre du Châtelet, Paris, June 2, 1909

Photo: Studio Batlles (Barcelona)

"…by the age of 12 we were strong as steel."

Joan Miró and Tatiana Riabouchinska
Monte Carlo, 1932
Photo: NYPL Jerome Robbins Dance
Division

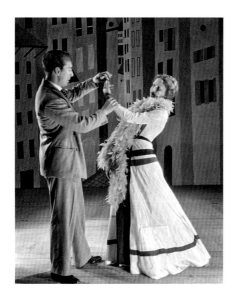

George Balanchine and Irina Baronova
rehearsing *La Concurrence*, 1932
Photo: Boris Lipnitzki
©Roger Viollet / The Image Works

It was October 1931. Father stayed in Paris to work, which was hard for me because I missed him, and my mother went with me to Monte Carlo. There were quite a few young dancers from the Paris studios so we had lots of mamas, Mama Riabouchinska, Mama Toumanova, Mama Baronova, and four others. Lots of mamas. Who never left our sides.

Everybody in the company was in love with Balanchine. He was young and had a wonderful sense of humor; he was fun with this extraordinary talent, extraordinary charm, very handsome. It was wonderful working with him. When Grigoriev would leave the rehearsal room, Balanchine would rush to the piano and start playing jazz or something, he played the piano beautifully. We were all having a ball. The whole thing was a fairytale.

The Preobrajenska pupils, technically, were the strongest and the quickest to learn. Somehow she didn't nurse us along little by little. Dancing is, or was then, on your toes, so when you start learning this should be part of your training. Little by little, gently, but every day, it should be part of your training. Tatiana Riabouchinska was from Mathilde Kschessinska's studio; Tamara Toumanova and myself were both Preobrajenska pupils, so by the age of 12 we were strong as steel.

In *La Concurrence*, at one point the three of us (Riabouchinska, Toumanova, Baronova) had to do 32 fouettes with Tamara in the middle and Tania and me on either side. We were in front of the set of shop-fronts with dressmakers' dummies at the doors. Tamara was in her beautiful pink dress, Tania in her blonde wig and me in a black wig with red bows. Mama Toumanova was driving Tania and me crazy at the time, always standing in the wings and glaring at us, making us nervous because her glares said, "I wish you'd break your leg!" So, Tania and I thought we'd teach Mama Toumanova a lesson. We agreed that when we started our fouettes we would do eight in place, then start moving in and squeezing Tamara, then we'd move back and unsqueeze. So we did, we did eight fouettes in place and then started moving in. Mama Toumanova went into hysterics. "My Tamarachtka! They're going to kill my Tamarachtka!" Tania and I were delighted, we

Irina Baronova in *La Concurrence*, 1932, age 12
Photo: Boris Lipnitzki ©Roger Viollet / The Image Works

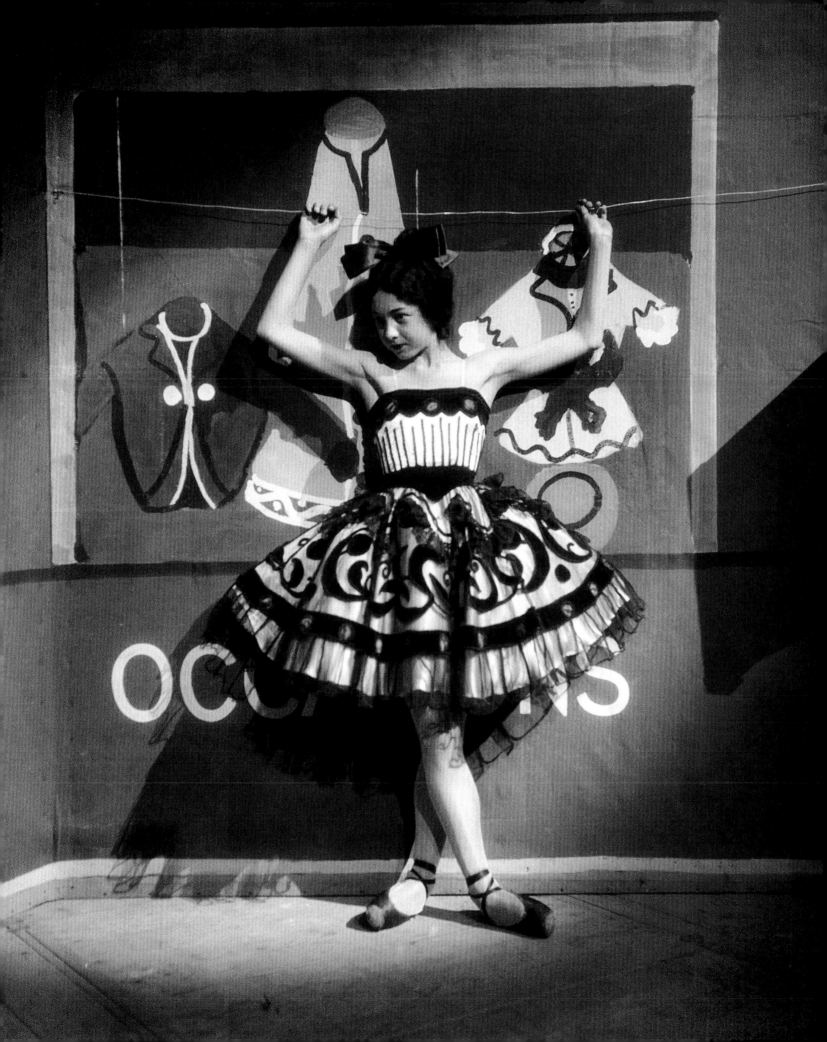

Rehearsing *Les Sylphides* in the studios under the Casino

Irina Baronova rehearsing in satin tunic
Photo: Raoul Barba (Monte Carlo)

unsqueezed and then we moved in to squeeze again and disaster struck: Tania hit a dummy with her foot, knocked it over and fell on top of it. While she was rolling around on the floor with the dummy, my wig came off and stayed stuck to my head by one hairpin so each time I turned it slapped me in the face, so I couldn't see where I was, or what I was doing. God punished us, you see. We both thought we were going to get hell from de Basil and Balanchine, and when the curtain came down Tania and I just stood there like two wet chickens. De Basil dashed onto the stage, "What the hell do you think you're doing?" and we just stood there, we couldn't say a thing. Balanchine appeared; at first, he didn't say a word. Finally he said, "You really mustn't behave that way." But his eyes were laughing so we knew we got away with it.

One day, after a performance of *La Concurrence*, Tamara and I decided, "Let's face each other, start doing fouettes and see who will last the longest and how many we're going to do." And we went on and on and on. It was 100, 101, and 102. Neither of us would stop. Finally Grigoriev said, "Come on, girls, that's enough, that's enough!" and clapped his hands three times. We were both delighted because we were really, absolutely exhausted, but Tamara wouldn't stop and neither would I.

The first season went well. I was in Léonide Massine's ballet *Jeux d'Enfants*, dancing the part of the Shuttlecock; Balanchine's new ballets, *La Concurrence* and *Cotillon*; and *Les Sylphides*, in which I did the First Waltz. We opened in Monte Carlo in January 1932, then went to Paris and opened there at the Théâtre Champs Elysées on June 9th. Paris was a great success. After we closed on June 21st there was talk of extending our one-year contracts for another season that would start after the summer holiday. We were going to have July and August off and reconvene in Paris mid-September.

JEUX D'ENFANTS
Choreography by Léonide Massine
Libretto by Boris Kochno
Set and Costumes by Joan Miró; costumes executed by Karinska
Music by Georges Bizet
First night Théâtre de Monte Carlo, April 14, 1932
Irina Baronova — The Shuttlecock
Photo: Maurice Goldberg (New York)

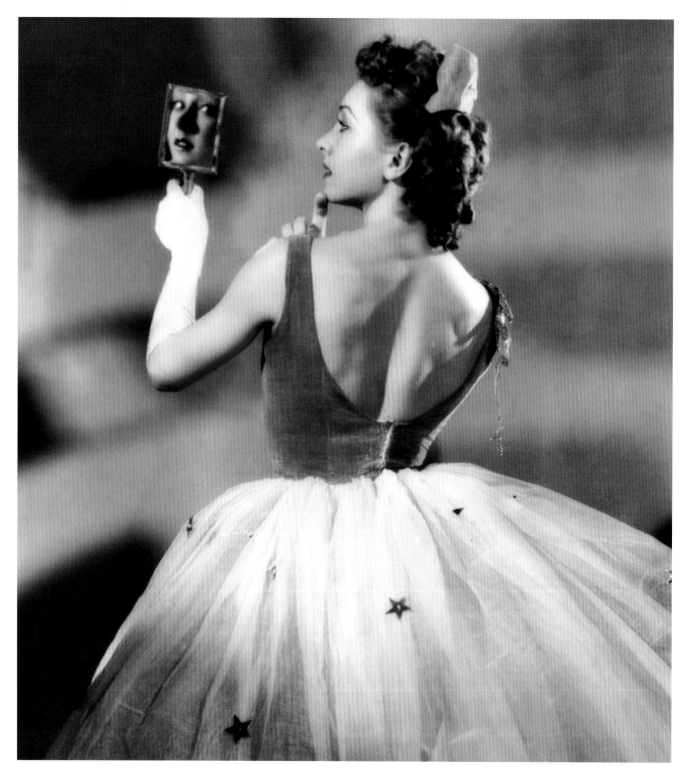

COTILLON

Choreography by George Balanchine

Libretto by Boris Kochno

Set and costumes by Christian Bérard; costumes executed by Karinska

Music by Emmanuel Chabrier

First night Théâtre de Monte Carlo, April 12, 1932

Irina Baronova as the Daughter of the House

Photo: Gordon Anthony / ©Victoria and Albert Museum

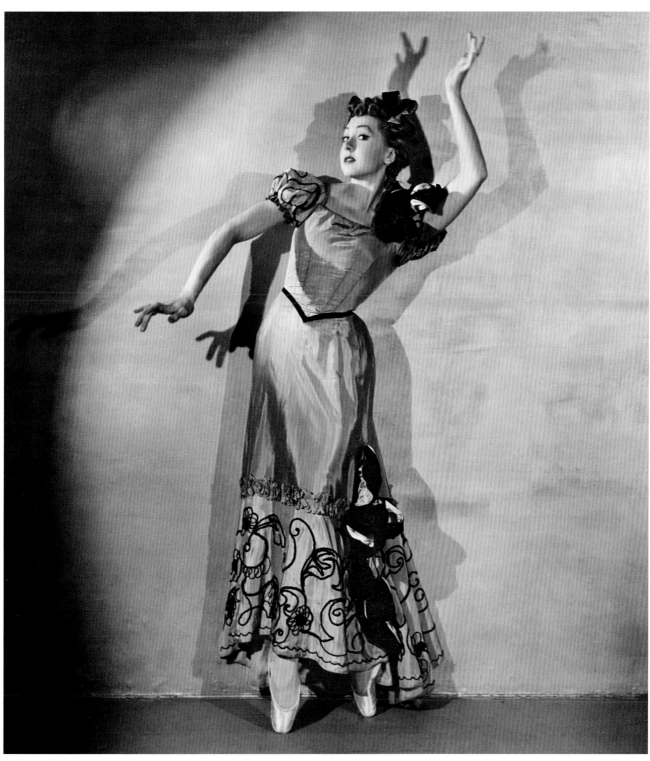

LA CONCURRENCE
Choreography by George Balanchine
Libretto by André Derain
Set and costumes by André Derain; costumes executed by Karinska
Music by Georges Auric
First night Théâtre de Monte Carlo, April 12, 1932
Irina Baronova as the Young Girl
Photo: Gordon Anthony / ©Victoria and Albert Museum

Irina Baronova

LIFAR TOUR, JULY AND AUGUST 1932

Just before the summer holiday started our leading dancer Serge Lifar invited me to dance with him on a tour of all the chic resorts: Deauville, Trouville, Biarritz and Le Touquet. The tour would be for July and August and was being sponsored by Lord James. I would dance *Spectre de la Rose* and *Prométhée* as Lifar's partner and the First Waltz of *Les Sylphides.* It was a big compliment for me. I also learned a great deal. Lifar was coached by Pierre Vladimiroff, who gave us both classes; he was a brilliant, brilliant teacher. Preobrajenska had given me the foundation, the technique; with Vladimiroff it was the artistic side, it was the beginning of putting my imagination into thinking through my roles. It wasn't legs anymore, it wasn't from here down, it was from here up. It was a tremendous thing for me.

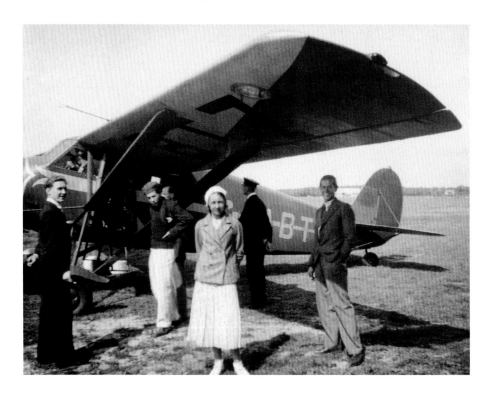

Biarritz
First time in a plane, with Serge Lifar and
Sir Edward James as pilot

SPECTRE DE LA ROSE
(Lifar Tour)
Choreography by Mikhail Fokine (version by Serge Lifar)
Libretto by Jean-Louis Vaudoyer after a poem by Théophile Gautier
Set and costumes by Léon Bakst
Music by Carl Maria von Weber
First performance by Diaghilev's Ballets Russes, Casino Monte Carlo, April 19, 1911
Photo: Fritz Henle (Monte Carlo) ©Fritz Henle Estate

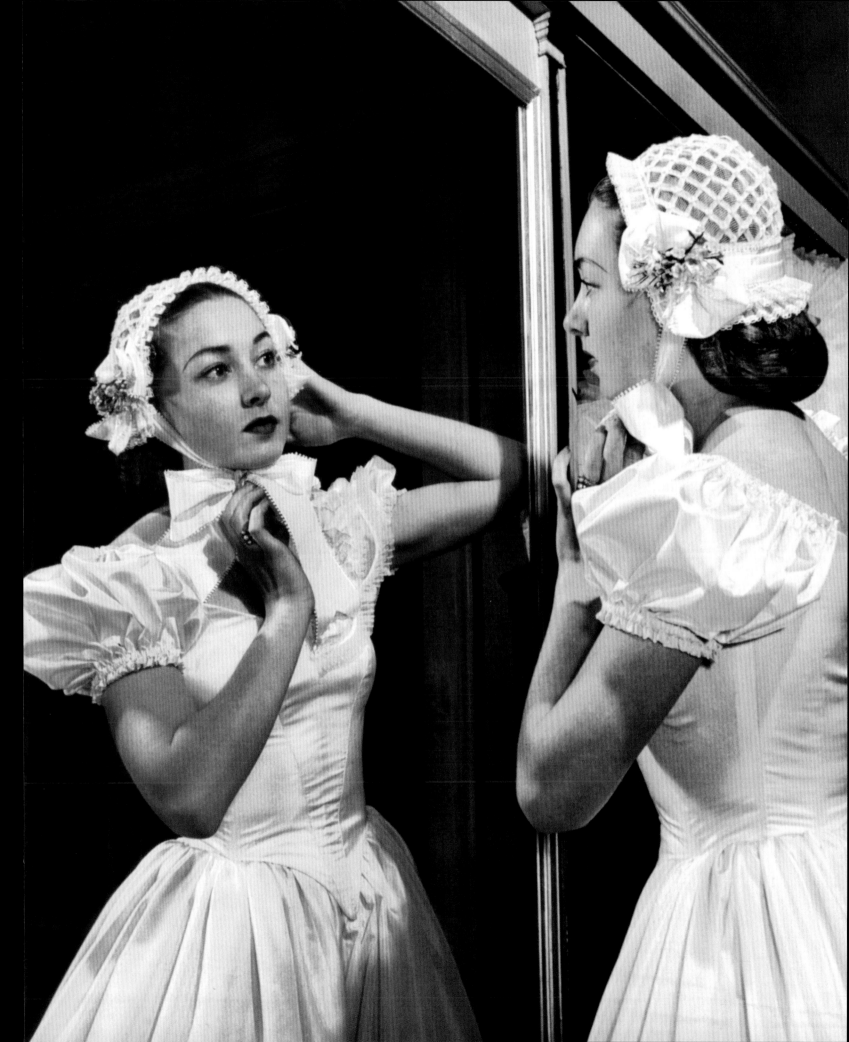

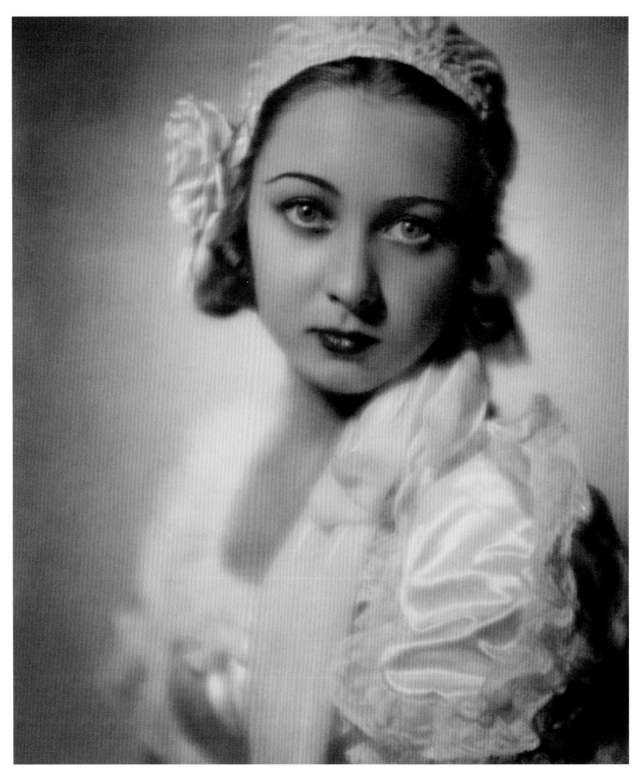

SPECTRE DE LA ROSE

Photo: Studio Batlles (Barcelona)

LES CREATURES DE PROMETHEE (Lifar Tour)
Choreography by Serge Lifar
Costumes by Prince Alexandre Schervachidze
Music by Ludwig van Beethoven
First performance Paris Opera Ballet, December 30, 1929
Irina Baronova as the Woman, with Serge Lifar
Photo: Studio Iris (Paris)

On their Sundays off, the Ballets Russes de Monte Carlo dancers would go to the beach.

Yurek Lazowsky and Narcisse Matouchevsky
on the beach, Monte Carlo, 1932

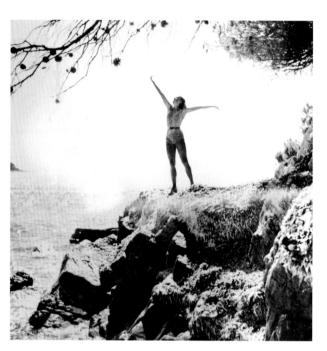

Irina Baronova on the beach, Monte Carlo, 1932

Irina Baronova on the beach, Monte Carlo, 1932

Narcisse Matouchevsky and Yurek Lazowsky
on the beach, Monte Carlo, 1932

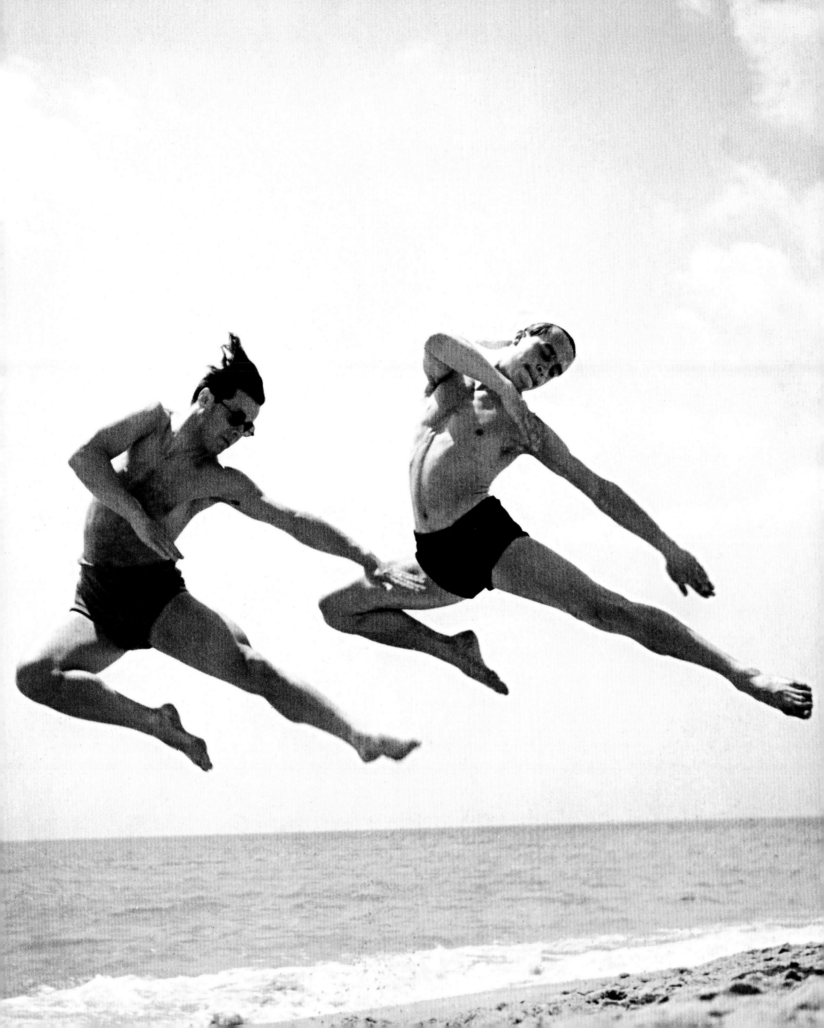

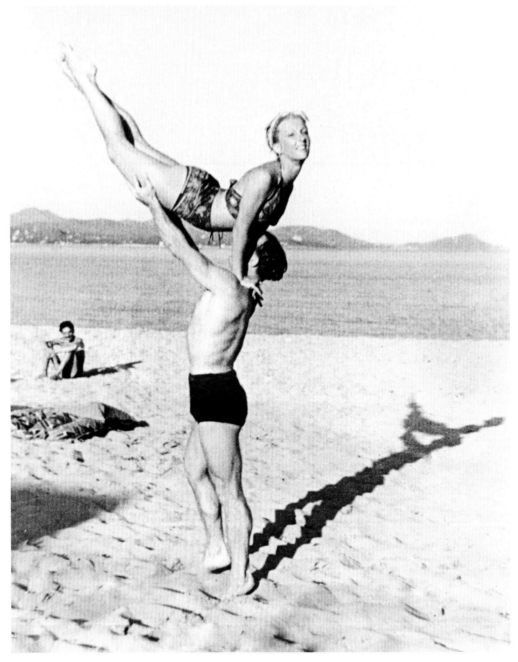

Tania Riabouchinska and David Lichine on the beach, Monte Carlo, 1932
Photo: NYPL Jerome Robbins Dance Division

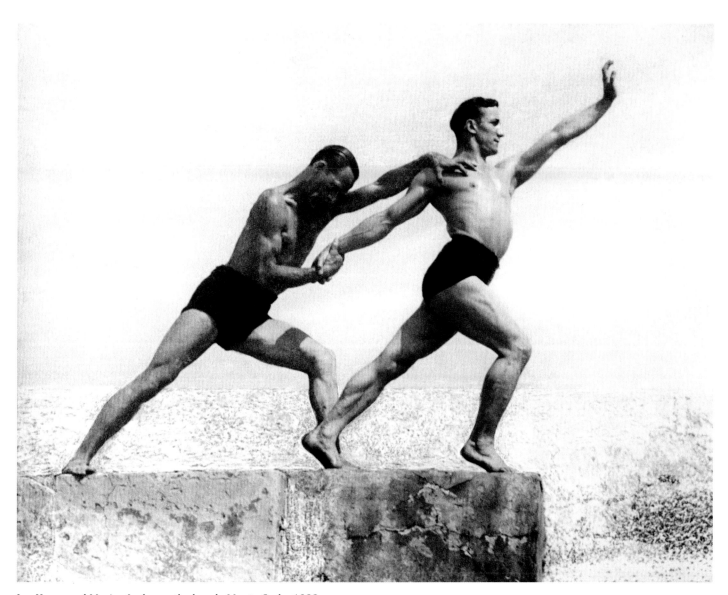

Jan Hoyer and Marian Ladre on the beach, Monte Carlo, 1932

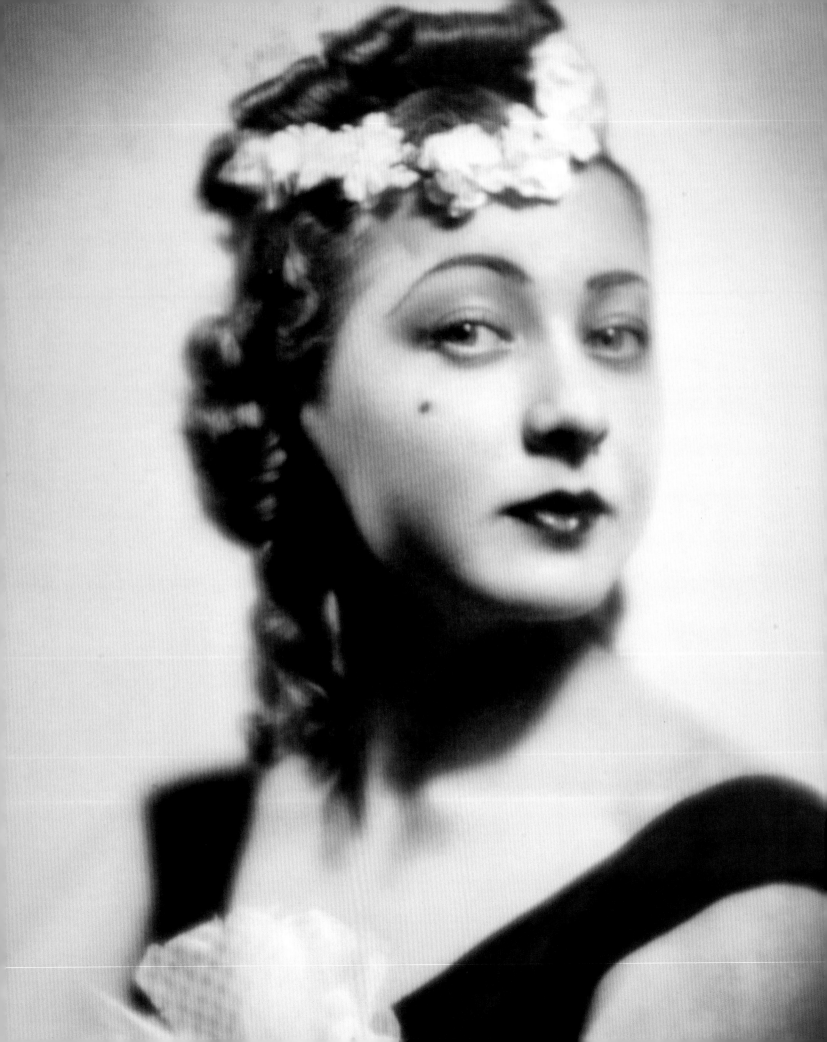

CHAPTER FOUR
London, 1933
Becoming a Star

In the picture of Massine and my mother standing on a hill, the wind catching her skirt, her hair in braids, she looks like a child. However, in the pictures of her dancing in makeup and costume, she looks like a woman. It must have been hard for her to go back and forth between the two, onstage an equal among adult artists, offstage a child under the absolute control of her mother. This situation went on for years, and I think that inside herself, she had a split sense of who she was her whole life.

After the summer, there were some changes. Balanchine had gone to start his own company, Les Ballets 1933, taking Toumanova with him. Massine replaced him as choreographer.

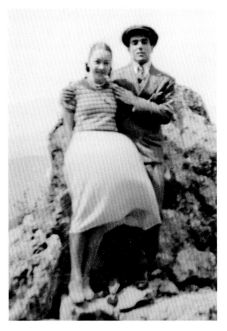

Irina Baronova and Léonide Massine on the beach, Monte Carlo, 1932

We were all in tears, all of us. Balanchine was
fun and we adored him, Massine was a dry piece of toast. Balanchine would come in and think up something, Massine would come in with lots of books, he'd open them and put them out on chairs, it was all so scientific. No sense of humor, just those huge, beautiful, cold eyes looking at you. He would walk about with a book and for each sixteen bars he'd make seven different versions of the steps, and out of all that

LE BEAU DANUBE
Choreography and libretto by Léonide Massine
Set by Vladimir Polunin after Constantin Guys
Costumes by Count Etienne de Beaumont
Music by Johann Strauss
First night Théâtre de Monte Carlo, April 15, 1933
Irina Baronova as the First Hand

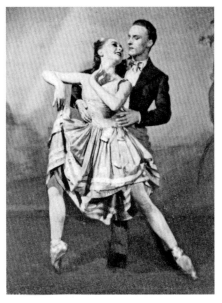

Irina Baronova and Yurek Shabelevsky in
Le Beau Danube
Photo: Maurice Goldberg /
NYPL Jerome Robbins Dance Division

Massine reworked the ballet to capitalize on the technical strengths and personalities of his dancers (Baronova was given 32 fouettes to execute). The acting and individual characterizations of the dancers drew passionate responses from the audiences. The premiere was a special performance for the birthday of the Princess of Monaco.
Photo: Studio Batlles (Barcelona) 1934

he'd pick and choose. The First Variation he'd use the second version, the Second Variation he'd use the fifth version, the Third Variation he'd use the sixth version, we were going crazy trying to remember it all. There could be eight variations in the final product. But it was good for us. The appearance of Massine made us realize that it was serious, that we had to be professionals and not just horse around. Discipline. It was very good for us youngsters, very, very good.

Alexandra Danilova, the Diaghilev ballerina, joined us now. Balanchine, her ex-lover, had told her that at 27 she was too old for our company but now he was gone. She was 12 years older than Riabouchinska and 15 years older than me and it was hard on her; we two kids were doing the same things as her, when usually you finish ballet school at 17, go into the corps de ballet and work your way up. It was all very unusual.

We rehearsed a revival of Massine's *Le Beau Danube* and his new ballet, *Scuola di Ballo*, in Paris in September 1932, then, on October 1st we left for a six week tour of Belgium, Holland, Germany and Switzerland. We toured in two buses rented for a cut-rate price

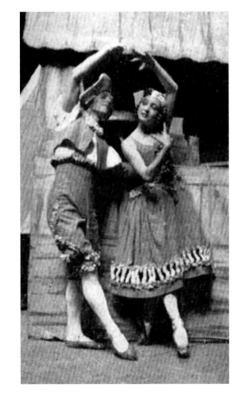

SCUOLA DI BALLO
Choreography Léonide Massine
Libretto by Léonide Massine after Goldoni
Set and costumes by Count Etienne de Beaumont; costumes executed by Karinska
Music by Luigi Bocchenini
First night Théâtre de Monte Carlo, April 25, 1933
Irina Baronova as Josephina, the favorite pupil

Massine based his ballet on a five-act verse play by Carlo Goldoni. Greatly influenced by his acting training at the Moscow Theatre School and exposure to the Commedia dell'Arte tradition, he believed in spontaneity and a strong, clearly defined personality for each character. He cast each dancer carefully, then gave them the freedom to develop their characters. Each dancer collaborated and contributed to the interpretation of their role. This brought a freshness, a naturalness to every gesture as if it were happening in the moment for the first time. Every movement was an outward expression of a flowing internal emotion with clear intent. Massine brought books on 18th-century dance and Commedia dell'Arte characters to rehearsals.
Photo: Boris Lipnitzki / NYPL Jerome Robbins Dance Division

TOUR ITINERARY

OCTOBER – NOVEMBER 1932
Belgium • Holland • Germany • Switzerland
(68 days)

Brussels - 's-Hertogenbosch - Amsterdam - Hague -
Utrecht - Paris - Antwerp - Brussels - Dusseldorf -
Duisburg - Hagen - Essen - Bochum - Cologne -
Aachen - Amsterdam - Hague - Rotterdam - Goutum -
Groningen - Zwolle - Nijmegen - Arnhem - Zeist -
Eindhoven - Maastricht - Basel - Lausanne - Geneva

Performing 11 ballets:
Cotillon, La Concurrence, Jeux d'Enfants,
Le Bourgeois Gentilhomme, Petrouchka, Chout,
Les Sylphides, Swan Lake, L'Amour Sorcier,
Pulcinella, Suite des Danses Glinka

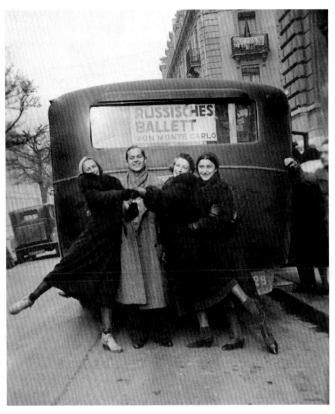

Olga Morosova, Roman Jasinsky, Tania Riabouchinska,
Kira Strakhova behind their tour bus, 1933
Photo: NYPL Jerome Robbins Dance Division

through Lichine's uncle who ran a transport company in Paris. The
scenery and costumes were loaded on the roofs and covered with
tarpaulins. Col. de Basil drove ahead in his own car. On one occasion
the buses arrived at the back of a theatre and de Basil was standing
outside. The theatre owner wasn't going to let us in unless we paid the
rent up-front. The colonel called for Mama Riabouchinska to disembark,
and, watched by the whole company through the bus windows, he
spoke urgently to her for a couple of minutes, at which she hauled up
her skirt, reached into her bloomers, and came up with a bundle of
banknotes which she handed him. On travel days, when there was no
time for a company class before the performance, Grigoriev would look
for a suitable grass verge and when he saw one, he would stop the
coach and the company would do an hour's barre work holding onto
their towels wrapped around a barbed wire fence, watched by a field
full of bemused cows.

"My role was Passion, but I was only thirteen. I had no idea how to convey Passion. I was forced to look inside myself and to explore my moods and feelings."

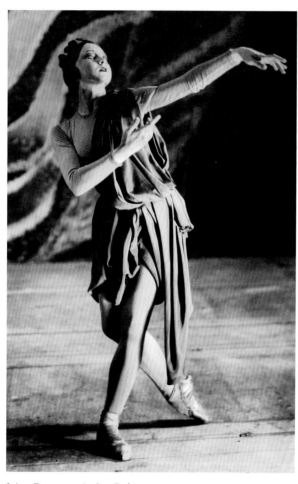

Irina Baronova in *Les Présages*
Photo: Studio Iris (Paris)

January 1933 we were in Monte Carlo where Massine made two new ballets, *Les Présages* and *Beach.* In *Les Présages*, my role was Passion, but I was only thirteen. I had no idea how to convey passion. I went around the rehearsal studio asking everyone how to portray passion and if someone said that I had got it, I had no idea how to reproduce it again because I had come up with something spontaneously and had no idea what I'd done. I was forced to look inside myself and to explore my moods and feelings.

LES PRESAGES
Choreography and libretto by Léonide Massine
Set and costumes by André Masson; costumes executed by Karinska
Music by Pyotr Ilyich Tchaikovsky
First night Théâtre de Monte Carlo, April 13, 1933
Irina Baronova as Passion, with David Lichine

Massine set *Les Présages* to Tchaikovsky's Fifth Symphony in E Minor. It was the first time, outside of Russia, that a classical ballet interpreted symphony music in movement. It was a sensation when it opened in Monte Carlo and then Paris. Some musicians thought that it was a sacrilege to try and interpret a symphony that was a complete work of art in itself. The art world had never seen an abstract symbolist ballet set before, making no attempt to represent reality. The dance world was shocked at the modernity of the work coming from a classical ballet company. *Les Présages* immediately established Massine as an important choreographer.

Photo: Studio Batlles (Barcelona)

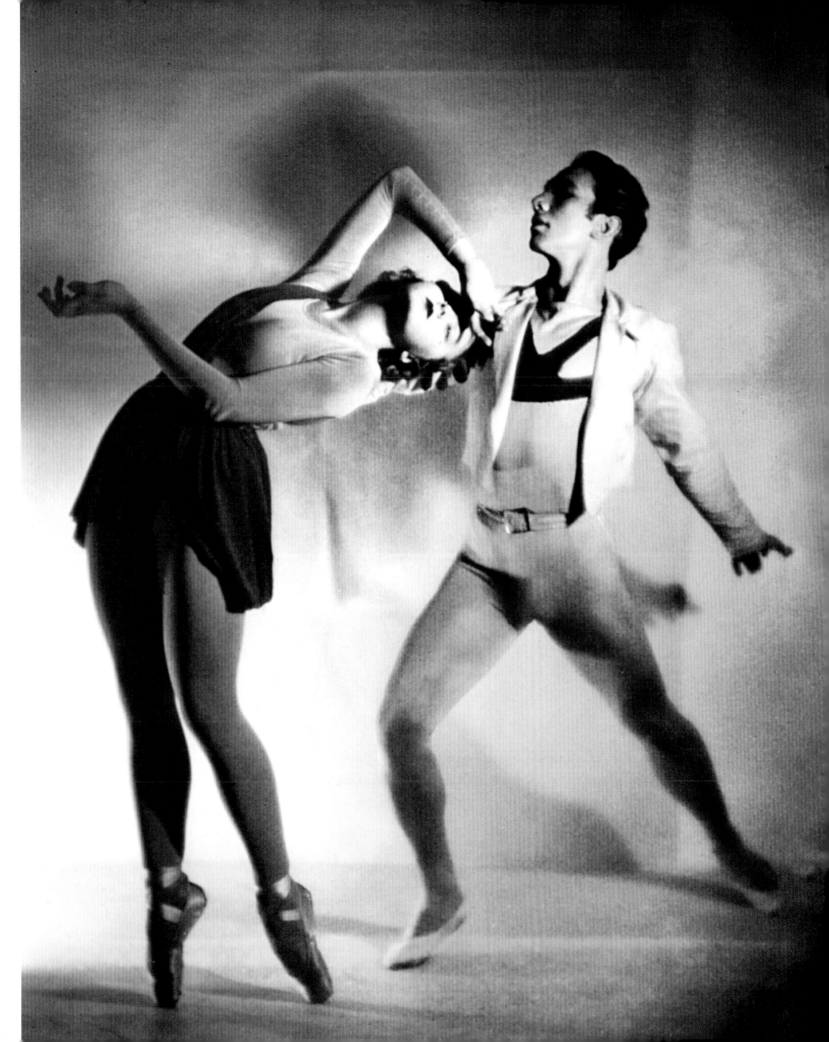

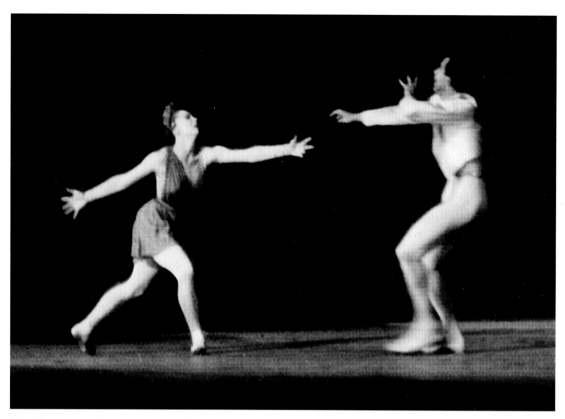

Irina Baronova as Passion in *Les Présages*

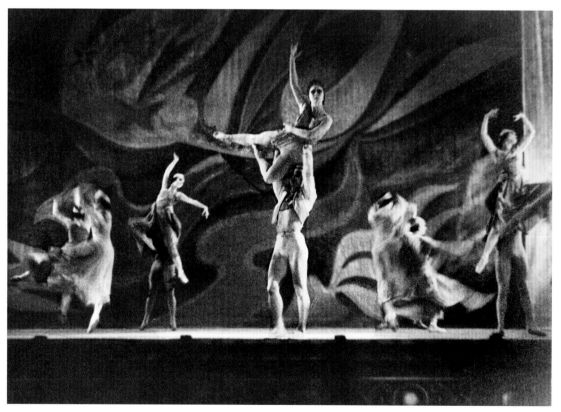

Les Présages

There are no known performance images of *Nocturne,* but I discovered these unmarked photographs amongst the Lichine-Riabouchinska papers in the New York Public Library Dance Division and identified them as being rehearsal photographs of *Nocturne*. I sent the images to Anna Volkova (ninety-four years old) who danced with the Ballets Russes de Monte Carlo, and she confirmed that they are indeed *Nocturne*. This was a thrilling discovery.

 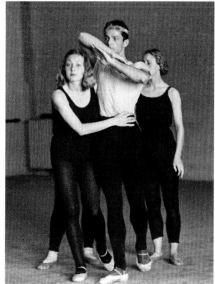 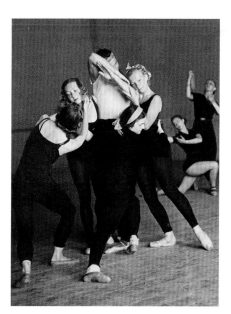

David Lichine choreographing *Nocturne* with Irina Baronova, André Eglevsky and Tatiana Riabouchinska
Photo: NYPL Jerome Robbins Dance Division

NOCTURNE
Choreography by David Lichine
Libretto by Count Etienne de Beaumont after Shakespeare's *Midsummer Night's Dream*
Set and costumes by Count Etienne de Beaumont
Music by Rameau
First night Théâtre du Châtelet, Paris, June 30, 1933
Irina Baronova and André Eglevsky as the First Betrothed Pair

This was Lichine's first choreographic work. He was helped and advised by Massine.

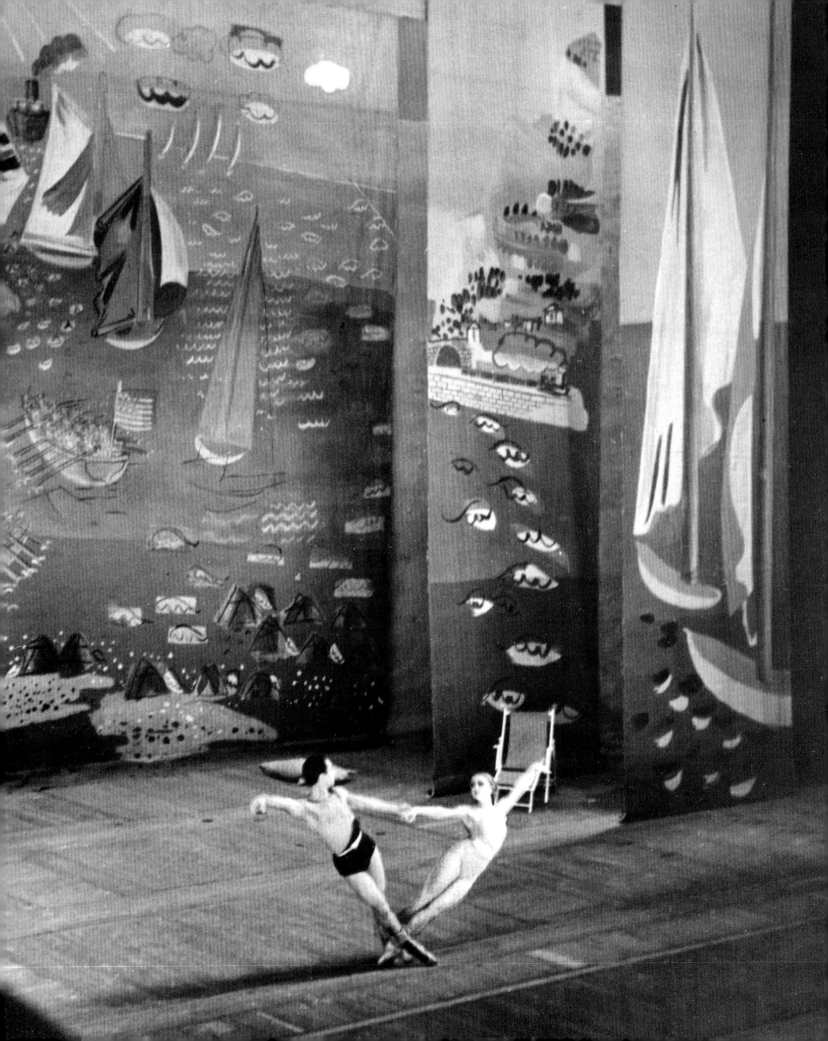

Beach was created by Massine as a tribute to Monaco, the home of the company. It was light, jazzy, and filled with smart Riviera characters. The set, designed by Raoul Dufy, was a witty homage to Monte Carlo. The choreography was athletic, even acrobatic, incorporating tap, a fox trot, and a classical pas de deux for the Swimmer (Lichine) and the Rose White Maid (Baronova).

Massine had trained at the Moscow Theatre School, performing in ballets and operas at the Bolshoi Theatre and in plays at the Maly Theatre. He was drawn to the Commedia dell'Arte tradition of incorporating mime, dance and song into the acting, and of improvising around the written text. He cast his dancers carefully and worked with them to develop their roles, allowing them the freedom to create their characters. He was influenced by Stanislavski, and his choreography had a naturalness that looked fresh and spontaneous, with every role having a distinct, specific personality. A crucial element in reviving any Massine ballet is that the dancers have to develop their roles in rehearsal the way actors do, if the dancers don't have the ability to do this then the ballet will not work. Massine's ballets require perfect casting as if they were plays.

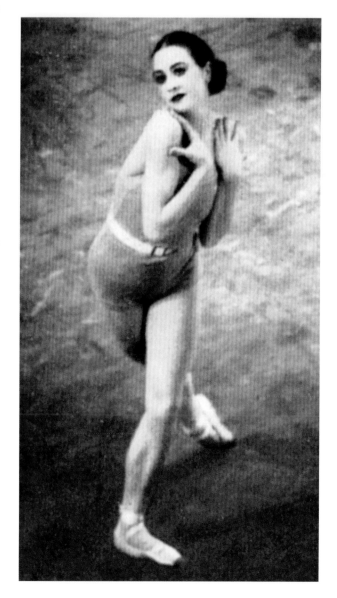

BEACH

Choreography Léonide Massine

Libretto by René Kerdyk

Set and costumes by Raoul Dufy; costumes executed by Karinska

Evening gowns by Lanvin

Music by Jean Françaix

First night Théâtre de Monte Carlo, April 19, 1933

Irina Baronova as the Rose White Maid, with David Lichine

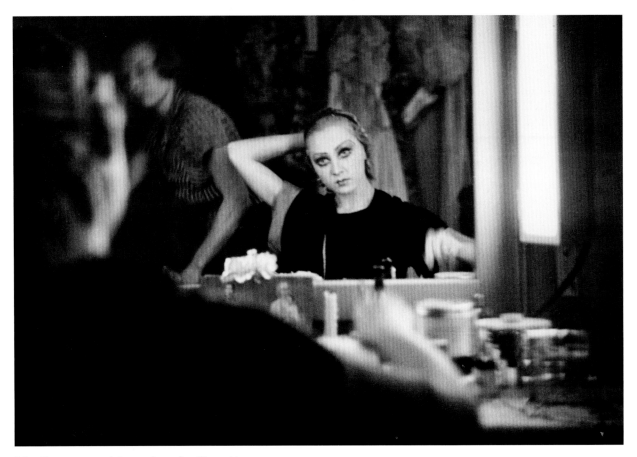

Irina Baronova applying makeup for *Choreatium*

CHOREATIUM
Choreography by Léonide Massine
Set and costumes by Constantin Terechkovitch
Music by Johannes Brahms
First night Alhambra Theatre, London, October 24, 1933
Irina Baronova in the First Movement with David Lichine

Massine's second symphonic ballet set to Brahms's Fourth Symphony. Completely abstract, with no story, theme, or characters. Pure movement to music. Choreography based on architecture, shapes, and the use of space. If *Les Présages* had created controversy, this ballet incited an uproar of debate. Massine was regarded as one of the foremost avant-garde artists of the time.

Irina Baronova practicing *Choreatium* in her dressing room

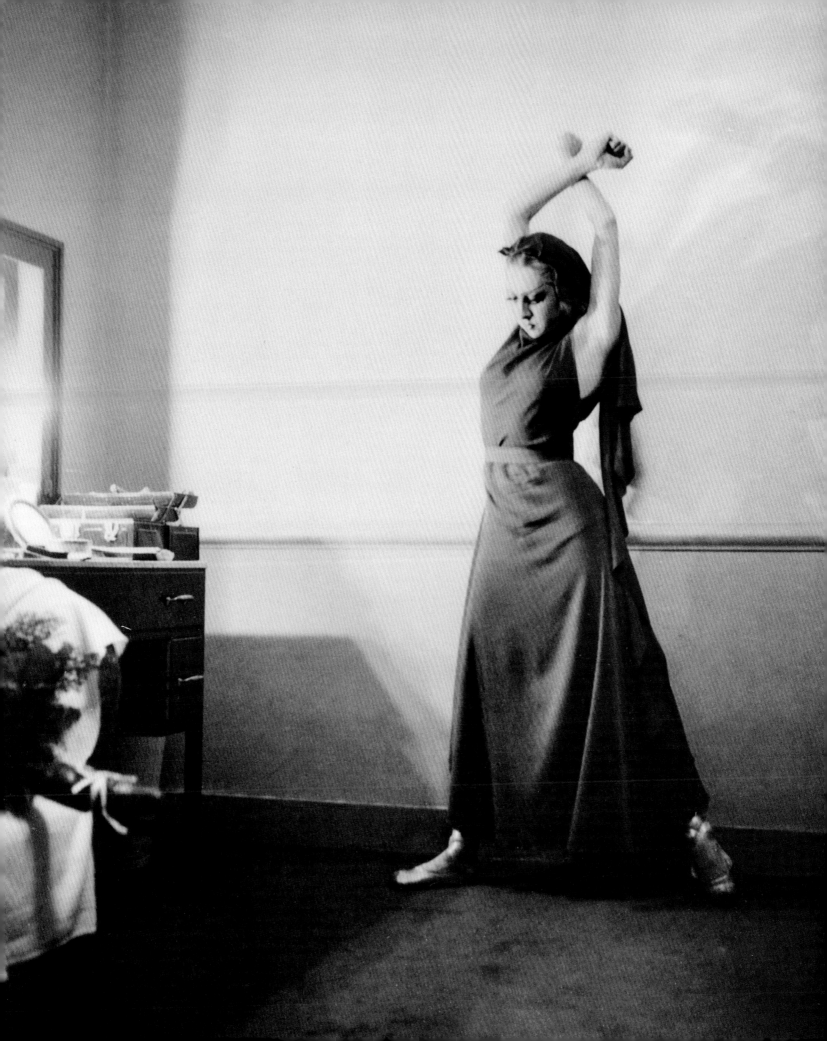

In May we went to Barcelona. June we were in Paris at the Châtelet. July 4th we were set to open at the Alhambra Theatre in London. During our first season de Basil had been invited to come to London and had rightly decided that we were not ready, because London was really Diaghilev's town and we needed a little more time to present ourselves as a new company. It was decided that we would go the following season. When we arrived in London one of Diaghilev's leading dancers, Anton Dolin, joined us as a guest artist and his arrival created much excitement in the company. His partnering of Danilova was a revelation: his presence, his elegance, the total regard he showed her, his touch, his lifts, I thought, "To dance with Dolin must be the dream of every ballerina."

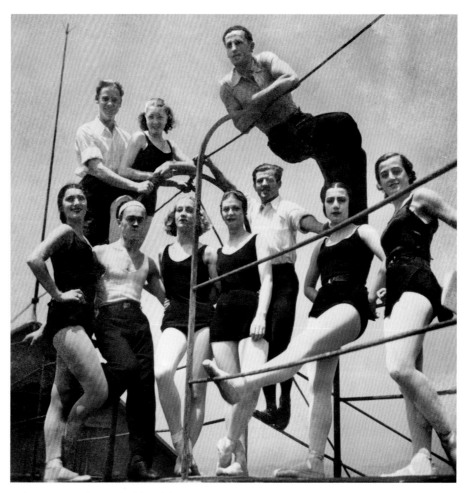

Rehearsing on the roof of the Châtelet Theatre, Paris

"'Tamara Platonova Karsavina wants to meet you,' he said. My eyes filled with tears and my head spun. She put her hands on my shoulders and gently kissed my cheek."

The first night of our London season was *Les Sylphides*, *Les Présages* and *Le Beau Danube.* Tania and I danced in all three ballets, Danilova in *Les Sylphides* and *Le Beau Danube*. The performance was sold out. The English audiences had a reputation for being balletomanes: they were knowledgeable, understood what they were watching, and if you lived up to their high expectations and they liked you, it was for life. *Les Sylphides* went well, big applause after the variations and curtain calls. We changed and assembled onstage for *Les Présages*, the big test of the evening. Massine stood in his dressing gown in the first wing, made up for his role as the Hussar in *Le Beau Danube*. He was visibly nervous. The ballet started and it became clear that the audience loved it. It was a triumph for Massine. At the curtain calls the audience shouted his name and Lichine and I brought him out onstage. *Le Beau Danube* finished the evening well and backstage we had throngs of complimentary visitors. We were happy and the Mamas were happy. Eventually the visitors left and Tania and I were about to take off our makeup when de Basil appeared with a beautiful lady and said, "Tamara Platonova Karsavina wants to meet you." My eyes filled with tears and my head spun. Karsavina was here? Here, in my dressing room? I whispered to her, "I saw you in Bucharest when I was seven. You are my magic princess forever!" She put her hands on my shoulders and gently kissed my cheek.

"De Basil decided that I would dance Danilova's role. I had one day to rehearse. My big chance."

By October 1933 Balanchine's company had disbanded in London, he left for America, and Toumanova went back to de Basil. Balanchine had tried to compete with de Basil's company and failed. The Ballets Russes de Monte Carlo came to London for three weeks and stayed for four months, playing to sold-out houses and glorious reviews. Danilova was the only one who danced *Swan Lake.* It was considered that the younger dancers were not ready to take on big parts like that. The new, modern ballets by Balanchine and Massine, yes, but the classics were Danilova's. The day before she was to dance the opening night of *Swan Lake* in London, she fell ill.

De Basil decided that because I always watched everybody else's performances from the wings and I had a good memory, I would dance Danilova's role. I had one day to rehearse. My big chance. Of course, Mama Toumanova was spitting all over the place in a rage because she wanted her daughter to have the role, but de Basil said, "No. Irina." It was Lichine who danced *Swan Lake* with Danilova, and sometimes Dolin, but for this particular performance it was Lichine. Lichine was called and told to rehearse with me and help me, and Lichine refused. He said, "What! With that thing no higher than a piss pot! I'm not dancing *Swan Lake* with her!" So, I was in floods of tears and Mama was in floods of

SWAN LAKE
Choreography after Marius Petipa by Mikhail Fokine
Libretto by Vladimir P. Begichev and Vasily Geltzer
Set and costumes by Aleksandr Golovin and Konstantin Korovin
Music by Pyotr Ilyich Tchaikovsky
First performance with Petipa's choreography, Maryinsky Theatre
St. Petersburg, February 17, 1894
First performance with Fokine's additional choreography by
Diaghilev's Ballets Russes, Covent Garden Theatre, London, November 30, 1911
Irina Baronova as the White Swan

When Baronova first danced the role with Anton Dolin she was 14 years old.

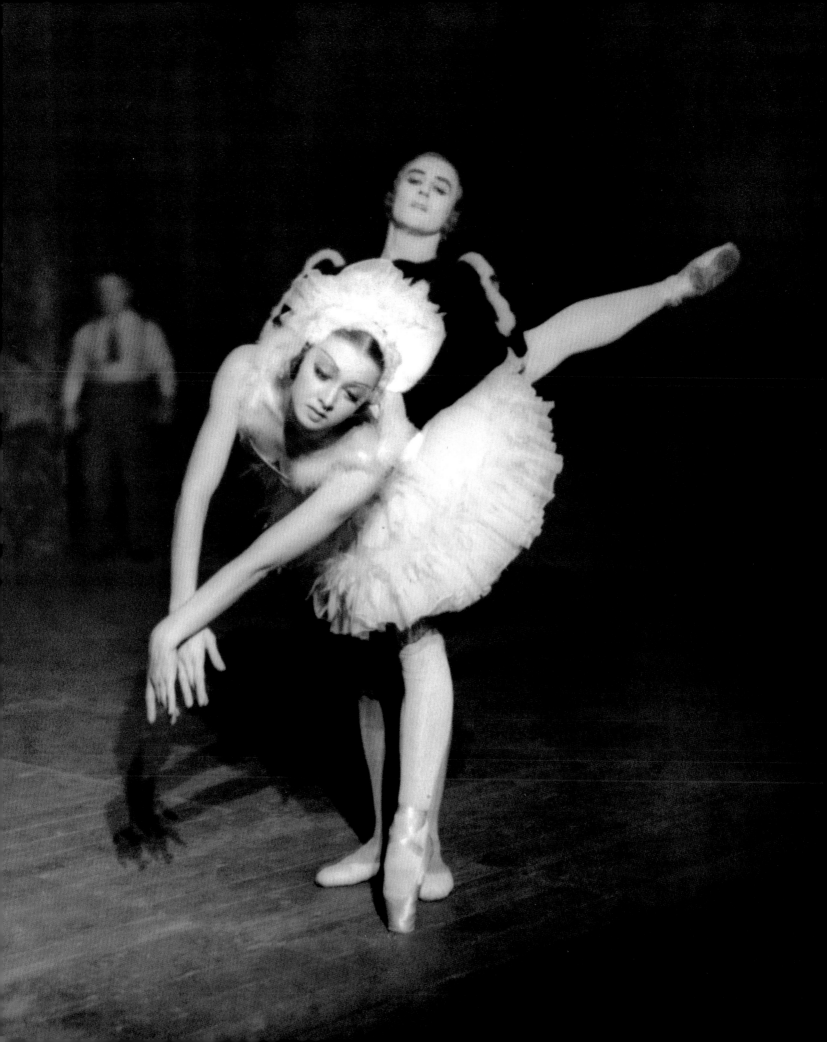

"The thing that made me most happy, the biggest thrill for me, was that in front of the whole audience, the great Dolin kissed my hand. Bowed, and kissed my hand. That's what I will always remember about *Swan Lake*."

tears, everybody was in floods of tears. I felt awful, Lichine had said that he didn't want to dance with me — who the hell was I? At that very moment in walked Dolin and he asked what on earth was going on? He was told, and his response was, "I never heard such nonsense, I shall dance with her myself!" He whisked me into a taxi and took me to his studio in Chelsea. He sat me down and said, "Relax, do you want a glass of milk?" He explained the role to me then said, "Right, now, we'll start rehearsing." He had a very nice studio with a mirror and good floor space. He drilled the role into me all that day and the next morning. That night we gave a very good performance. The audience went mad. But the thing that made me most happy, more than the fact that I had done it and that everybody was pleased with it, the biggest thrill for me, was that when we took our curtain calls, in front of the whole audience, the great Dolin kissed my hand. Led me forward, bowed, and kissed my hand. That's what I will always remember about my first *Swan Lake*. Anton Dolin kissed my hand.

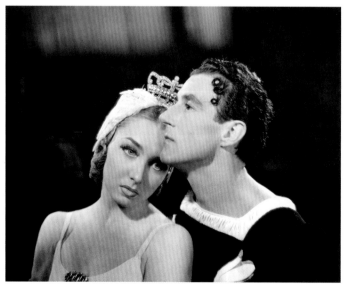

Swan Lake, 1933

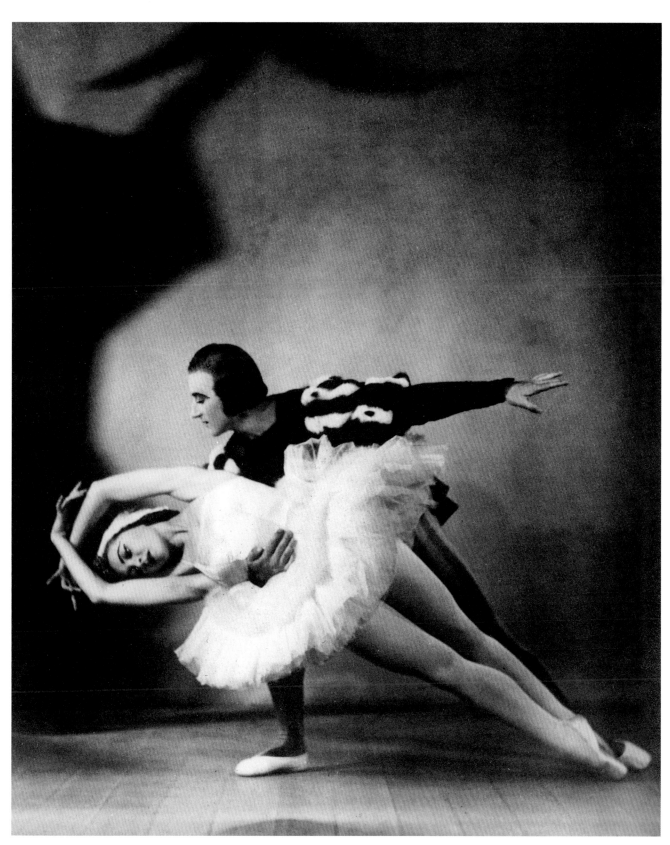

Irina Baronova and Anton Dolin in *Swan Lake*, 1933

Photo: National Library of Australia

CHAPTER FIVE

America and Canada, 1933–1938
Baby Ballerina — Pioneer Tours

FIRST TOUR: DECEMBER 1933 – APRIL 1934

Sitting on the floor, I sifted through the images trying to place the photographs in time. There were clues to help me: I looked at my mother's hairstyles — was her hair long or short? Certain hats and berets made their appearances then vanished. The way she did her makeup varied (her "Picasso" she used to call it). The mountain of paper in the middle of the room diminished as orderly piles of photographs began to line up around the edge of the carpet. I kept all the American tours together because they constituted a single, enormous undertaking: to bring ballet to every corner of a continent that hadn't seen a ballet in years.

The Baby Ballerinas in a
Hurok publicity shot, 1933

Ballerinas:
Tatiana Riabouchinska (*Petrouchka*)
Irina Baronova (*Swan Lake*)
Tamara Toumanova (*Cotillon*)

Framed costume and scenery designs:
Larionov *(Le Renard)*
Goncharova (*Liturgie*)
Picasso (*Three Cornered Hat*)
Bakst (*Scheherazade*)

We arrived in New York on the ship *Lafayette*. The
whole company was on deck as dawn broke, excited to see the Statue of Liberty and the skyscrapers of Manhattan come into sight. Little boats carrying the impresario Sol Hurok and lots of press reporters came

Ballerinas on board the *Lafayette*
sailing to New York
From left to right: Morosova, Gregorieva,
Riabouchinska, Danilova, Baronova,
Verchinina, Toumanova, Zorina, Osato,
and Adrianova
Photo: NYPL Jerome Robbins Dance
Division

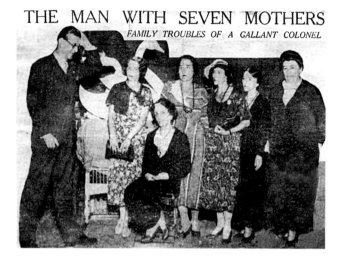

THE MAN WITH SEVEN MOTHERS

FAMILY TROUBLES OF A GALLANT COLONEL

Photo: NYPL Jerome Robbins
Dance Division

around the ship and the men were climbing aboard yelling, "Mr. Diaghilev! Mr. Diaghilev!" They didn't believe he was dead. Mr. Hurok started the publicity campaign there and then with stories about the three "Baby Ballerinas," and the name stuck to us forever.

Sol Hurok was a Ukrainian émigré who arrived in New York in 1906 and started his career arranging concerts for labor organizations. He became the most important and influential impresario in America, presenting musicians, opera singers, and ballet companies for over fifty years.

One press story about the Baby Ballerinas and maternal rivalry was:

THE MAN WITH SEVEN MOTHERS: FAMILY TROUBLES OF A GALLANT COLONEL. *The courage displayed by him in his military adventures is nothing compared to what's required by his daily skirmishes with the seven mothers.*

Another newspaper revealed that there were seven mothers and one father, there to protect the ballerinas from late nights and male admirers.

Colonel de Basil had asked my father to join the company to maintain and retouch the scenery, so we were reunited on the ship. It was a dream come true. My parents found a cheap, small apartment to rent in a building on the West Side of Manhattan, near the docks, and a number of the other dancers stayed there too. One of the Mamas proposed that we club together to buy food and offered to do the cooking for all of us. This was enthusiastically agreed to, and we were well fed by her good home cooking.

Now, the company no longer fit into two buses with the scenery and costumes strapped to the roofs; now, the tour consisted of sixty-four dancers, a fifty-piece orchestra, eighty-four back-drops and curtains, and six thousand costumes. There hadn't been much ballet in America for several years. At the dress rehearsal for *Les Sylphides*, de Basil was standing at the back of the St. James Theatre with the theatre manager when the manager remarked that he had never seen a ballet before. De Basil asked him how he liked it and the manager said, "Well, it's very pretty . . . the girls are very pretty . . . but what's that guy doing? Get him out of there!"

Irina Baronova

It seems extraordinary now, when every town has a ballet school and every little girl has a tutu in her dress-up drawer, that there was a time when ballet was largely unknown in America.

On opening night the program was *La Concurrence*, *Les Présages,* and *Le Beau Danube*. Grand Duchess Marie of Russia was there and everyone with a title in New York. But the first week's box office was disappointing; the public didn't like the new ballets. They especially didn't like *Les Présages*; it wasn't what they expected. A powerful critic advised Hurok to add pre–First World War ballets, so *Petrouchka* and *Carnaval* appeared for the second week and the ticket sales improved so much that the theatre invoked a stop clause to prevent the company from leaving on tour. The company had come with twenty-two ballets, but for several weeks they performed a single program, *Les Sylphides*, *Petrouchka,* and *Prince Igor*. The dancers called it "Ham and Eggs."

We had our own train and we lived on it. You name a town in America, we played it. Theatres, little stages, college auditoriums, anything they could stick together. We'd arrive at the station and go straight to the theatre. While the scenery was carried in Tchernicheva would give a class. Then, makeup, performance, and to the corner drugstore to eat something. De Basil would have rented a ballroom in the local hotel or a big room

From a 1933 program cover
Photo: Du Bois

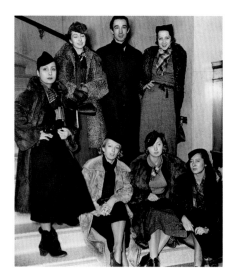

Left to right standing: Toumanova,
Morosova, Lichine, and Danilova
Seated: Riabouchinska, Baronova,
and Chamie
Photo: NYPL Jerome Robbins Dance
Division

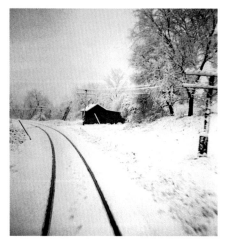

Snowy train tracks

somewhere, and, after eating, we'd rehearse a new ballet with Massine until four or five in the morning. Then back to the station, into our pyjamas and sleep until the next town. By the end of four months like this we were all so tired, we couldn't wait to get on the boat, get to our cabins and sleep all the way to Europe. But there was always somebody on the boat who was fun, Maurice Chevalier or Rosalind Russell, so we never went to bed after all! That's how we lived. Yes, we worked hard but I loved every moment of it. We were working with big, thrilling people. Massine, Fokine, Nijinska. The designers were Benois, Miró, Picasso, they were there, we were talking to them, it was all part of our education. Stravinsky, Ravel, came to our rehearsals, they played the piano themselves, discussed the ballets. We were exploited, of course, but we adored every minute of it. If the Colonel would have said to me, "Okay, you can have a week off. Somebody else will dance your part," I would have said, "Over my dead body!" So you can't only blame them, we didn't kick back. Then there were no unions. The first time I had to join a union was with Ballet Theatre, when AGMA (American Guild of Musical Artists) came in, and none of us could understand, how can you be an artist and do creative work and look at the clock all the time? You're in the middle of a rehearsal and they say you've got to take a break and you're just about to produce something.

I have to interject here and say that this is precisely why artists have to have unions: because the artists only care about the work and somebody has to protect them. Take these tours, for example. I knew about the trans-America tours — my mother talked about them — but it wasn't until I was in the New York Public Library holding the rehearsal director Serge Grigoriev's black notebooks in my hands that it fully dawned on me what these tours were. Starting with the company's first performance in 1932, he had written out, in ink, meticulous lists of all the cities played and how many nights, which ballets were performed, and who danced in them. I came to the American and Canadian tour pages and just stared at the lists. I couldn't believe it.

Irina Baronova

De Basil

Massine reviewing music for *Union Pacific*

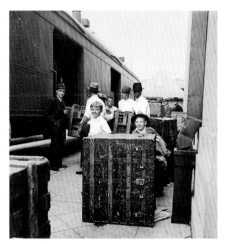

Loading trunks onto Ballets Russes train

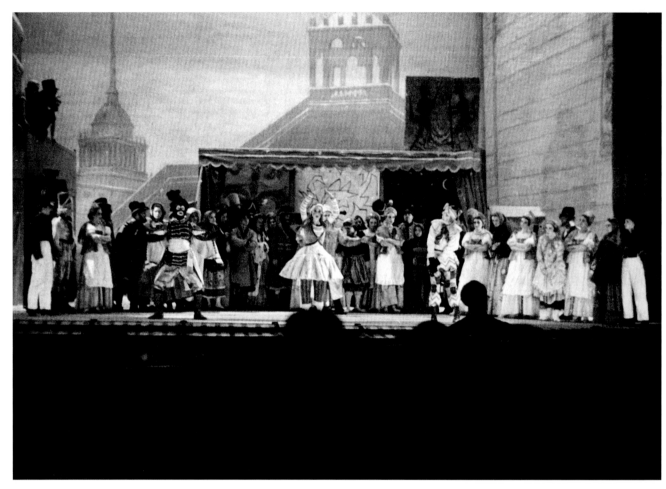

PETROUCHKA

Choreography by Mikhail Fokine

Libretto by Alexandre Benois and Igor Stravinsky

Music by Igor Stravinsky

Set and costumes by Alexandre Benois

First performance by Diaghilev's Ballets Russes, Théâtre du Châtelet, Paris, June 13, 1911

Irina Baronova as the Doll

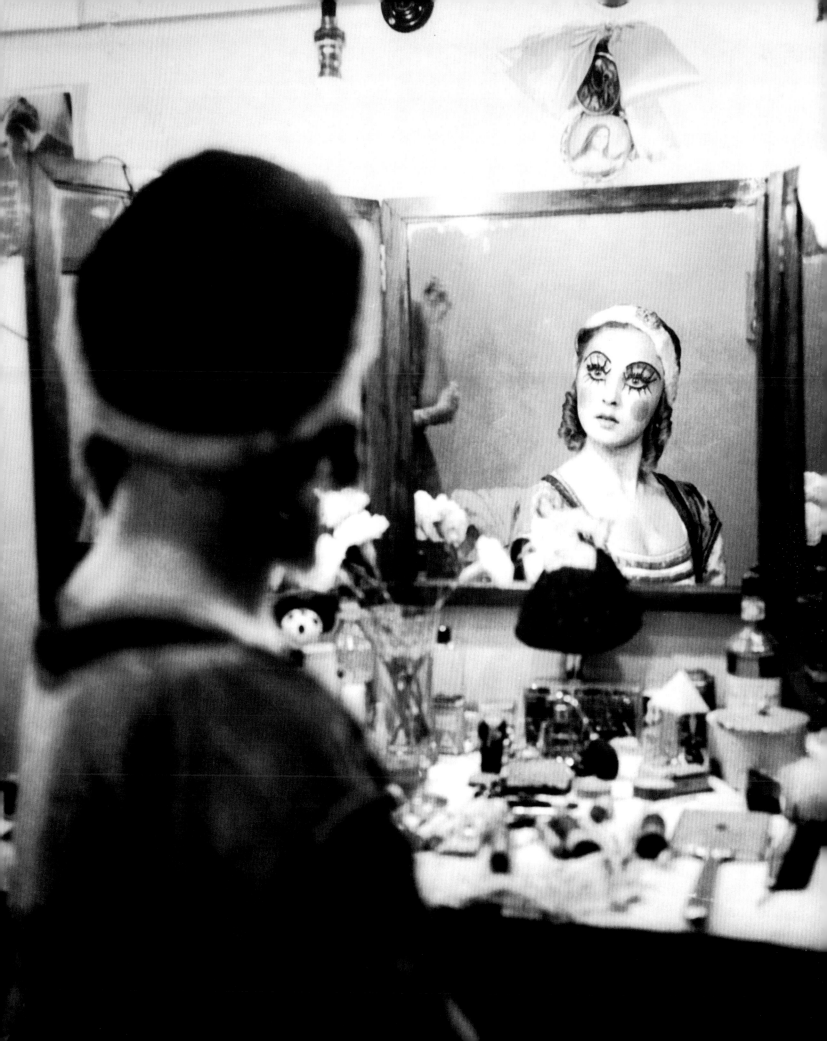

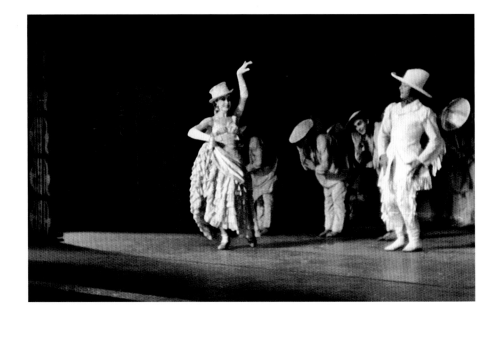

UNION PACIFIC

Choreography by Léonide Massine

Libretto by Archibald MacLeish

Set by Valentine Kashuba

Costumes by Irene Sharaff

Music by Nicolas Nabokov

First night Forrest Theatre

Philadelphia, April 6, 1934

Irina Baronova as Lady Gay

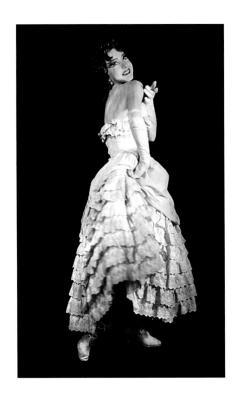

Massine had wanted to do a ballet with an American theme for some time. The libretto, by the poet Archibald MacLeish, who had just won a Pulitzer Prize, told the story of the building of the railroad. The composer, Nicolas Nabokov, asked his friend Gerald Murphy, who had a rare collection of early American recordings, if he would play them for Massine, MacLeish, and himself. These recordings included Chicago and New Orleans jazz, which Massine used along with steps from the Cake Walk, Strut, and Shuffle shown to him in Harlem and New Orleans. In *Union Pacific*, Massine introduced American folk character dance that was further developed in later years by Eugene Loring (*Billy the Kid*, 1938) and Agnes de Mille (*Rodeo*, 1942). It was the first American ballet performed by an international company, and on opening night there were twenty curtain calls. The role of Lady Gay was created by Eugenia Delarova but was later "almost exclusively identified with Baronova, who gave remarkable performances in America and Europe."

Quote from my mother:

Our first tour ended with *Union Pacific.* I really enjoyed that ballet, oh, it was lovely camping.

Photo: Spencer Shier / National Library of Australia

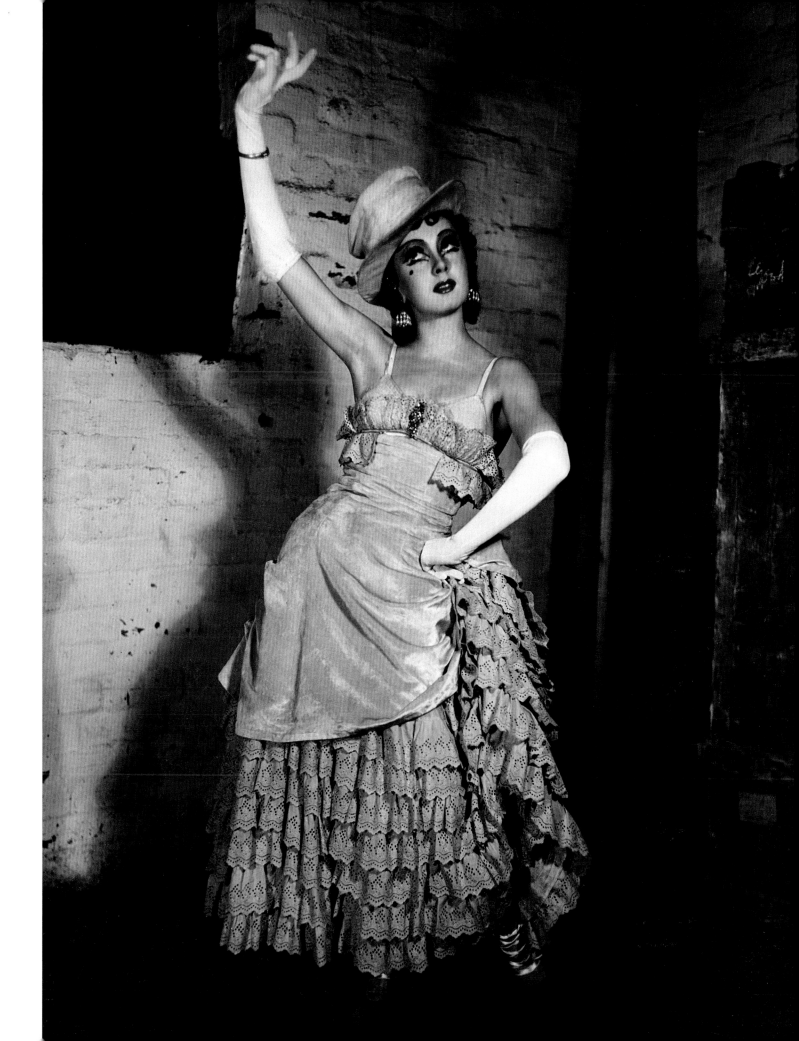

Irina Baronova

Gerry Sevastianov

A new character appeared in New York, a distant relative by marriage of Tania Riabouchinska. Tall, handsome German Sevastianov had appeared backstage in London to say hello and now reappeared in New York. A White Russian refugee, he was thrilled to find a whole company of Russians and soon a romance developed between him and Danilova. De Basil took a shine to the young man and persuaded him to leave his job managing a ranch in Colorado for Senator Mayo and become his private secretary.

Gerry came from Moscow. His father had been an opera singer, and his mother was the daughter of a textile magnate, Sergei Alexeiev, a patron of the arts. When the Russian Revolution came, Gerry was studying at the Naval Academy which was evacuated to Sevastopol.

The naval cadets were put on a battleship attempting to escape from the Red Navy. The older boys were told to shovel coal into the engines while the younger boys, like Gerry, were given guns and told to stand on deck and fire at their pursuers. The battleship managed to evade the Red Navy ships and then ran out of fuel in the Black Sea and was found drifting by an English battleship that towed them to Constantinople. King Alexander of Yugoslavia offered the refugee cadets the use of a vacant army barracks for their academy, and Gerry found himself in Sarajevo. His two sisters chose to remain in Moscow with their mother while their father escaped to Paris. Gerry finished his education in Yugoslavia, then joined his father in Paris and took any job he could find. Washing cars led to a job as a chauffeur for the Duesenberg car company, and while driving Senator and Mrs. Mayo around Paris, he was invited to tell them his story and ended up in America running their ranch.

Irina Baronova

During this first tour, Mama Riabouchinska became ill, in so much pain that she had to stop playing poker with the male dancers. De Basil took her to New York for tests; it was cancer. Mama Riabouchinska returned to her older daughter in Paris and died soon after. Without a chaperone Tania's romance with David Lichine became open knowledge. Later they married and were together all their lives.

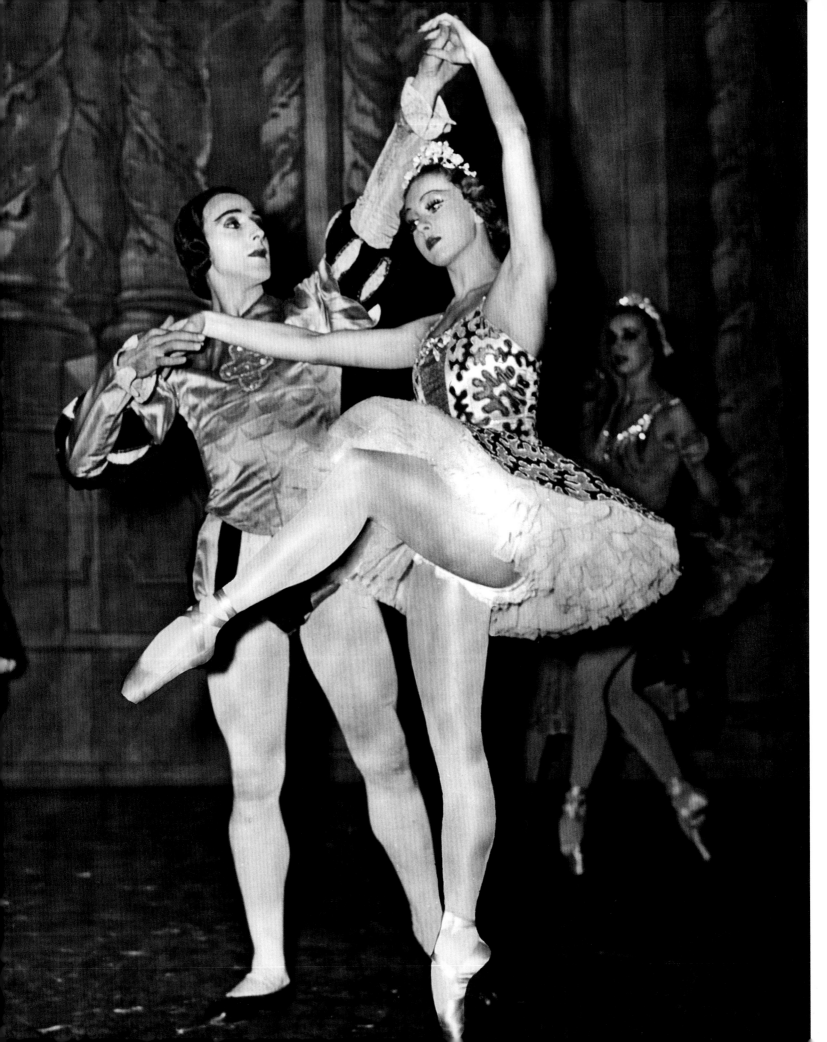

SECOND TOUR:

SEPTEMBER 25 – OCTOBER 17, 1934, Mexico City

OCTOBER 25 – NOVEMBER 1934, Tour of Canada

DECEMBER 1934 – MARCH 1935, Tour of America

Danilova's romance with Gerry Sevastianov had cooled during the months in Europe. However, he had become indispensable to de Basil. With his family background, he was knowledgeable about music and theatre. He had good taste in costumes and design and could discuss things with the designers and artists intelligently. He never imposed his views but listened carefully to Kochno and Fokine. He was also good at business, which he conducted in a straightforward way, unlike de Basil. During the Paris season, with Granny's permission, he had taken my mother out to the cinema and bought her an ice cream; my mother asked him how old he was and he told her, fifteen years older than her. Since then, my grandparents, realizing there might be a romance brewing between them, decided Gerry was too old and unsuitable and forbade my mother to talk to him. The result, of course, was that he instantly became more interesting. They managed to have a few furtive minutes together, passing each other in the street or at the theatre, but Granny watched my mother like a hawk, so these interludes were few and far between. On the ship to New York in September 1934, my mother's best friend, Tatiana Semenova, passed her a note from Gerry asking her to meet him in his cabin. She managed to sneak away and Gerry immediately told her he wanted to marry her, to which she replied that her mother had told her she couldn't get married until she was thirty. Gerry was responding to this when Danilova entered his cabin in a dressing gown, and my mother fled, terrified that Danilova would report to her parents that she had been in Gerry's cabin.

Irina Baronova

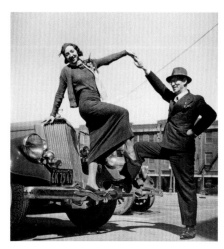

Danilova with de Basil

The company and orchestra arrived in New York by ship and transferred to their special train: eleven Pullman cars, with another train for the scenery and costumes. For the next six months this train was their home. Danilova had stopped speaking to my mother; my mother wasn't able to speak to Gerry; my grandparents definitely weren't speaking to Gerry, and Gerry was trying to distance himself from Danilova. It must have been something, living on the train on top of one another, while the company performed a grueling succession of one-night stands: three ballets a night, six on Wednesdays and Saturdays.

Building on their pioneer tour the year before, the Ballets Russes de Monte Carlo brought ballet on a grand scale to every part of the continent. In addition to their repertoire, four new revivals were presented: *Aurora's Wedding*, *Le Soleil de Nuit*, *Les Femmes de Bonne Humeur,* and *Scheherazade*. The audiences loved them. There were also two premieres of new Massine ballets: *Jardin Public* and *Le Bal*.

In Canada, the train got snowed in and marooned on the tracks. It took three days for the snowplow to get to them. On the first day it was fun; the dancers played in the snow. On the second day the heating started to fail and the restaurant car started to run out of food. By the third day, there was no heating and everyone was freezing, hungry and worried. To their great relief the snowplow showed up that afternoon. When the train finally arrived at its destination, the manager of the local theatre was waiting for them on the platform. He had tried to reimburse his audience for the cancelled performance, but when they heard that the train was on the way, the ticket-holders decided to wait for it in the theatre. He knew that it was late, but would the company please, please come to his theatre because the audience was waiting, sitting in their seats. The curtain went up just before midnight.

Los Angeles in January was a welcome change of climate. There were friends from the previous season, and new admirers, one of whom was Marlene Dietrich, who was fascinated by Massine. She installed herself on a chair in the first wing backstage and watched

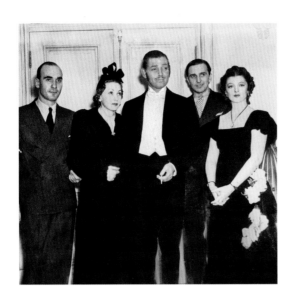

Left to right:
Boris Kochno, Irina Baronova, Clark Gable,
Gerry Sevastianov, and Myrna Loy

every performance. Two of the dancers got the flu, and Papa Grigoriev asked the Mamas for two volunteers to join the cast of *Union Pacific*. He needed them to play the wooden sleepers being laid across the tracks. Only Mama Baronova was the right size; one more sleeper was needed. Marlene Dietrich offered to do it, and the two ladies climbed into their sacks and were carried onstage as pieces of wood. When the company moved to Santa Barbara for three days, Marlene went too. She moved into the trailer hitched behind Massine's car and drove up the coast with Massine and his wife.

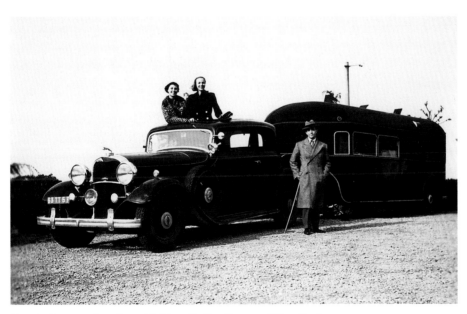

Massine's car and trailer, with his wife, Danilova, and Vera Zorina

AURORA'S WEDDING

Choreography by Marius Petipa with additions by Bronislava Nijinska

Libretto by Marius Petipa

Set (originally designed for *Le Pavillon d'Armide*, 1909) by Alexandre Benois

Costumes by Alexandre Benois with additions by Natalia Goncharova

Music by Pyotr Ilyich Tchaikovsky

First performance by Diaghilev's Ballets Russes, Théâtre National de l'Opera
May 18, 1922

Irina Baronova as Princess Aurora in the Ballets Russes de Monte Carlo revival

Aurora's Wedding was devised by Diaghilev in 1922 when he couldn't afford to put on the full production of *The Sleeping Beauty* that he was contracted to present in Paris. He took the last scene of *The Sleeping Beauty* and re-named it *Aurora's Wedding*. He replaced the 1921 *Sleeping Beauty* set by Bakst with an old 1909 set by Benois for *Le Pavillon d'Armide.* The original Petipa choreography was supplemented by additional dances choreographed by Bronislava Nijinska, who was obliged to dance four of the roles herself because Diaghilev couldn't afford more dancers.

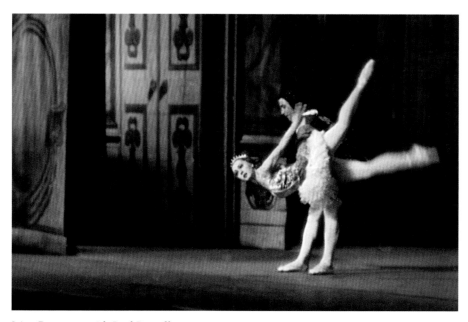

Irina Baronova with Paul Petroff

Photo: Studio Batlles (Barcelona)

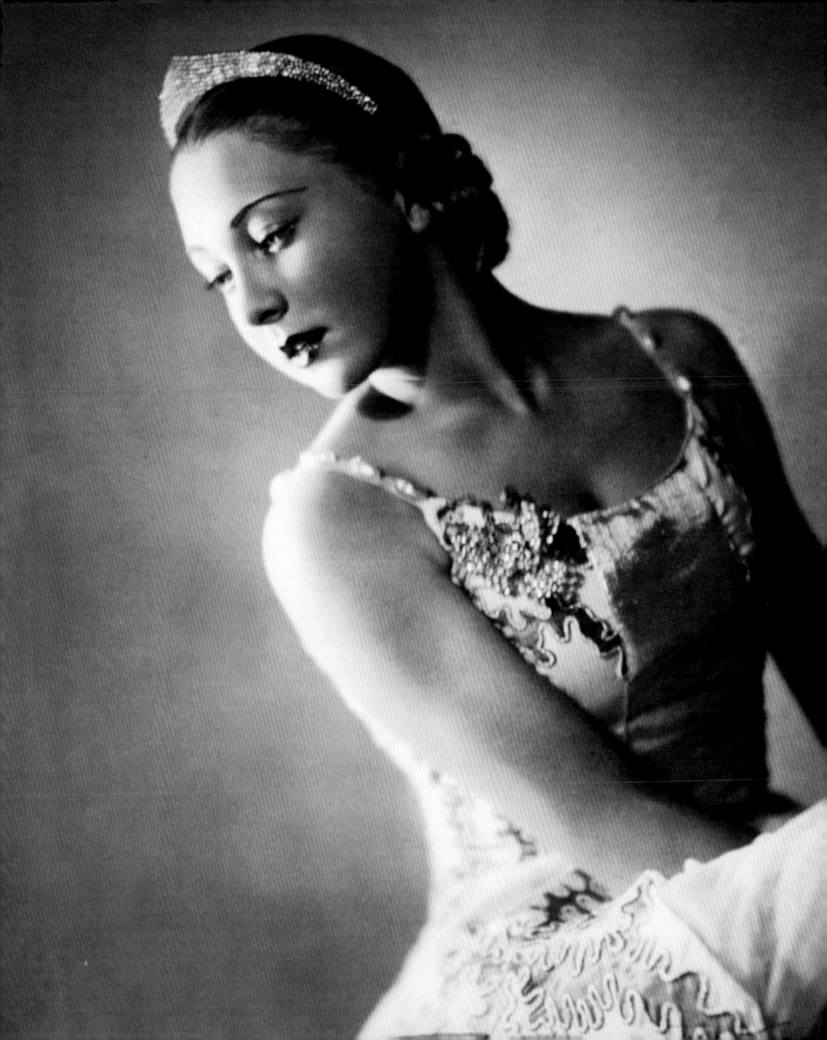

Irina Baronova in *Aurora's Wedding*

Papa Grigoriev with Eugenia Delarova

Center: Eugenia Delarova, Paul Petroff, Irina Baronova, and Tatiana Riabouchinska

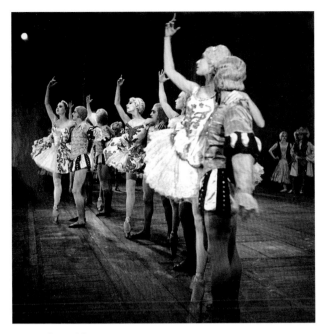

Aurora's Wedding

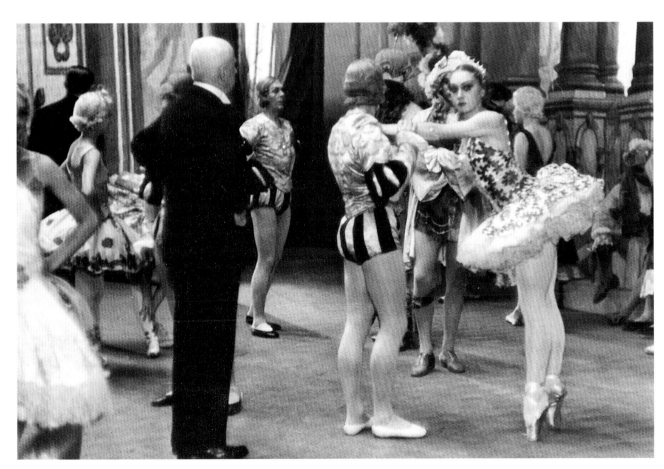

Irina Baronova as Princess Aurora with Paul Petroff

AMERICA AND CANADA
SECOND TOUR ITINERARY

October 1934 – March 1935
167 DAYS

DAYS		DAYS	
4	Toronto	1	Santa Barbara
4	Montreal	1	Oakland
2	Albany	1	Sacramento
1	Newburgh	6	San Francisco
2	Baltimore	1	Portland
2	Washington D.C.	3	Seattle
4	Philadelphia	3	Vancouver
1	Reading	1	Spokane
1	White Plains	1	Billings
1	New Haven	1	Fargo
1	Hartford	4	Winnipeg
8	Boston	3	St. Paul
1	Worcester	1	Sioux City
1	Providence	1	Lincoln
1	Schenectady	1	Omaha
1	Utica	2	Kansas City
2	Rochester	1	Dallas
3	Buffalo	1	Austin
1	Youngstown	1	San Antonio
1	Akron	2	Houston
2	Pittsburgh	1	New Orleans
4	Cleveland	1	Birmingham
4	Detroit	1	Chattanooga
1	Grandville	1	Atlanta
3	Cincinnati	1	Savannah
1	Indianapolis	1	Richmond
1	Lafayette	2	Washington D.C.
1	Urbana	1	Durham
1	Bloomington	1	Roanoke
3	Milwaukee	1	Lexington
2	Madison	1	Louisville
1	Davenport	5	Chicago
1	Terre Haute	1	Grand Rapids
13	Chicago (January 1935)	1	Toledo
4	St. Louis	1	Columbus
1	Joplin	1	Springfield
1	Tulsa	1	New Brunswick
1	Wichita	1	Harrisburg
1	Colorado Springs	2	Philadelphia
3	Denver	1	Brooklyn
8	Los Angeles	5	New York

New Year's Eve 1934/1935

Crossing America

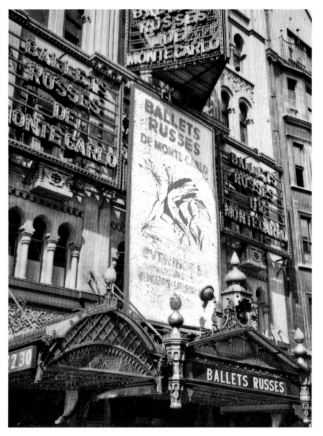

New York

Irina Baronova with Efrem Kurtz, Conductor

Montana

Texas

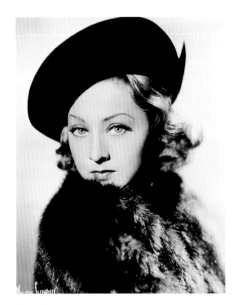

Irina Baronova
Photo: Maurice Seymour

Six months later, the last stop was New York. As my mother was warming up onstage before a performance, Danilova appeared and asked her to come to her dressing room. Nearly in tears, Danilova asked my mother to stop the flirtation with Gerry because Gerry belonged to her. My mother always wanted to please everyone; she always put herself last. Impulsively she hugged Danilova, then leaving the dressing room, bumped into Gerry and, as loudly as she could, told him to leave her alone because he belonged to Danilova. Gerry's response was to shout that he didn't belong to anyone, and he'd do whatever he wanted. All the dressing room doors up and down the corridor had opened; the whole company was listening to the fracas. Gerry didn't speak to either of his ballerinas for a while. Granny was very pleased. And my mother? She was a sixteen-year-old, completely confused about everything.

Danilova with her dresser

LE SOLEIL DE NUIT (MIDNIGHT SUN)
Choreography by Léonide Massine
Set and costumes by Mikhail Larionov
Music by Nikolai Rimsky-Korsakov
First performance December 20, 1915
Irina Baronova in Russian Dance with Léonide Massine
Photo: Maurice Seymour

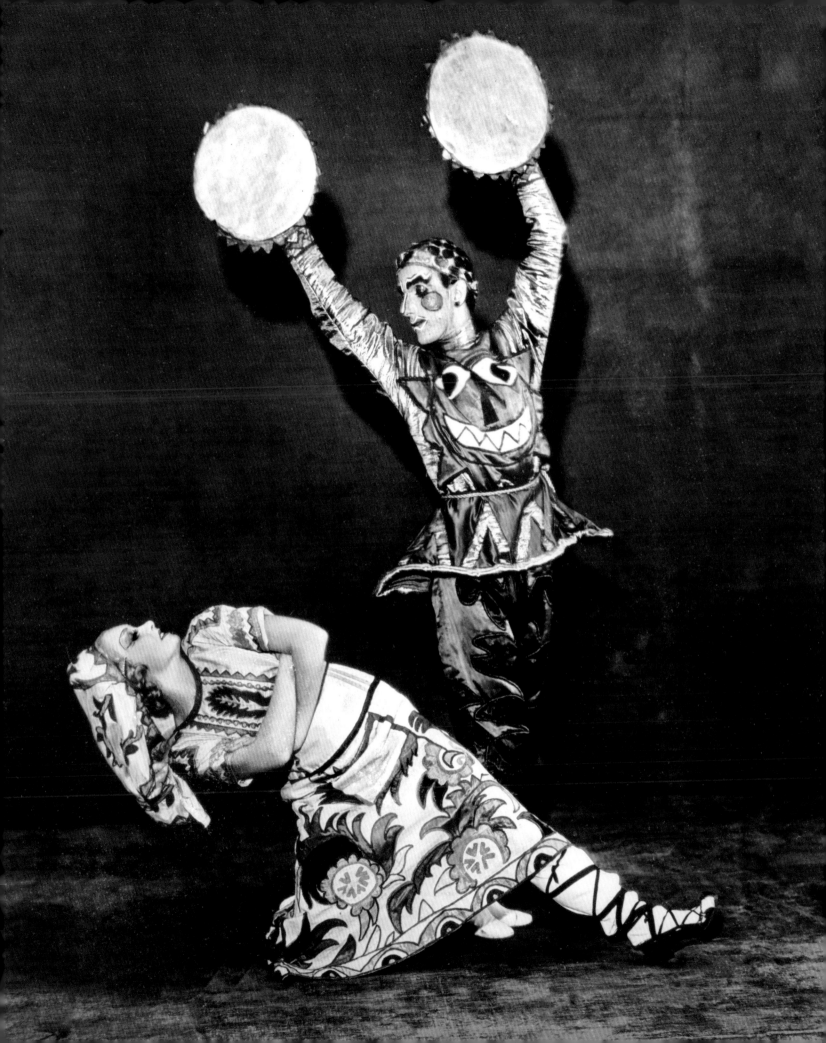

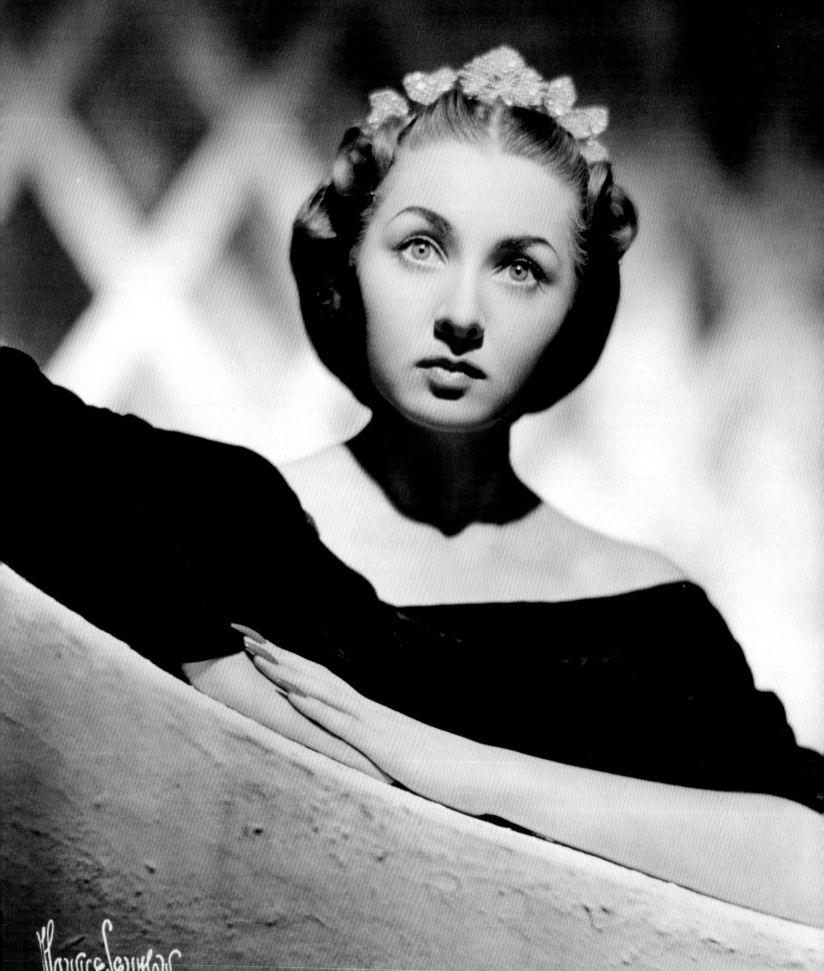

THIRD TOUR:

OCTOBER 9 – 20, 1935
Metropolitan Opera House, New York

OCTOBER 21, 1935 – APRIL 5, 1936
America, Canada and Cuba

APRIL 14 – MAY 8, 1936
Second Season Metropolitan Opera House, New York

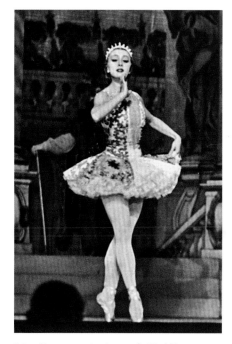

Irina Baronova in *Aurora's Wedding*
Photo: Hugh P. Hall / National Library of Australia

A year had gone by, a year of Gerry and my mother watching one another from a distance and occasionally managing to exchange a few words. Things came to a head on the third tour. At one of the stops between Abilene and New Orleans, with a couple of hours off before the evening performance, my mother went looking for Gerry. Hoping he would be in the coffee shop near the theatre, she went there and sat at the counter, but he didn't appear. When she returned to the theatre Granny demanded to know where she'd been. When my mother said, "At a rehearsal," Granny slapped her. That night my mother performed with a black eye covered with makeup. At 1:45 AM, de Basil woke my mother up to see her face for himself and ask her what had happened. She told him she had slipped in the bathroom. He said she should get some sleep and tell him the truth tomorrow. Next day, after class, she told him everything. He looked at her though his thick glasses.

From my mother's book:

"You'll be seventeen soon?" he asked.
"Yes, in March," I replied.
"Gerry wants to marry you. Do you want to marry him?"
"Yes!" This impulsive statement flew out of my mouth before
 I had time to think of all its consequences . . .

Irina Baronova
Photo: Maurice Seymour

"And so, to my total bewilderment, in less than fifteen minutes my fate was decided."

"All right then, I'll talk to Hurok. We'll sort out where and when your elopement should take place. Meanwhile you must not tell anyone, not a soul, about the plan. Understood?" And so, to my total bewilderment, in less than fifteen minutes my fate was decided.

Because she was so young, my mother's whole life, up until that point, had been managed and controlled by other people. Her days were regimented to an unusual degree with very little free time. She was used to doing what she was told. If offstage life got complicated, she could always escape into the magic world of her art, a fairytale world, where even tragedy ended with applause. There wasn't going to be any applause at the end of this particular story.

By the time the train reached Ohio, Hurok and de Basil had decided on a plan. Hurok's tour manager relayed their instructions to my mother in a whisper. The next night she would be in the first ballet on the program. At the interval, she was to tell Granny that she wanted to watch the rest of the evening from the auditorium, and instead, slip out of the side door where Gerry would be waiting in a taxi. The two would go to the airport and fly to Cincinnati, because in Ohio the legal age for marriage was eighteen, but just across the state line in Kentucky it was seventeen. They would have time to get married before the company train caught up with them the following afternoon. When her parents realized that she was missing, he would tell them where she was and try to pacify them (Good luck with that . . . I can only imagine the scene my Granny must have made!), and that's how my mother got married in Kentucky. Her witnesses were a taxi driver and a peanut vendor hastily pulled off the street. She said she was seventeen, but her seventeenth birthday was twenty-two days away. My mother found herself illegally married to someone she really didn't know at all.

"...and my mother got married; her witnesses were a taxi driver and a peanut vendor hastily pulled off the street."

My grandparents tried to put a civilized face on. My mother's seventeenth birthday came and went. Grandpa brought a red rose to her dressing room and silently kissed her. During the stop in Philadelphia, the fragile truce between my grandparents and the newlyweds blew up. My mother was in the first and last ballets on the evening's program. The middle ballet was *La Boutique Fantasque*, in which my mother had danced the Tarantella (alternating with Toumanova) in earlier years, but that part had been passed on to Olga Morosova as my mother took on more leading roles. During the first intermission, de Basil and Gerry came to my mother's dressing room to tell her that Morosova was suffering stomach pains and to ask her to dance the part that night. Granny, who was always in the dressing room, immediately said no; to her it was a step back. There was a face-off. De Basil and Gerry on one side and my grandparents on the other, my mother in the middle. When my mother told Gerry to have wardrobe bring her the

Sevastianov, Baronova, Riabouchinska,
unknown (*seated*), Lichine
Photo: NYPL Jerome Robbins Dance Division

costume, Granny was furious; Gerry had won. The next morning my grandparents checked out of their hotel and left. Tipped off by Hurok's tour manager that they were leaving, my mother ran to the lobby in time to see them walk out with their suitcases. She was still sobbing in the lobby when the tour manager and Gerry found her. She had a matinee to perform.

My grandparents went to New York and rented a cheap apartment on the Upper West Side and Grandpa got a job at Bobri's, a graphic design studio owned by a Russian friend. When my

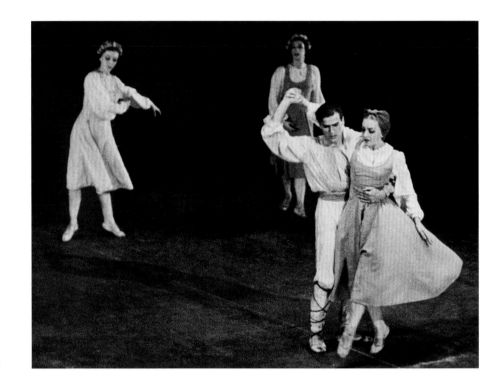

LES NOCES

Choreography by Bronislava Nijinska

Set and costumes by Natalia Goncharova

Music by Igor Stravinsky

First American performance April 20, 1936

Irina Baronova (*far right*) in Corps de Ballet

mother arrived a few weeks later to end the tour with a second season at the Metropolitan Opera House, my grandparents refused to see her. Exercising her new-found freedom, my mother then did something that Granny would have never permitted. Nijinska was remounting *Les Noces* for the Met, and because they had worked together in London on *Les Cent Baisers*, my mother very much wanted to work with her again

I had learned so much from her, and enjoyed working with her so much that I was aching to be in *Les Noces*. I wanted to be there, not just to sit and watch the rehearsals but to actually do the movements. I went to de Basil, and he said, "There's nothing for you to do in *Les Noces*." I said, "Stick me in the corps de ballet, I want to work with her." He was so surprised he couldn't believe it. "Everyone wants to get out of the corps de ballet and you want to get in?" I said, "I mean it, I want to work with her." So he shrugged and said all right. The way Nijinska showed us what to do really turned your guts out. It was wonderful how she moved when she showed you something. It was such a terrific characterization — she would have made a great actress. You learned when you saw her, and it really hit you. *Les Noces* is modern and beautiful, a very powerful

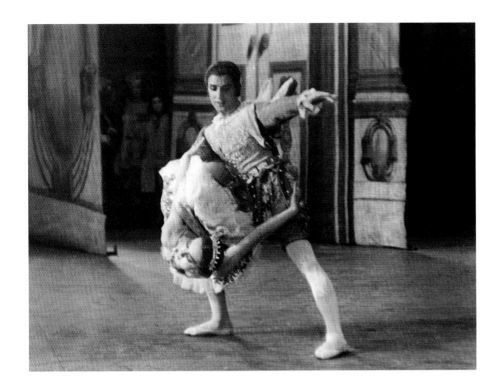

Aurora's Wedding
Irina Baronova with Paul Petroff

work. She was a chief influence on Frederick Ashton. Her work was the height of sophistication but with a great human quality. When we were rehearsing *Les Noces* in New York, Stravinsky came to play the piano for us and explain the music to us himself. When he saw me he said, "What are you doing here?" Nijinska told him that I had asked to be in the ballet and he patted my shoulder and said, "Clever girl."

The *Lafayette* sailed out of New York Harbor, bound for Europe, horns blaring, people waving from the pier. My mother stood at the rail watching the skyscrapers get smaller and smaller, not knowing where her parents lived or if she would ever see them again. For Gerry, their absence was a great relief, but for her it was devastating.

While all this private drama was going on, the company had blazed a trail across North America. The Ballets Russes de Monte Carlo had become a "craze that was to endure seventeen years and sweep everything else into the corners" in the words of Agnes de Mille. Playing to sold-out houses across the continent, their extensive tours had established ballet as a popular art form and laid the way for the great American companies and choreographers that were to follow in the coming years.

AMERICA AND CANADA
THIRD TOUR ITINERARY

October 1935 – May 1936
226 DAYS

DAYS		DAYS		DAYS	
16	New York	2	Vancouver	1	Montgomery
	Metropolitan Opera House	1	Portland	1	Macon
1	Albany	10	San Francisco	1	Jacksonville
1	Ottawa	1	Fresno	1	Orlando
2	Quebec	1	Pasadena	1	Tampa
4	Montreal	2	Los Angeles	3	Havana, Cuba
1	Springfield	1	San Diego	1	Miami
7	Boston	9	Los Angeles	1	Palm Beach
1	Manchester	1	Phoenix	1	Daytona
1	Worcester	1	El Paso	1	Rock Hill
1	Providence	1	Abilene	1	Durham
2	Hartford	1	Dallas	1	Roanoke
1	White Plains	1	San Antonio	1	Philadelphia
2	Baltimore	1	Houston	1	Wilmington
8	Philadelphia	1	New Orleans	1	New Brunswick
1	Washington D.C.	1	Birmingham	1	Philadelphia
1	Brooklyn	1	Memphis	2	Syracuse
1	Toronto	1	Little Rock	1	Hanover
2	Rochester	2	Kansas City	1	Lowell
2	Pittsburgh	1	Kalamazoo	1	Portland
11	Chicago	1	Gary	1	Springfield
1	Duluth	1	Columbus	2	New Haven
2	Winnipeg	1	Louisville	1	Bridgeport
2	Minneapolis	3	Cincinnati	1	Boston
2	Milwaukee		[Baronova and Sevastianov	1	Brockton
1	Cedar Rapids		get married, Feb. 20]	1	Lowell
1	Davenport	1	South Bend	3	Boston
1	Champaign	1	Fort Wayne	8	Rehearsal days New York
1	Springfield	1	Toledo	25	2nd Season Metropolitan Opera House,
4	Cleveland	3	Detroit		New York
1	Wheeling	1	Nashville	2	Newark
1	Huntington				
2	Indianapolis				
4	St. Louis				
1	Joplin				
1	Wichita				
1	Des Moines (January 1936)				
1	Omaha				
1	Hastings				
1	Denver				
1	Salt Lake City				
2	Seattle				

Irina Baronova

Driving from San Diego to Los Angeles: Morosova, Baronova, Riabouchinska, Danilova and Zorina

Irina Baronova

Irina Baronova

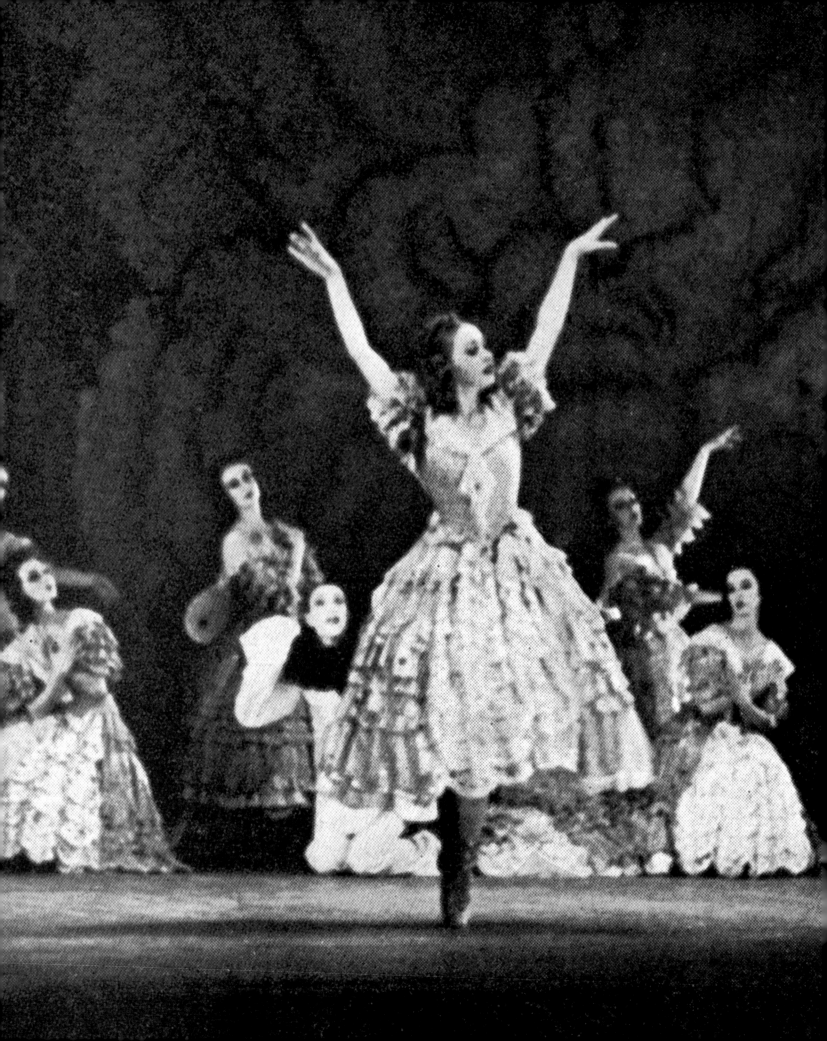

FOURTH TOUR:

OCTOBER 29 – NOVEMBER 8, 1936
Metropolitan Opera House, New York

NOVEMBER 9, 1936 – APRIL 8, 1937
America and Canada

APRIL 9 – 13, 1937
Metropolitan Opera House, New York

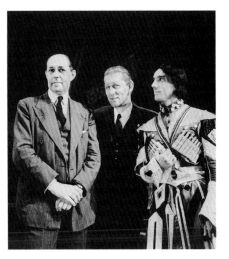

Grigoriev, de Basil and Massine

On the *Ile de France*, sailing to New York, Gerry and my mother had the luxury of a first-class cabin. Now that my grandparents were not travelling with them, there was more money to spend on accommodations. Waiting on the pier was a family friend with bad news. Grandpa had suffered a heart attack and was still in bed; they had also been burgled, losing all their savings, which they had kept at home. He gave their address to my mother, thinking it would do Grandpa good to see her even if it was against Granny's wishes. Knowing my mother, I am quite sure she blamed herself for the heart attack. She dumped her suitcases at their hotel, asked Gerry for all the cash he had on him, and rushed over to her parents' apartment. Grandpa held her for a long time, until she stopped crying; Granny offered her a cup of tea. The ice was broken.

That night, Gerry took my mother to the Russian Tea Room for dinner, and they had a long talk about her parents. My mother's salary had always been paid to her parents, then after the elopement, to

LES PAPILLONS
Choreography by Mikhail Fokine (sequel to *Le Carnaval*)
Set by Mstislav Doboujinsky
Costumes by Léon Bakst
Music by Robert Schumann
First performance Maryinsky Theatre, St. Petersburg, March 10, 1912
Irina Baronova as the First Young Girl

Les Papillons had been performed by Diaghilev's company in 1914. This latest revival premiered in Chicago, December 17, 1936. The role of the First Young Girl was usually danced by Riabouchinska.

89

AMERICA AND CANADA
FOURTH TOUR ITINERARY

October 1936 – April 1937
205 DAYS

DAYS		DAYS	
8	Rehearsal days New York	4	San Francisco
13	New York	1	San Jose
	Metropolitan Opera House	1	Sacramento
2	Philadelphia	1	Oakland
2	Washington D.C.	1	Eugene
1	Wilmington	2	Seattle
1	Philadelphia	1	Tacoma
1	Newark	1	Portland
1	Baltimore	1	Spokane
1	Reading	1	Boise
1	Brooklyn	1	Salt Lake City
1	Hartford	2	Laramie
1	Worcester	1	Denver
2	Providence	1	Salina
1	Springfield	1	Springfield
5	Boston	3	Kansas City
3	Montreal	1	Little Rock
1	Toronto	1	Mobile
1	Pittsburgh	1	Montgomery
3	Indianapolis	1	Savannah
1	Richmond	3	Atlanta
1	Cedar Rapids	1	Spartanburg
1	Wichita	1	Durham
1	Oklahoma City	1	Hampton
1	Edmond	1	Richmond
1	Tulsa	1	Roanoke
1	Ottawa	2	Huntington
15	Chicago (January 1937)	1	Nashville
3	St. Louis	1	Louisville
1	Memphis	1	Fort Wayne
1	New Orleans	5	Detroit
1	Beaumont	1	Kalamazoo
1	Houston	1	Anderson
1	San Antonio	1	Canton
1	Dallas	3	Cleveland
1	Amarillo	2	Milwaukee
1	El Paso	2	Rockford
1	Tucson	5	Chicago
1	Pasadena	1	Cincinnati
6	Los Angeles	1	Columbus
1	Claremont	1	Buffalo
2	Los Angeles	1	Toledo
2	San Diego	6	New York
1	Pasadena		2nd Season Metropolitan Opera House
1	Fresno		

Irina Baronova at the zoo

De Basil at the zoo

"At the Russian Tea Room my mother and Gerry bumped into Balanchine. He said that he supposed he should congratulate them on their marriage, but he didn't give it more than a couple of years. Charming!"

Gerry. She just lived on the pocket money she was given. Now, she asked Gerry to send her parents two-thirds of her salary every month; the two of them would have to make do with what was left and economize. Gerry agreed. My mother wanted her parents to move to Long Island where they had Russian friends living in Sea Cliff. It was a White Russian colony by the beach. It would be good for her father's health, and her mother would be happy there. Gerry agreed. With the help of friends, they found my grandparents an apartment in Sea Cliff with a large garden, available immediately, and my grandparents moved into it.

Another night at the Russian Tea Room, my mother and Gerry bumped into Balanchine. He said that he supposed he should congratulate them on their marriage, but he didn't give it more than a couple of years. Charming!

After 15 performances in 11 days at the Metropolitan Opera House in New York, the company boarded its train and set off on tour, giving 150 more performances in 151 days. There were three new revivals: *Cimarosiana* (Massine), *Cléopâtre* (Fokine) and *Les Papillons* (Fokine). During the tour, Massine left, and Danilova went with him. He wanted to start his own company where he would have complete control, the total authority that de Basil wouldn't give him. The dancers didn't know he was leaving; they didn't even get to say goodbye. By chance, my mother, with a few others, bumped into him outside the stage door as they were going out, and he told them that he was off to New York. They were shocked.

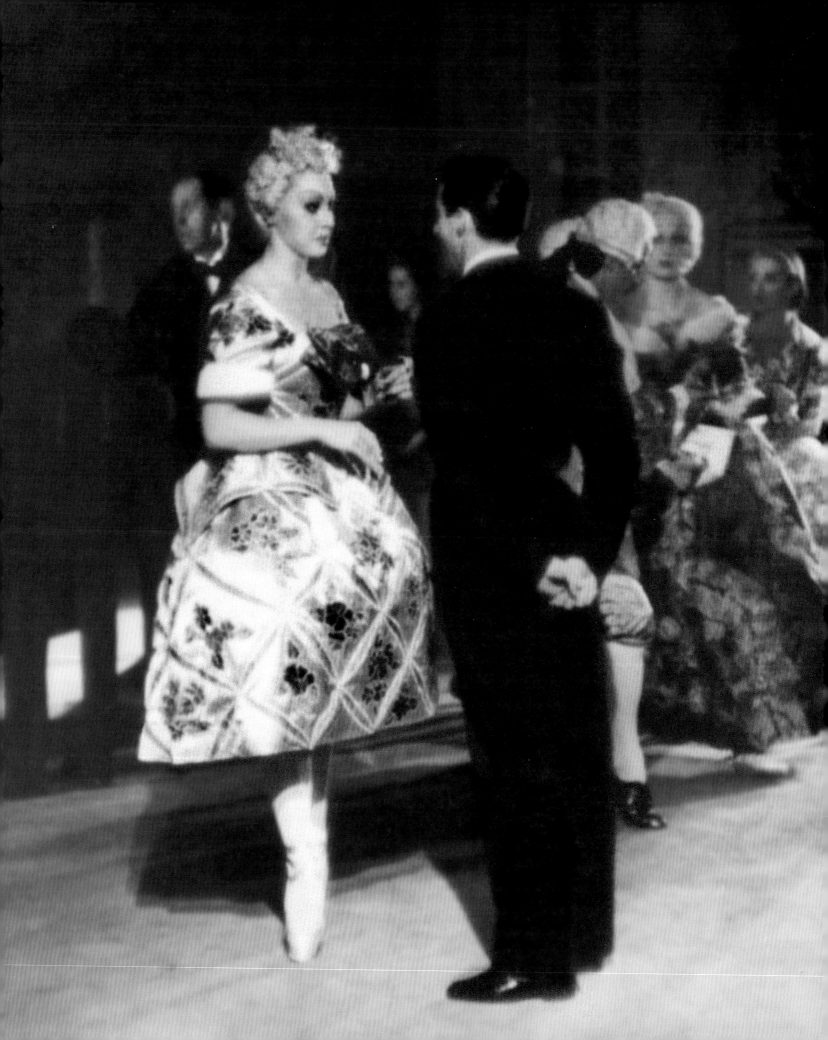

When the tour ended, and the company sailed to Europe on the *Normandie*, the United Press published this: "In three American seasons the de Basil ballet has amassed well over $2 million — a figure made all the more remarkable by the fact that the last ballet to swing about the nation, the Diaghileff ballet, ended with a net loss of $350,000."

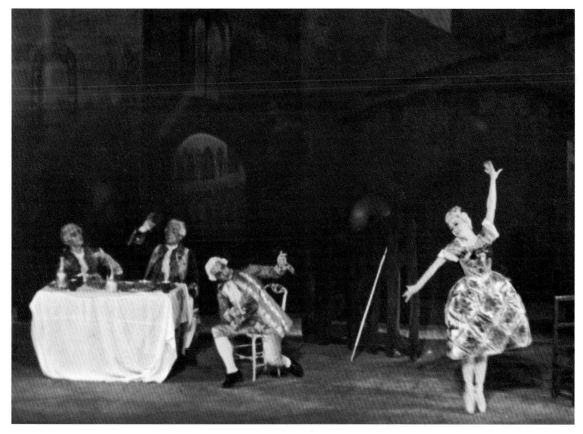

Edouard Dzikovsky, Ladre, Petroff, and Baronova Photo: Hugh P. Hall / National Library of Australia

LES FEMMES DE BONNE HUMEUR
Choreography by Léonide Massine
Libretto by Vincenzo Tommasini, adapted from the play by Goldoni
Set and costumes by Léon Bakst
Music by Domenico Scarlatti, orchestrated/arranged by Tommasini
First performed by Diaghilev's Ballets Russes, Teatro Costanzi, Rome, April 12, 1917
Irina Baronova as Mariuccia

FIFTH TOUR:

OCTOBER 21 – 31, 1937
Metropolitan Opera House, New York

NOVEMBER 1, 1937 – MARCH 11, 1938
Tour of America and Canada

This time, when the *Champlain* sailed into New York, my grandparents were waiting on the pier. They were happy to see my mother, cool but polite toward Gerry. Reassured that my mother's ballet career was safely established and that even Gerry couldn't damage it, they were prepared to be civil. My mother was relieved, although she and Gerry often fought; now that her parents were being friendly, she was able to focus on her dancing.

My grandparents had bought a little cottage in Sea Cliff. They had their own home again and friends at last, eighteen years after

Grandpa and Granny in Sea Cliff, 1938

Grandpa's commercial art

fleeing Russia. They had gone from a grand life in St. Petersburg to destitution in Romania, then the life on the road of the Ballets Russes. Now, in Sea Cliff, Grandpa made himself a painting studio, they helped to build the local Russian Church, and they kept a room for my mother, where she spent her last three days in America without Gerry, having a nice time with her parents. My mother bought a dog, a wire-haired terrier named after her favorite perfume, Jicky. The dog was going to live in Sea Cliff; it would be a part of my mother that would remain with them. When it was time for my mother to leave, Granny cried and cried. She cried so much that she couldn't accompany my mother to the station.

My father struggled all his life, he adored the theatre, he had a great talent for painting, and then, after he bought this little house in Sea Cliff, he eventually achieved what he wanted. He got this marvelous job with CBS television. CBS was good to him; he became their head scenic designer and the first television program in color was a Balanchine ballet with my father's decors and costumes.

95

AMERICA AND CANADA
FIFTH TOUR ITINERARY

October 1937 – March 1938
149 DAYS

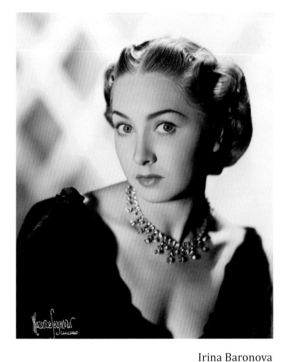

Irina Baronova
Photo: Maurice Seymour

DAYS		DAYS	
11	New York	1	Waco
	Metropolitan Opera House	2	Dallas
1	Brooklyn	1	Fort Worth
6	Boston	1	Abilene
1	Springfield	2	El Paso
1	Fitchburg	2	Los Angeles
1	New Haven	1	San Diego
1	Hartford	3	Los Angeles
1	Providence	4	San Francisco
2	Burlington	2	Oakland
3	Montreal	2	Vancouver
2	Toronto	3	Seattle
2	Buffalo	1	Tacoma
1	Erie	1	Portland
1	York	2	Pendleton
1	Hershey	1	Ogden
1	Binghamton	2	Salt Lake City
1	Rochester	1	Lawrence
2	Pittsburgh	1	Kansas City
1	Mansfield	2	Indianapolis
1	Grand Rapids	3	Cincinnati
1	Green Bay	1	Louisville
1	Oshkosh	2	Roanoke
1	Duluth	1	Richmond
2	Bismarck	2	Allentown
1	Minot	1	Newark
1	Fargo	6	Philadelphia
1	Grand Fork	1	Brooklyn
1	Winnipeg	1	Baltimore
3	Minneapolis	2	Washington D.C.
1	Lima	1	Wilmington
1	Detroit	1	White Plains
1	Sandusky		
3	Cleveland		
14	Chicago (January 1938)		
3	Milwaukee		
1	Quincy		
1	St. Louis		
1	Memphis		
1	New Orleans		
1	Houston		
1	San Antonio		

AURORA'S WEDDING
Photo: Maurice Seymour

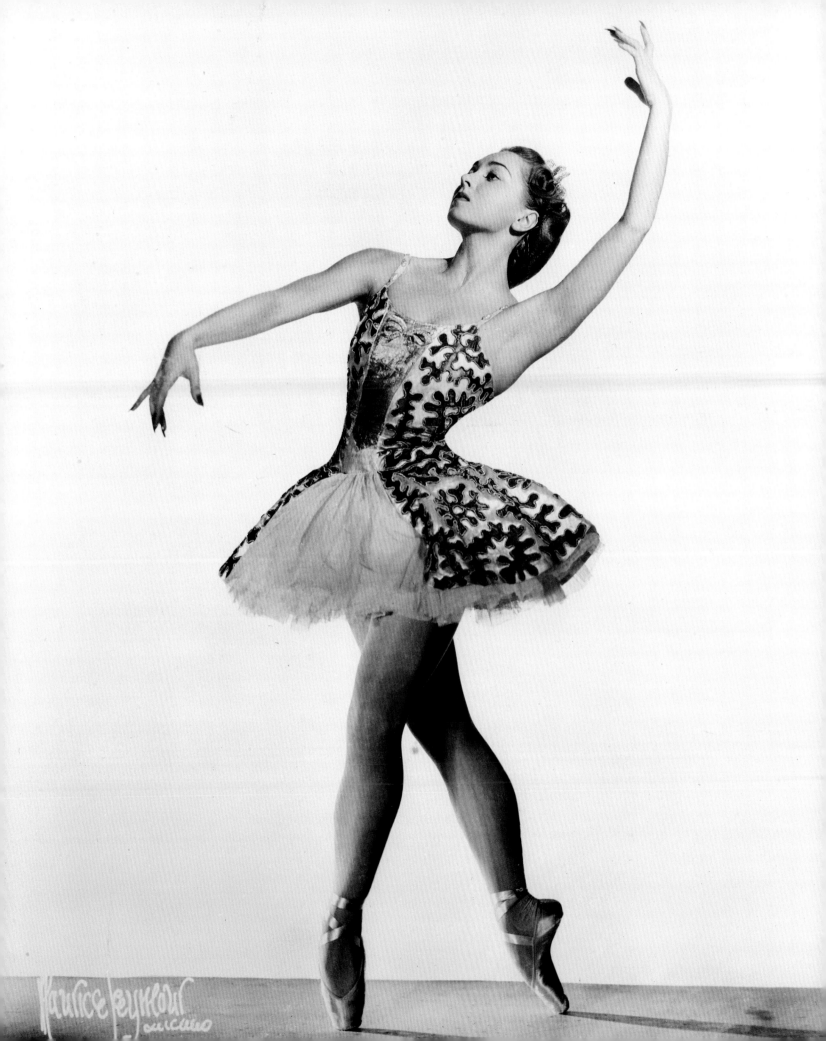

Covent Garden, 1934–1938

A New Home

Now to some more of my favorite images: the backstage photographs of Covent Garden. I think my Grandpa took them, and I see that de Basil used some of them in his programs. You really get a feel for what it was like behind the scenes and for all the trades involved in the work. These Covent Garden photographs cover the same years as the American photographs, but Covent Garden could not have been more different. America was about taking the work out to find an audience. Covent Garden became the home where the audience came to them, and where the work was created.

JUNE 19, 1934 – AUGUST 11, 1934

The company mounted four revivals, which had great success: *Le Tricorne* (Massine), *Firebird* (Fokine), *La Boutique Fantasque* (Massine), and *Contes Russes* (Massine). Two ballets were new to London, *Union Pacific* and *Les Imaginaires* (Lichine). In addition to the two conductors, Antal Dorati and Efrem Kurtz, who travelled with the company and the company orchestra, Sir Thomas Beecham also conducted during this season.

We finished our Paris Season June 16, travelled to London the next day and went straight to the Royal Opera House to find our dressing rooms and start rehearsing. We needed to reacquaint ourselves with the stage because our opening night was only two days away. The trucks arrived with the scenery and costumes and started unloading as we settled in to our new home. On opening night, we were welcomed with applause that went on for fifteen minutes and the stage was filled with flowers. Our first Season was sold out and then extended until the middle of August.

Irina Baronova and Arnold Haskell, ballet critic, Covent Garden, 1934

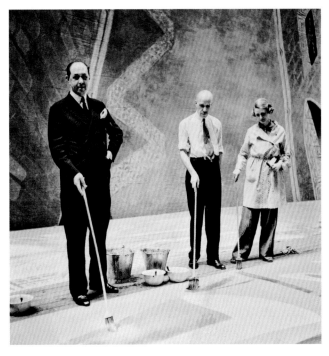

Scenic artists

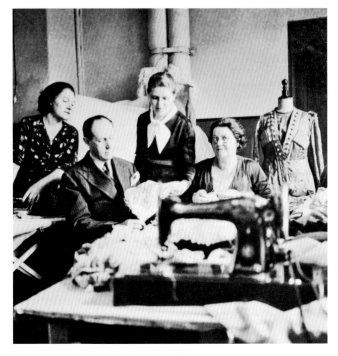

Seamstresses

Costume hampers

Electricians

Opera masks designed by Henri Matisse

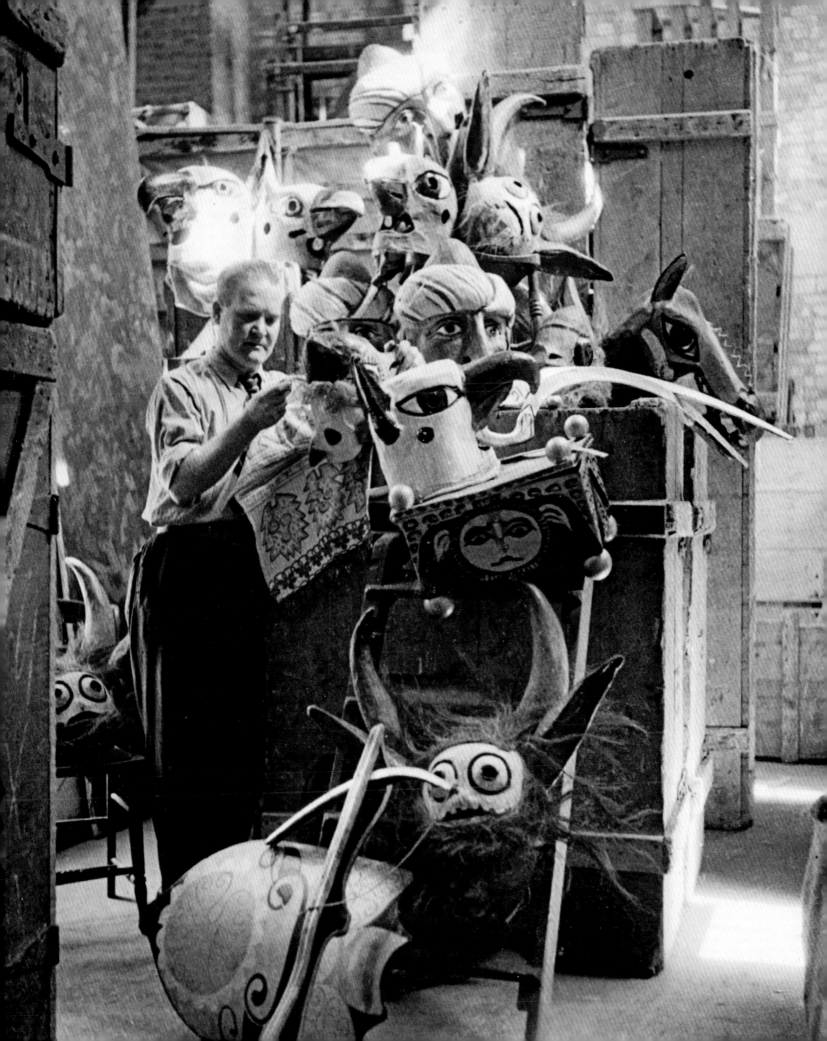

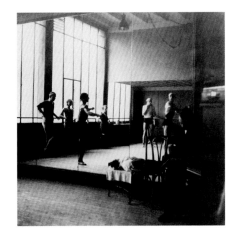

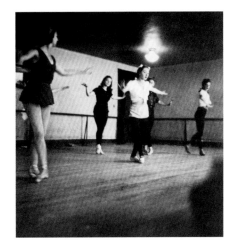

On non-matinee days, Danilova, Toumanova, and my mother were rehearsing *Aurora's Wedding* with Grigoriev. They were going to take turns in the role of Princess Aurora and would present the ballet on the next American tour. One day Kochno was watching the rehearsal and at the point where Aurora does a single, then a double, then a triple pirouette, Toumanova did a double, a triple then a quadruple pirouette. Not to be outdone when it was her turn to rehearse, my mother did the same. After the rehearsal Kochno called them over and said, "What the hell do you think you are doing distorting Petipa's choreography? He wanted one, two, three pirouettes. He had his reasons — style and musicality. Respect the choreographer, pay attention to the style and period of the old classics. No circus, please!"

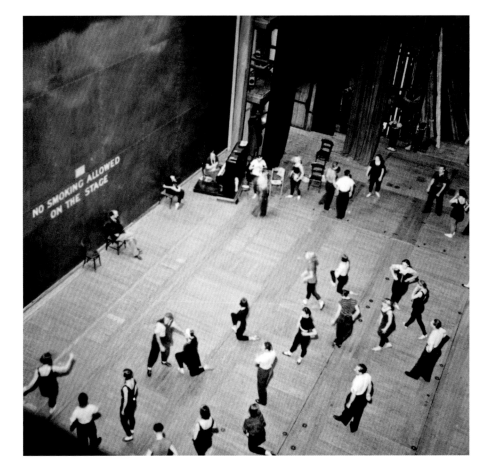

Tamara Toumanova and Irina Baronova

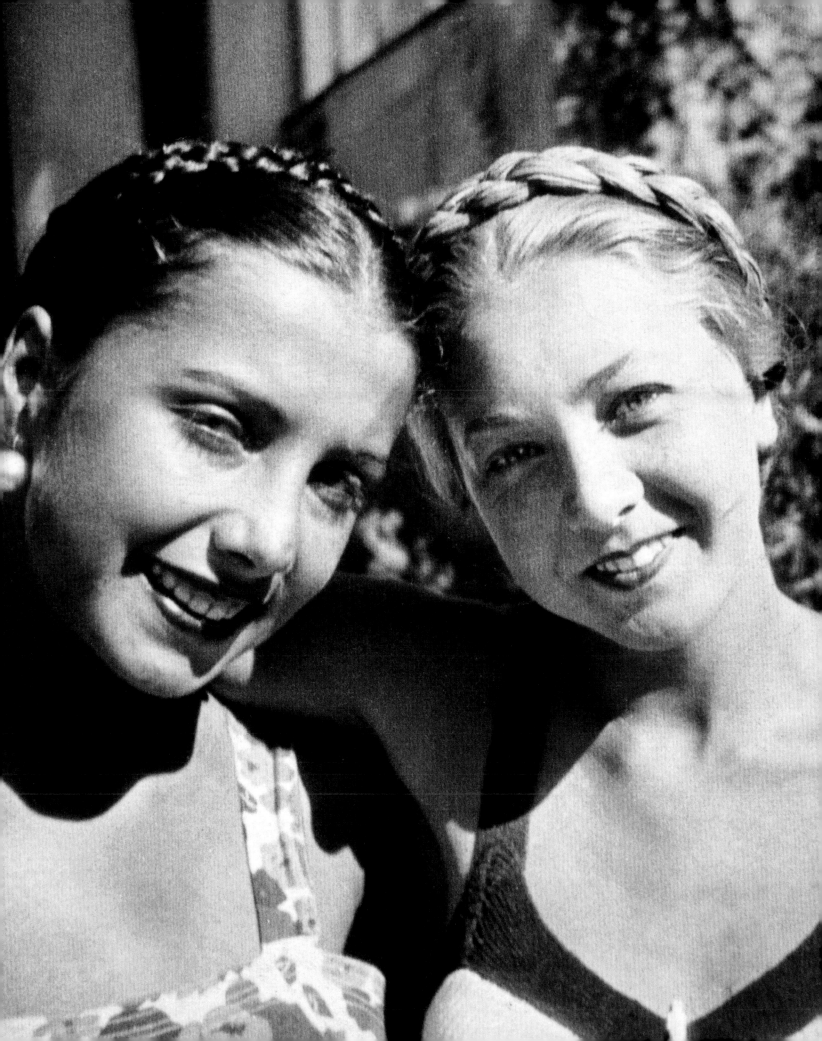

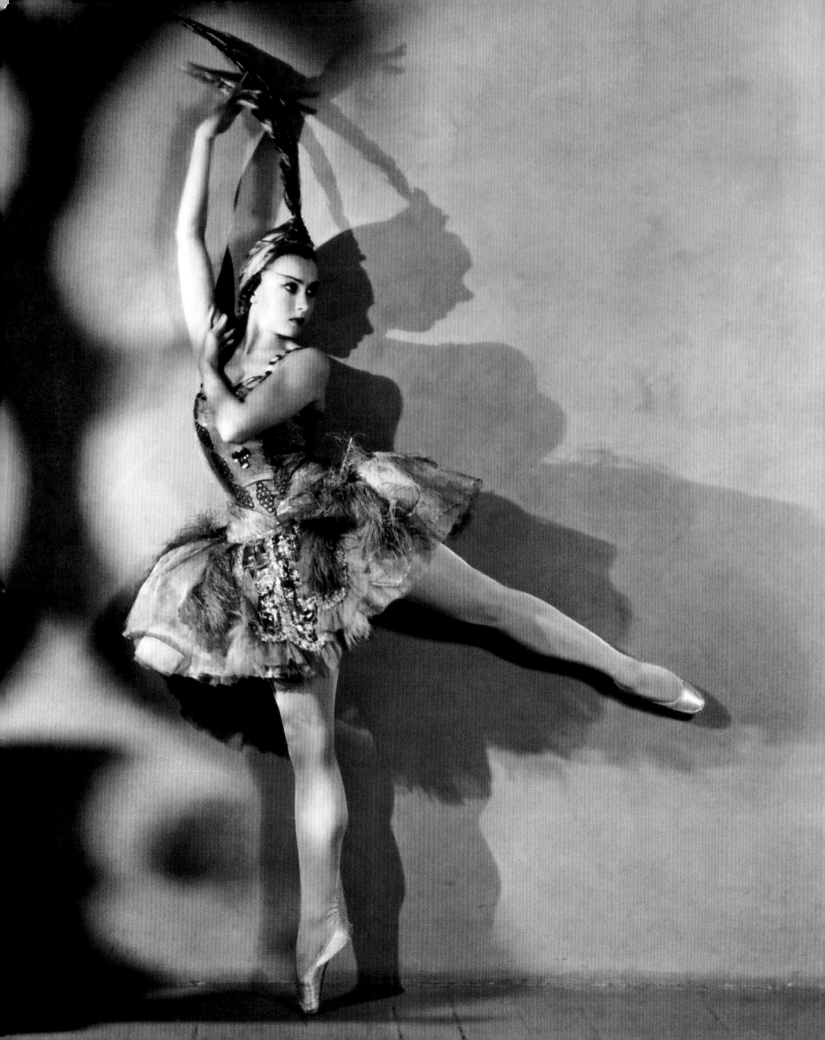

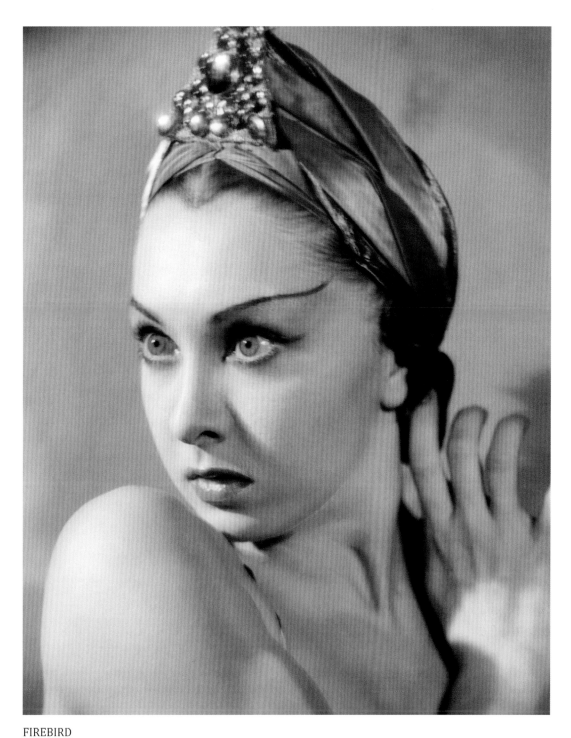

FIREBIRD

Choreography by Mikhail Fokine

Libretto based on a Russian folk story

Set by Natalia Goncharova

Costumes by Léon Bakst

Music by Igor Stravinsky

First performance by Diaghilev's Ballets Russes, Théâtre National de l'Opéra, Paris, June 25, 1910

Irina Baronova as the Firebird

Photos: Gordon Anthony / ©Victoria and Albert Museum

On the last night it was standing room only; many of the people up in the gallery had queued outside for twenty-four hours in lines that went around the block. After the performance the invited guests went to the Crush Bar while we dancers changed into evening dress and the scenery was carted away. The caterers then carried tables onto the empty stage and Grigoriev rushed around putting seating cards at the principal tables with the help of a seating plan. When everything was ready, and the company assembled on the stage, Grigoriev gave a sign for the curtain to be raised and de Basil escorted the Duke and Duchess of York (soon to be King and Queen), the Duke and Duchess of Kent, Captain Ottley and his wife, and Baron Frédéric d'Erlanger and Lady St. Just onto the stage. After dinner everyone stood for a toast to the King and Queen, then Jan Hoyer and Léon Woizikowski taught the Duke of Kent how to drink a glass of vodka like a true Russian, in one gulp, and everyone danced late into the night. For the next five years, we had our London Season at the Opera House, and it was my favorite theatre of all.

At the end of their first season at the Royal Opera House in Covent Garden it was clear that the Ballets Russes de Monte Carlo, which had outgrown its first base, had found its new home. René Blum now left as a result of de Basil adding his name to the company (Ballets Russes de Col. W. de Basil). Blum started his own company in 1936 with Fokine, who left in 1938 and was replaced by Massine.

SEPTEMBER 25, 1934 – MAY 26, 1935

Mexico City – Canadian Tour – American Tour – Monte Carlo – Barcelona – Paris – London

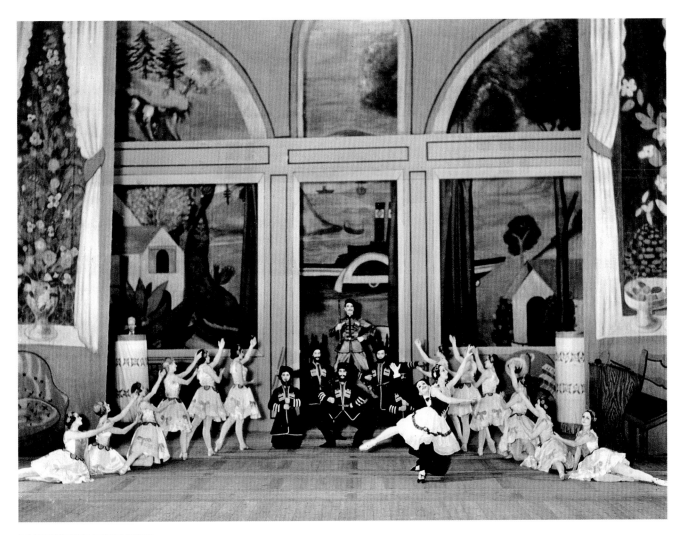

LA BOUTIQUE FANTASQUE

Choreography by Léonide Massine

Set and costumes by André Derain

Music by Giacomo Rossini

First performance by Diaghilev's Ballets Russes, Alhambra Theatre, London, June 5, 1919

Irina Baronova as Tarantella

Photo: NYPL Jerome Robbins Dance Division

JUNE 11, 1935 – JULY 25, 1935

The Royal Opera House was now officially our home base. Our season followed the opera season and our tickets became part of the members' annual subscription. This year our dancers took part in the production of the last opera, *Prince Igor*, before our season started.

New to London was *Aurora's Wedding*. I alternated the part with Toumanova, and revivals of *Thamar*, *Les Femmes de Bonne Humeur*, and *Scheherazade*. Massine also presented his ballets *Jardin Public* and *Le Bal*. Very important for me was *Les Cent Baisers*.

Irina Baronova and Bronislava Nijinska rehearsing *Les Cent Baisers* in London
Photo: National Library of Australia

Irina Baronova in *Les Cent Baisers*
Photo: Maurice Seymour

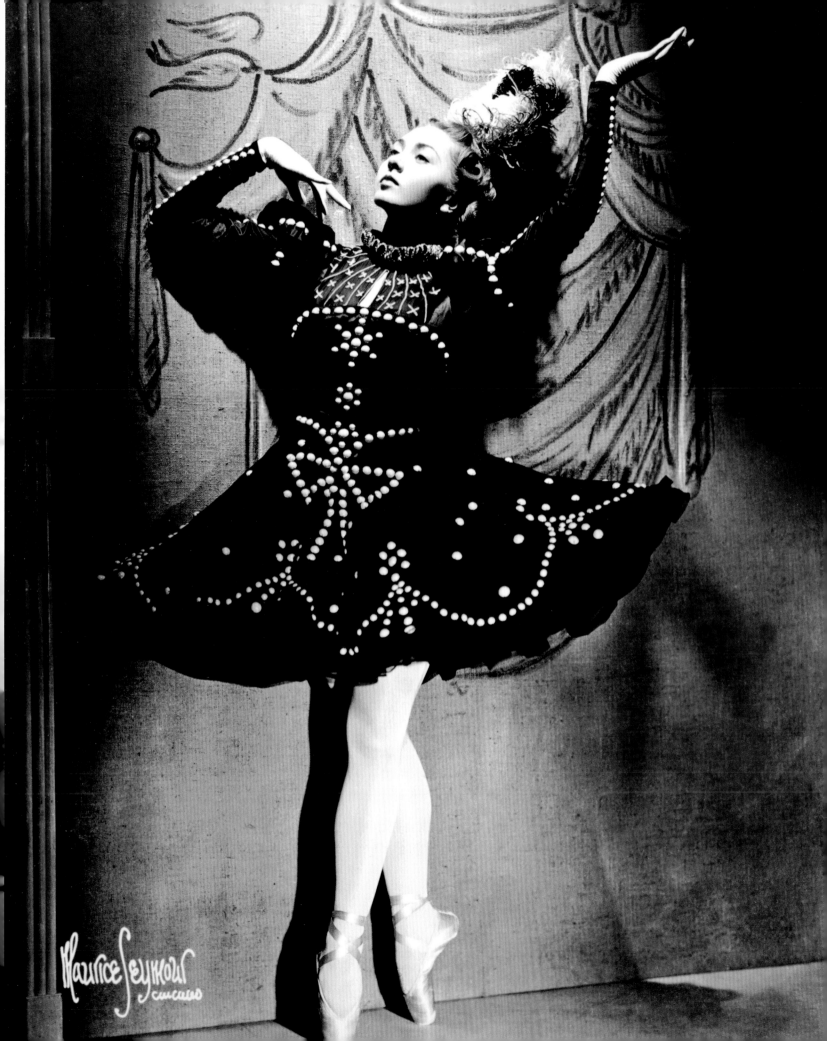

Nijinska, Baronova, and Tchernicheva in London

Nijinska, d'Erlanger, and Baronova
Opening night party, London
Photo: NYPL Jerome Robbins Dance
Division

Frédéric d'Erlanger was writing the music for *Les Cent Baisers* when Kochno said that Nijinska would be a marvelous choreographer for it. D'Erlanger, de Basil, Gerry, and Kochno met her in Paris. They explained to her the premise of the ballet and she said that she was interested and asked whom they had in mind for the Princess. D'Erlanger said, "Baronova," and Nijinska said, "No, Danilova." D'Erlanger didn't say a word; he collected his music and his manuscript, and walked out. De Basil ran after him and the others watched from a window as the two of them walked back and forth outside. De Basil came back in and told Nijinska, "Look, you've never worked with Baronova. Try her, because d'Erlanger wants her or there is no ballet." She consented to a trial basis.

Nijinska took to you or not the moment she met you. It wasn't only about liking you as a dancer, but as a human being too. If she didn't accept you she could be very sarcastic. We hit it off. She knew exactly what she wanted. Not as precise as Fokine but not messing around like Massine. Because she liked me, working with her was marvelous. I just gave her all I had, I worked like hell for her and she appreciated it. She was a strange little figure in trousers always puffing away on a long cigarette holder. Next to her chair was always another chair with her cigarettes, long cigarette holder, lighter and ashtray. She always wore white gloves because she couldn't bear to touch anyone without her gloves on. She had a repugnance for sweaty bodies. Her eyes were pale blue, and watery, she didn't wear makeup except for a little lipstick put on wrong, and her thin, blonde hair was always pinned in a little bun at the back. *Les Cent Baisers* was a very successful ballet and very pretty. Technically it was extremely difficult, an enormous amount of turns and chaînés, fouettes and jumps. At the time, there weren't many of us who could do these things. Lichine was always the Prince, except when Dolin danced the role in Australia.

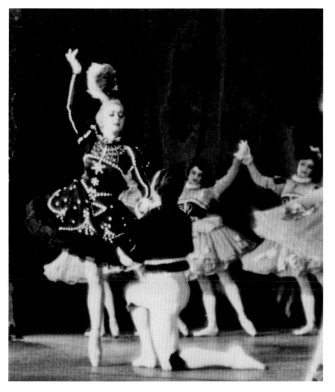

Irina Baronova

LES CENT BAISERS
Choreography by Bronislava Nijinska
Libretto by Boris Kochno
Set and costumes by Jean Hugo; costumes executed by Karinska
Music by Baron Frédéric d'Erlanger
First night July 18, 1935
Irina Baronova as the Princess

This ballet was a tremendous success for Baronova and important to her career as a ballerina. As well as demonstrating her immense technical skill it showed her profound emotional grasp of character and her acting ability. There were 22 curtain calls on opening night and wonderful reviews the next morning from all the critics. She was 16 years old.

Kochno, Nijinska, de Basil, Dorati, and d'Erlanger

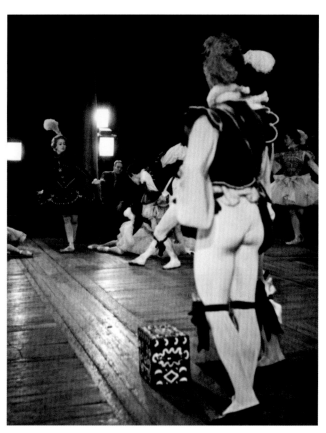

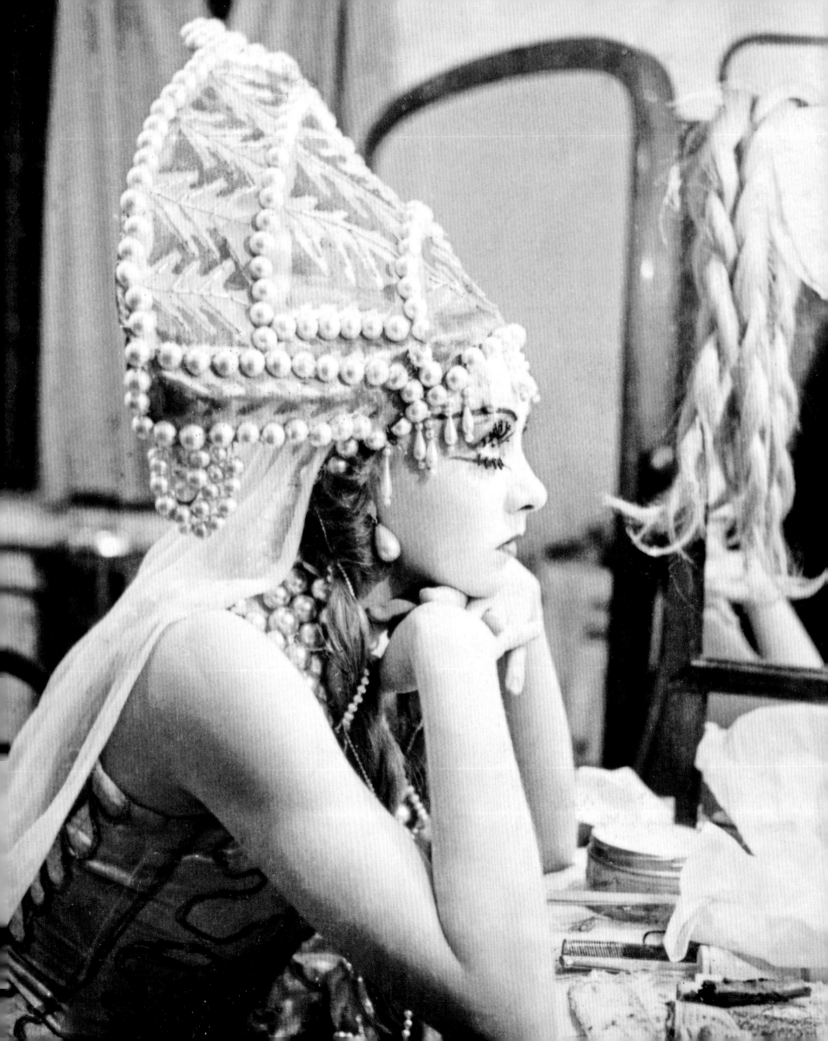

Léonide Massine as the Prince

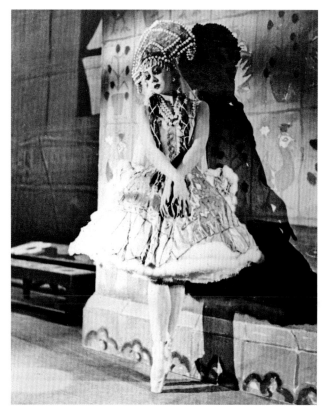

Irina Baronova as Thamar, the Queen of Georgia

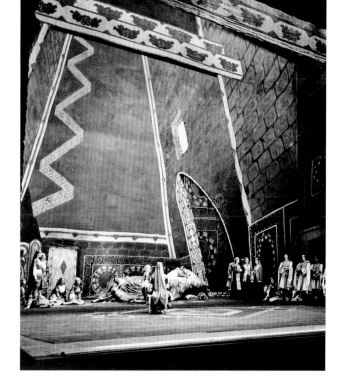

THAMAR

Choreography by Mikhail Fokine

Libretto after a poem by Mikhail Lermontov

Set and costumes by Léon Bakst

Music by Mily Balakirev

First performance by Diaghilev's Ballets Russes

Théâtre de Châtelet, Paris, May 20, 1912

JUNE 15, 1936 – JULY 29, 1936

The ticket line for nonsubscription opening night seats began to form outside the Opera House forty-eight hours before the performance. Special matinees for schools were organized. As well as *Aurora's Wedding* (Baronova/Petroff with Riabouchinska/Lichine), *Choreatium* (Toumanova), *La Boutique Fantasque* (Danilova), and *Le Beau Danube* there were two premieres: *Le Pavillon* and *Danses Slaves et Tziganes.*

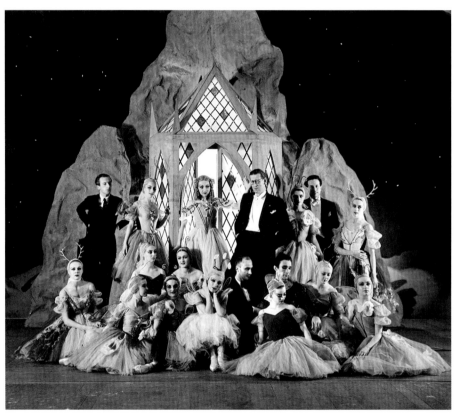

Le Pavillon with de Basil, Riabouchinska, and Lichine

LE PAVILLON
Choreography by David Lichine
Libretto by Boris Kochno
Set and costumes by Cecil Beaton; costumes executed by Karinska
Music by Alexander Borodin
First night August 11, 1936
Irina Baronova as the Young Lady
Photo: Maurice Seymour

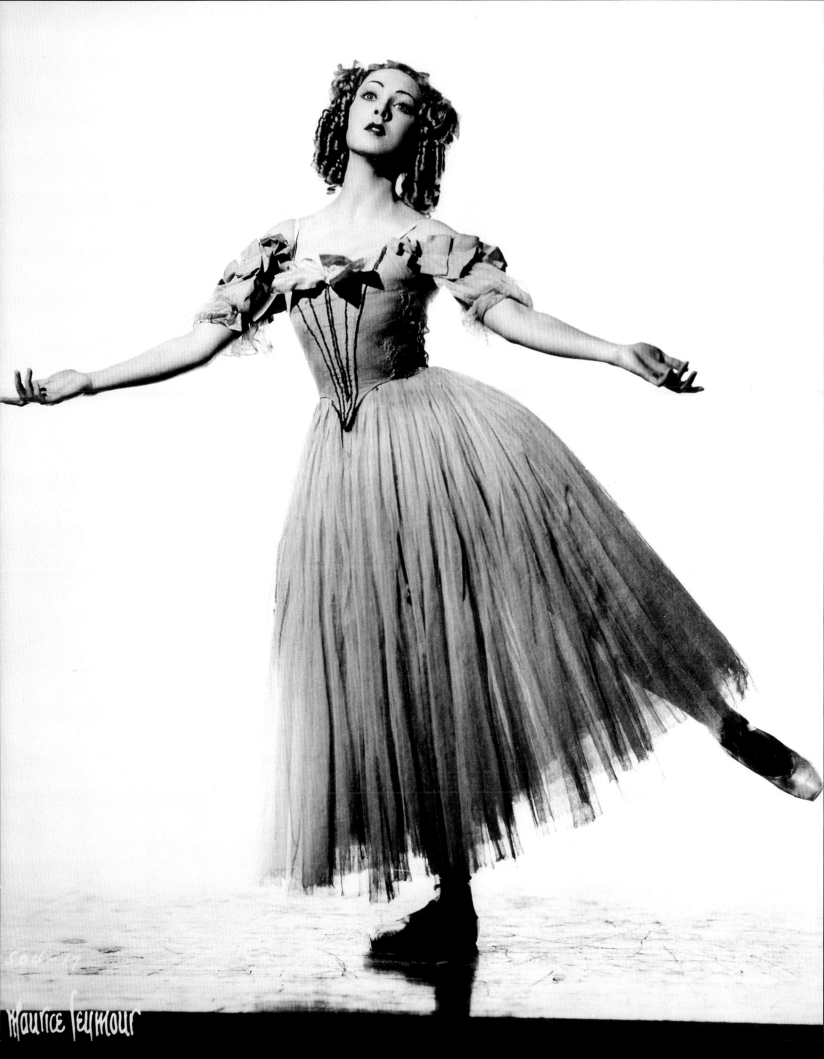

Danilova, Massine, and Baronova in Russian Dance

It was de Basil and Gerry's idea to do a special Gala at Grosvenor House in 1936. Kschessinska, Egorova, and Preobrajenska were invited to come from Paris. When Kschessinska said yes, the other two said no, being great rivals. We gave a performance, then at the party afterwards Massine, Danilova, and myself did a Russian dance; Shabelevsky and Lazowsky did a Polish mazurka; Adeline Genée and Philip Richardson did a polka; then Kschessinska did a Russian dance and brought the house down. Her distinguished, grand manner and style, her charm, it was something to behold, it was superb.

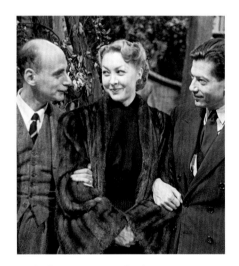

Haskell, Baronova, and Lifar
Photo: G. B. Wilson
©Royal Academy of Dance / ArenaPAL

OCTOBER 1, 1936 – MAY 19, 1937

Berlin – New York – American Tour – Canadian Tour – New York – Florence

Hitler and Goebbels came to the ballet in Berlin, accompanied by an escort of black-uniformed SS, and met the principal dancers onstage after the performance. Hitler kissed Danilova, Riabouchinska and Baronova's hands (Toumanova didn't come to Berlin). Goebbels followed suit. Each evening after that night Riabouchinska and Baronova received bouquets of lilacs from Goebbels with a card that always read: *With Thanks, J. Goebbels.*

DANSES SLAVES ET TZIGANES
Choreography by Bronislava Nijinska
Set by Aleksandr Golovin (originally for *Le Festin*, 1909)
Costumes by Konstantin Korovin
Music by Alexander Dargomijsky
(Devised in 1931 as an interlude during an opera
and adjusted as needed to suit the dancers)
Photo: Studio Batlles (Barcelona)

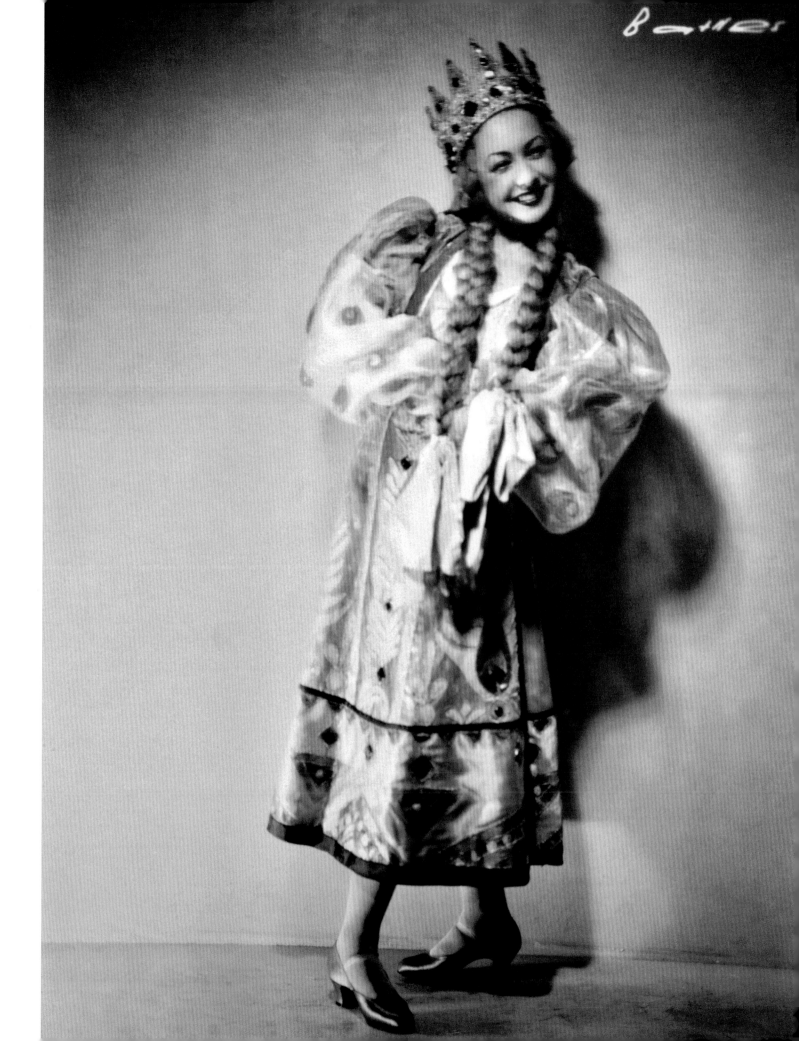

JUNE 9, 1937 – JULY 31, 1937

This was the Coronation Season at the Royal Opera House of Covent Garden, celebrating the coronation of the new king, George VI. The Ballets Russes provided dancers for the operas *Prince Igor* and *Orphée et Eurydice*, and participated in a television broadcast of rehearsals of *Orphée et Eurydice* (Baronova and Zoritch), *Cimarosiana,* and *Aurora's Wedding,* with commentary by Arnold Haskell. The company then commenced its own season on July 1 with *Cimarosiana, La Boutique Fantasque*, and *Aurora's Wedding.*

Massine had asked de Basil for complete artistic control. When de Basil wouldn't agree to that, Massine started talking to American investors about creating a company of his own. Anticipating Massine's departure when his contract expired, de Basil went to Fokine and made him a proposal: complete freedom to do what he wanted. Fokine accepted. He would be the artistic director and supervise his own ballets; the régisseur, Grigoriev, would supervise Balanchine's and Massine's ballets. For the month of July, while Massine was still under contract, both Massine and Fokine were with the company in London. Fokine insisted on rehearsing all his ballets in the company's repertoire, and he made many adjustments. Although it meant rehearsing roles they were already performing, the dancers were happy to have the privilege of working on their interpretations with Fokine himself. *Les Sylphides* was transformed after Fokine explained to the dancers what the intent was behind each gesture.

Nobody realizes that in *Les Sylphides* the whole thing is a dialogue between the Sylphides and the invisible creatures of the forest. It's a whispering talk. All the gestures are listening, questioning, whispering back. It's a conversation, and the Sylphides turn in the direction of the voice they hear and run to it. If you don't know that, there are no reasons for doing anything, it's just empty and boring. The whole ballet should be

acting and reacting. To do it any other way is not fair to Fokine. And the Prelude is all about balance, you really have to work. On the beat you stand and stand. Then an arabesque on the beat and you stand and stand. You can't cheat and move in between. In the Mazurka, the relevés have to be travelling, from the middle to the footlights, I've seen it done in one place — that's wrong. That's not Fokine's choreography.

LES SYLPHIDES
Choreography by Mikhail Fokine
Libretto by Fokine
Set and costumes by Alexandre Benois
Music by Frédéric Chopin, orchestrated by Sergei Taneyev, Anatoly Lyadov, Alexander Glazunov, Nikolai Tcherepnin, and Igor Stravinsky
First night restored by Fokine, Covent Garden Opera House, London, September 1937

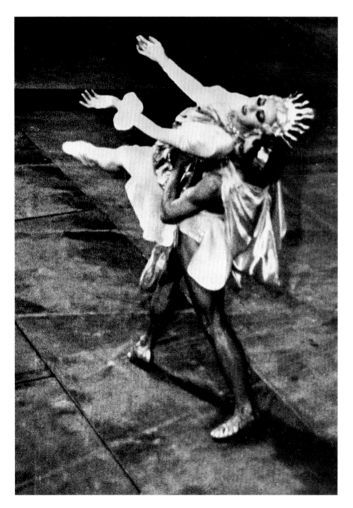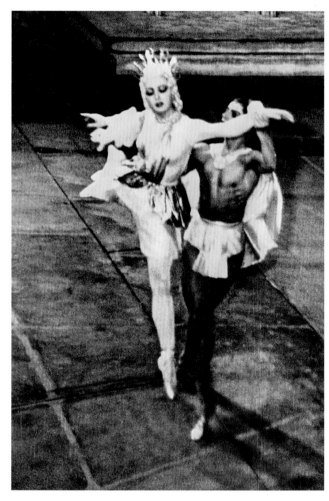

ORPHEE ET EURYDICE

Choreography by David Lichine

Opera music by Christoph Gluck

Costumes executed by Karinska

Performed June 9 and 17, 1937

Irina Baronova in pas de deux with George Zoritch

Photo: NYPL Jerome Robbins Dance Division

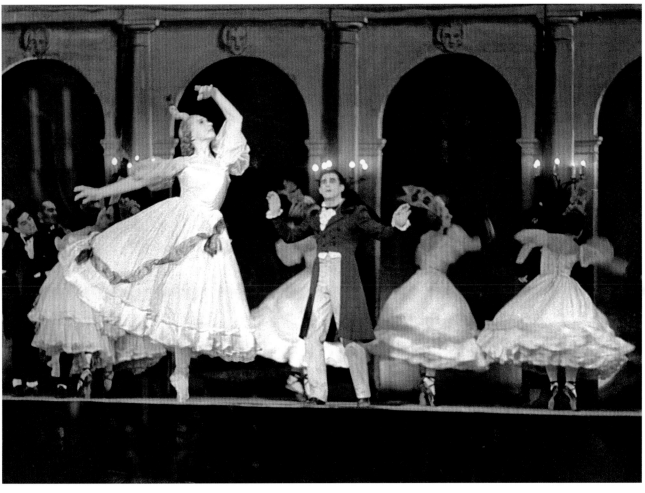

Irina Baronova and Anton Dolin

Photo: Hugh P. Hall / National Library of Australia

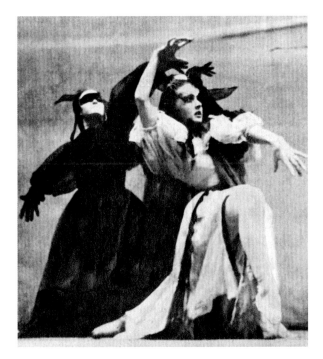

SYMPHONIE FANTASTIQUE
Choreography by Léonide Massine
Libretto by Hector Berlioz
Set and costumes by Christian Bérard
Symphony by Hector Berlioz
First night July 24, 1936
Irina Baronova as the Beloved

Symphonie Fantastique was premiered in 1936 with Toumanova dancing the Beloved. Baronova first danced the role in 1937 at the Opera House, Covent Garden. The ballet opens as the Musician takes opium; he then has a series of four hallucinations.
2nd Movement: The Ball — the Musician dances with the Beloved, but she disappears.
5th Movement: The Witches' Sabbath — the Beloved is now a diabolical creature in a Satanic rite.
Photo: NYPL Jerome Robbins Dance Division

SEPTEMBER 6, 1937 – OCTOBER 9, 1937

The company performed seven Fokine revivals, *Petrouchka, Prince Igor, Scheherazade, Le Spectre de la Rose, Les Sylphides, Les Papillons,* and *Cléopâtre,* but the biggest hit of the season was Fokine's *Coq d'Or.* Other premieres this season were two new ballets choreographed by Lichine, *Francesca di Rimini* and *Le Lion Amoureux,* and his new version of *Les Dieux Mendiants.* The season broke all records. On the last night, de Basil was presented with an antique gold cockerel by the subscribers and the stage was filled with flowers.

Fokine was very interesting to work with. When he came into a rehearsal room to make a new ballet he already had it all in his head. He didn't waste time trying this or that, he knew exactly the steps he wanted and how he wanted them done. When he showed us the steps it was as if he had already done the ballet. It was complete; all we had to do was learn it. No trial, no error, no probing. He was calm and reserved, but he could be sarcastic if the execution was not what he wanted and would get angry if he thought someone wasn't paying attention. Madame Fokine was always with him, sitting quietly next to his chair.

Marc Platt as King Dodon

COQ D'OR
Choreography by Mikhail Fokine
Libretto by Fokine after the opera by Rimsky-Korsakov
Set and costumes by Natalia Goncharova;
costumes executed by Karinska
(Original version first performed May 21, 1914)
First night September 23, 1937
Irina Baronova as the Queen of Shemakhan
Photo: Gordon Anthony / ©Victoria and Albert Museum

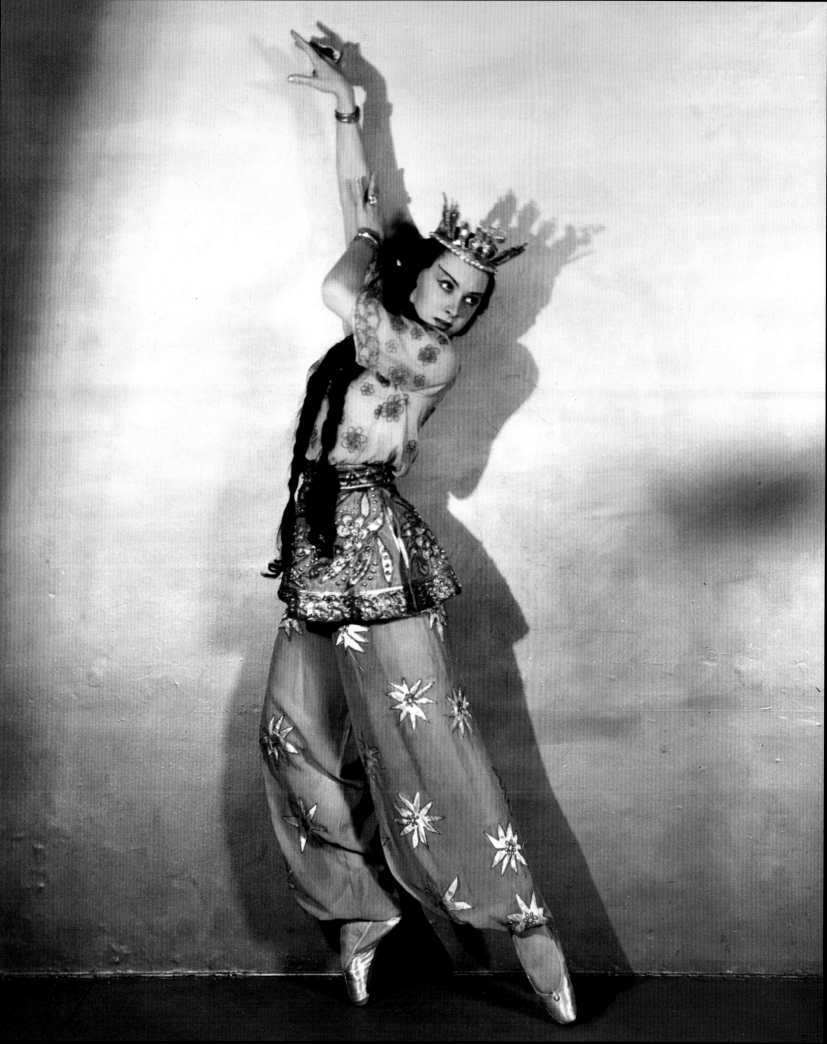

This *Coq d'Or* was a completely new version of the ballet. It was a lavish production with a premiere night attended by the royal family and a host of important artists, including Karsavina. There were 150 new costumes designed by Goncharova, some based on the 1914 originals and some adapted for the new choreography. The great costume maker Madame Karinska was a perfectionist, and the costumes didn't arrive for the dress rehearsal, and they still hadn't arrived when the curtain went up at 8:30 PM for the opening ballet on the program. Gerry had gone to Karinska's workshops to see what was going on and called to say that the costumes would be finished in half an hour. The dancers changed into their tights and toe shoes and waited nervously in their dressing rooms. Suddenly, there was a loud wailing of sirens, two ambulances careened up to the stage door, the back doors were flung open, and Karinska, her seamstresses, and the costumes tumbled out. An announcement was made to the audience that the intermission would be a little longer than expected; in fact it lasted fifty minutes, and the bar did extremely well that night. Karinska stood in the wings during the performance pinning and adjusting the outfits. The applause at the end was thunderous; the curtain calls went on forever. It was "the most magnificent spectacle since the war" (World War I) and was the big hit of the season. Haskell wrote, "Baronova's Queen is a brilliantly conceived character study as well as a dazzling piece of technical dancing." The 1937 season broke all box office records at the Opera House.

OCTOBER 21, 1936 – MAY 5, 1938

New York – American Tour – Canadian Tour – Berlin – Copenhagen

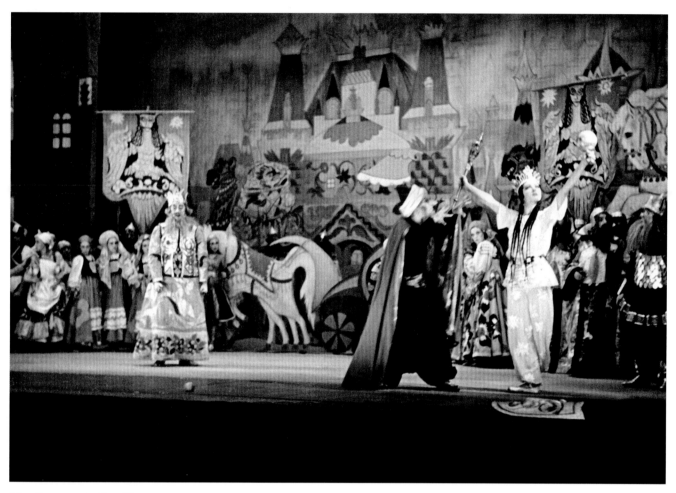

Irina Baronova in *Coq d'Or*

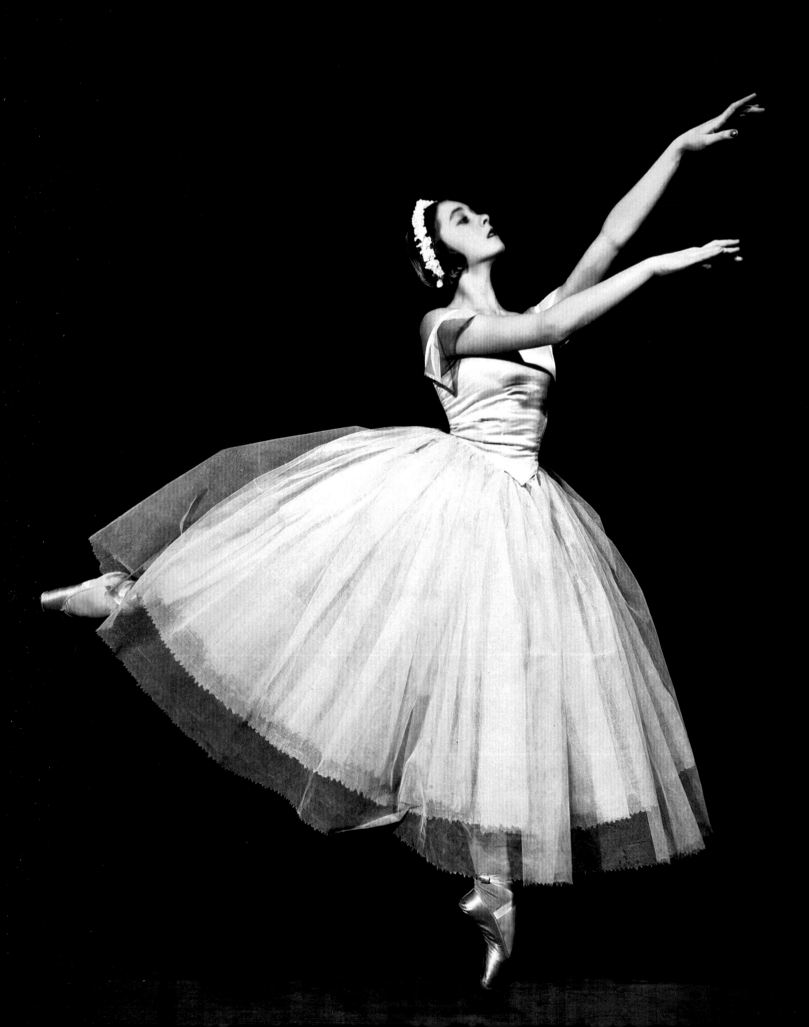

JUNE 18, 1938 – AUGUST 13, 1938

In addition to the now large repertory of ballets performed by the company, there were two premieres: *Protée* (Lichine), *Cendrillon* (Fokine), and revivals of Fokine's *Spectre de la Rose* and *Les Sylphides*. Fokine also started rehearsing a new ballet for the following London season, *Paganini*. The ballet that received the most attention was *Les Sylphides*, which under Fokine's personal direction acquired new life and meaning.

SEPTEMBER 28, 1938 – MAY 11, 1939

Melbourne - Sydney - New Zealand Tour - Melbourne - Adelaide - Sydney Honolulu

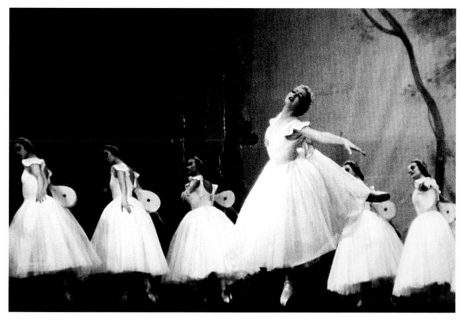

Les Sylphides Photo: Constantine

Protée had grown out of a day spent at Henry and Esther Clifford's villa in Florence the summer before. Fooling around at the pool, Lichine got the idea for a ballet and worked on it with Clifford. The set and costumes were designed by Giorgio de Chirico, and the ballet was based on Greek classicism.

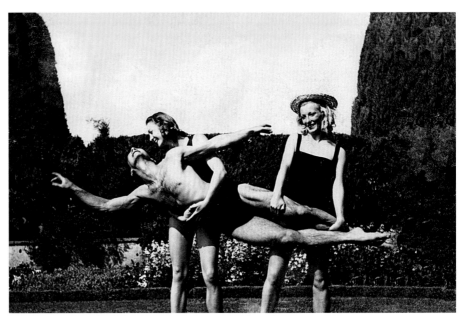

Lichine, Baronova, and Riabouchinska Photo: NYPL Jerome Robbins Dance Division

Petroff and Baronova

Runanine

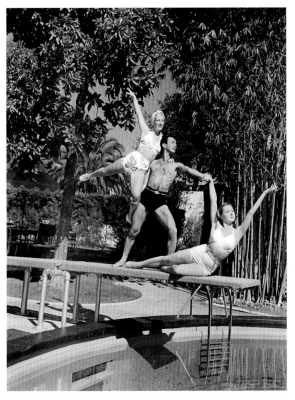

Riabouchinska, Lichine, and Baronova

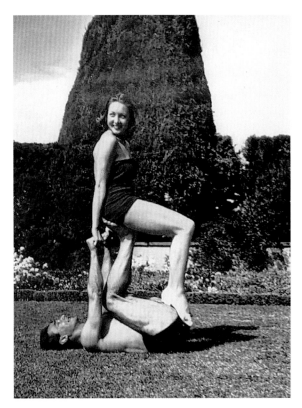

Lichine and Baronova

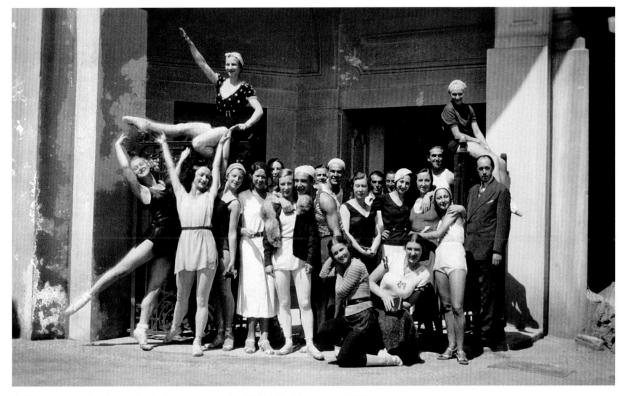

Ballets Russes de Monte Carlo Company at the Clifford's, Florence, 1938

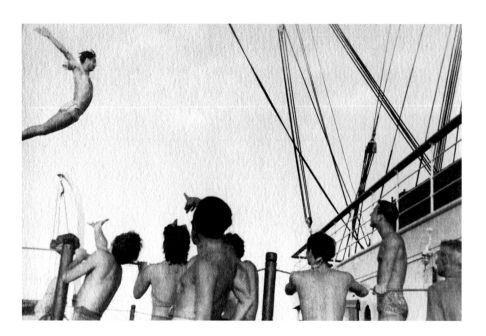

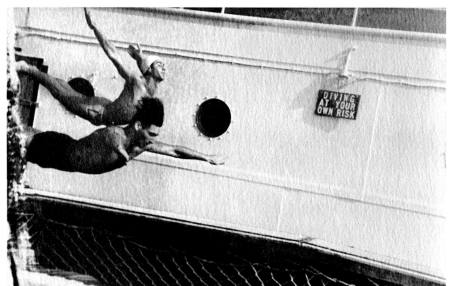

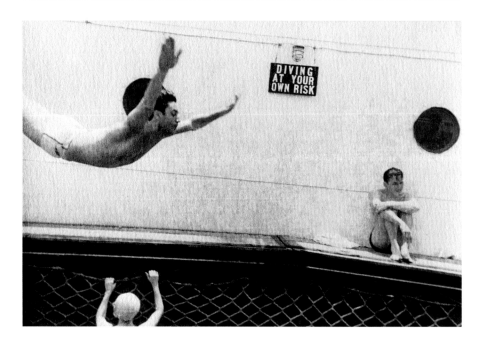

CHAPTER SEVEN
Australia and New Zealand 1938–1939
The Ballets Russes in Australia

The company arrived in Melbourne on the ship *Maloja.* It took six weeks to reach Australia from England via Port Said and Bombay. During the trip, a piano was hoisted up to the top deck, and there the company took class and rehearsed *Paganini* with Fokine. When they weren't rehearsing or taking class, there was a canvas swimming pool, Ping-Pong tables, and other games, which were immediately monopolized by the dancers, and unless the other passengers made friends with them, they had no chance.

Irina with Gerry

Just before the Australian tour a lawsuit was filed, arising from a proposed merger of de Basil's company with Massine's company, which was controlled by Hurok. While de Basil had been in Berlin an agreement had been signed on his behalf by a proxy, which he later discovered had signed away his right to perform several ballets, including *Coq d'Or*. After consultations with his backer, d'Erlanger, Gerry Sevastianov, and others, he decided that the only way to preserve his company was to step aside temporarily. By his stepping aside, de Basil's agreement could not be enforced because his company would now be under new management. It was a move Hurok had never anticipated. De Basil retreated to a small farmhouse in the South of France, and Gerry Sevastianov took over as managing director. Gerry suggested that Pavlova's husband, Victor Dandre, be asked to take the title of chairman and director to lend credibility, because he himself was young and unknown, but Dandre was never anything more than a figurehead.

Arriving in Australia, 1938
Middle row: Grigoriev, Volkova, Dolin, Morosova, Dandre, Riabouchinska, Fokine, Baronova, Sevastianov
Photo: NYPL Jerome Robbins Dance Division and National Library of Australia

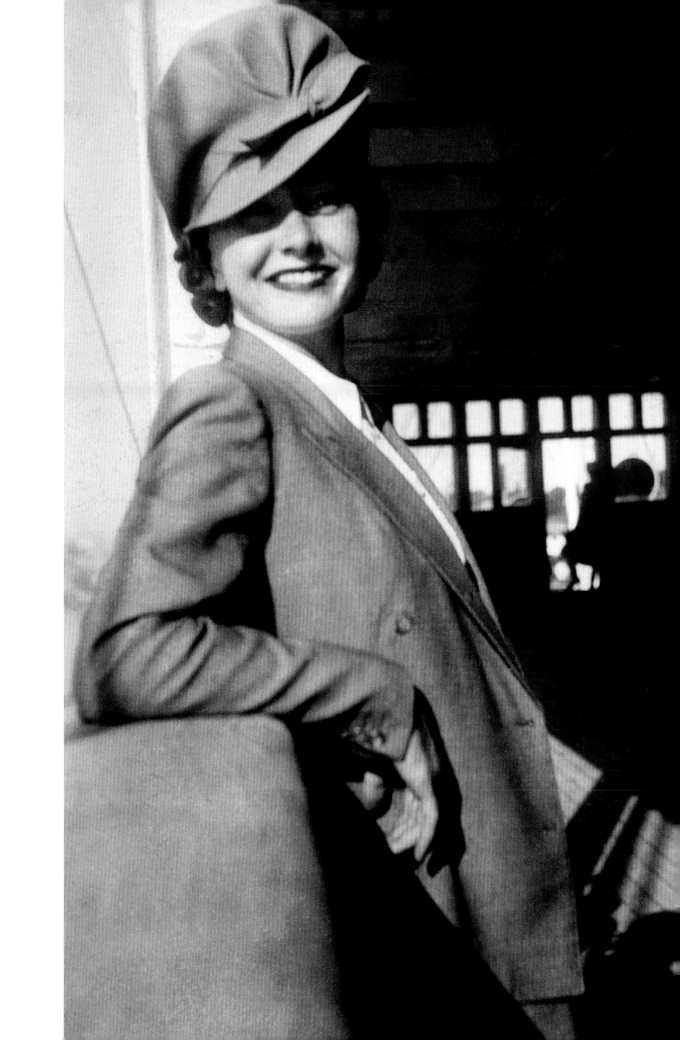

"This time the real Ballet Russe de Monte Carlo company arrived with its big stars, Baronova, Riabouchinska, Lichine, and Dolin."

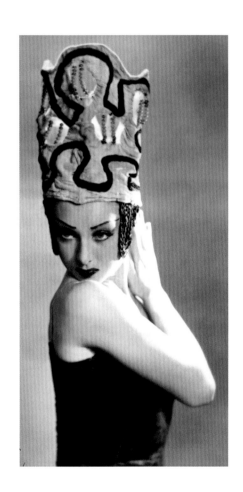

There had been an extensive tour the year before by a hastily assembled second company while the main Ballet Russe de Monte Carlo was touring America. De Basil had signed a contract to tour Australia, but the American tour was going unexpectedly well, so he arranged for Léon Woizikowski's company to incorporate some of the Ballet Russe de Monte Carlo dancers and go with the Ballet Russe de Monte Carlo repertoire and name. Massine had taken legal action to stop this second company performing his ballets in Australia, but when this failed, he rehearsed them himself to protect his work. This time the real Ballet Russe de Monte Carlo company arrived with its big stars, Baronova, Riabouchinska, Lichine, and Dolin. Very importantly, it was the only time that Fokine ever visited Australia.

THE PRODIGAL SON
Choreography by David Lichine
Libretto by Boris Kochno
Set and costumes by Georges Rouault
Music by Sergei Prokofiev
First night Theatre Royal, Sydney, December 30, 1938
Irina Baronova as the Siren

Baronova alternated the role of the Siren with Tamara Grigorieva and Sono Osato. Grigorieva had the opening night in Sydney; Baronova had the opening night in Covent Garden; and Osato had the opening night in New York. The ballet was a revival of a Diaghilev ballet originally choreographed in 1929 by Balanchine, with all new choreography by Lichine. Lichine had injured himself in *Protée* and had to choreograph the role of the Son on Dolin.
Photos: Spencer Shier / National Library of Australia

134

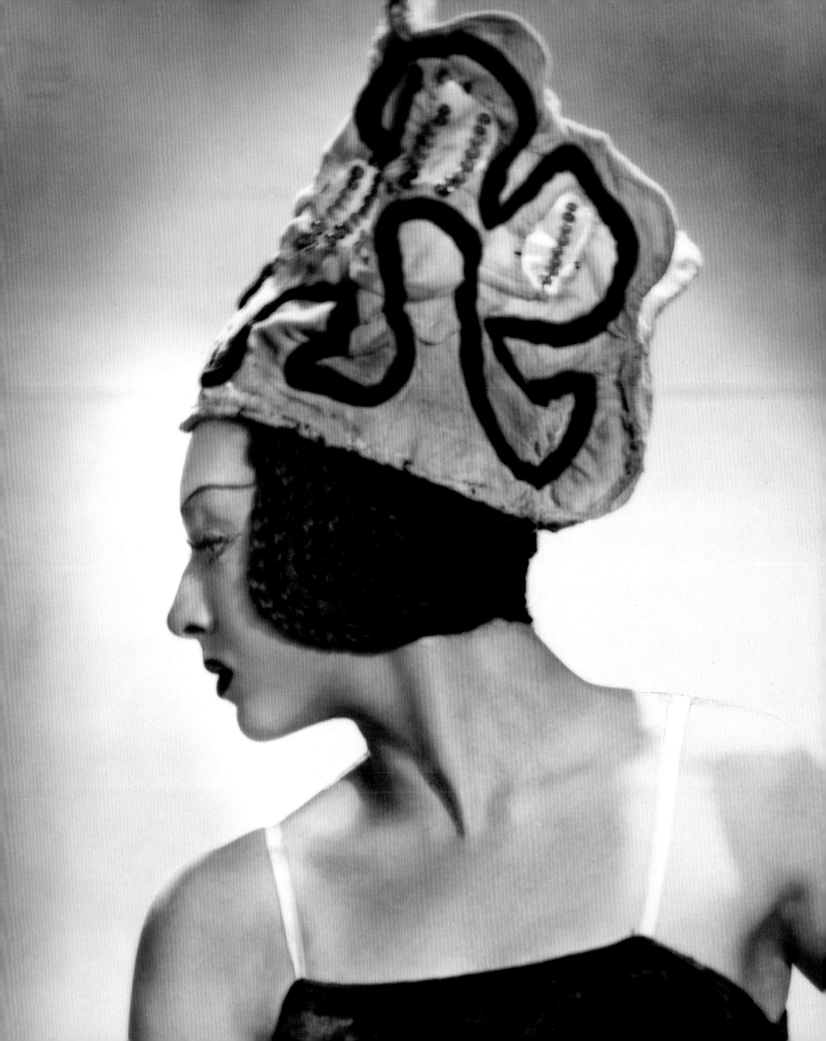

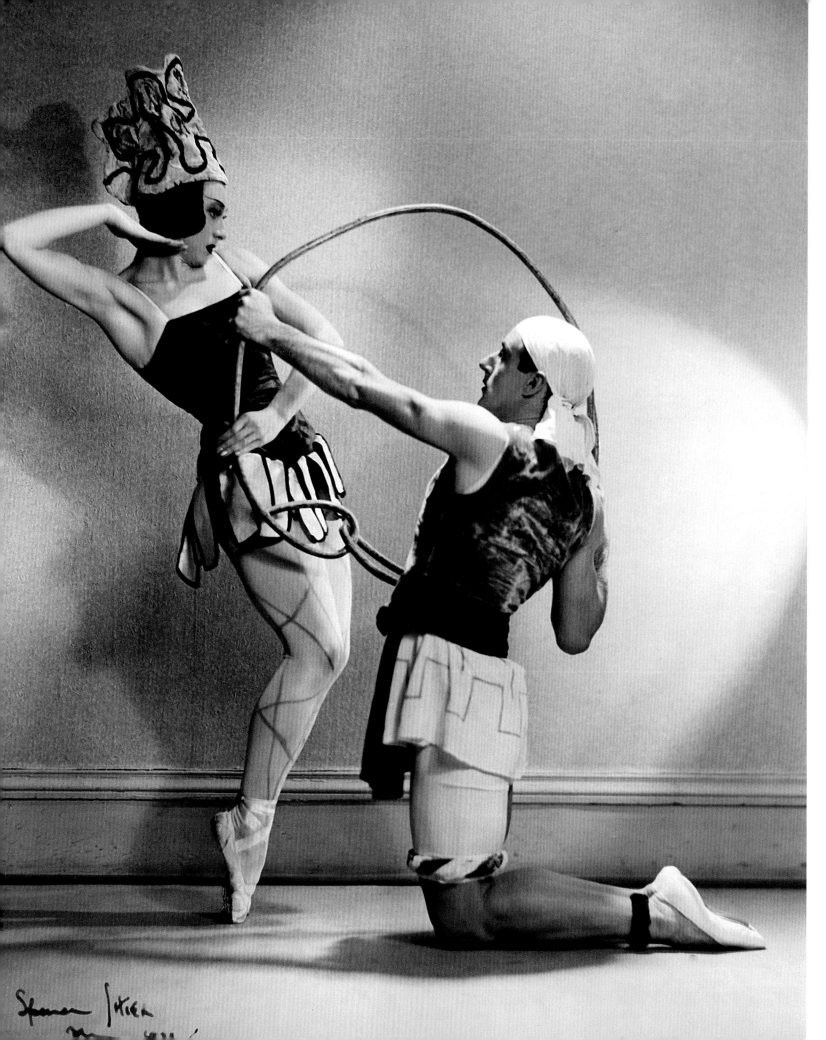

"The dancers knew that people would initially come out of curiosity and that it was their job to make them truly love and understand ballet."

The dancers knew that people would initially come out of curiosity and that it was their job to make them truly love and understand ballet. Building on the pioneer work done by the other company, the dancers worked hard and gave it their all, and the audiences responded. In America, the company had lived on their train; they were largely insulated from their audiences, except when they stayed in Los Angeles or New York, where they socialized with émigré Russians. In Melbourne and Sydney, lifelong friendships were made with the locals, among them a Melbourne ophthalmologist, Dr. Joseph Anderson and his wife, Mary. Dr. Anderson was given the run of the theatre and allowed backstage to film performances on his cine camera. Mary donated this rare film footage to the archives of the Australian Ballet after her husband's death. The Andersons hosted the dancers on Sundays at their house, and Mary's school-age nephew, Robert Southey, used to play with the dancers in the pool. When he grew up, he became the chairman of the Australian Ballet.

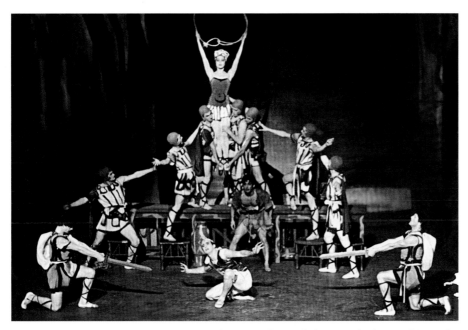

Photo: Hugh P. Hall / National Library of Australia

Irina Baronova and Anton Dolin in *The Prodigal Son*
Photo: Spencer Shier / National Library of Australia

AUSTRALIA AND NEW ZEALAND
TOUR ITINERARY
September 28, 1938 – April 27, 1939
227 PERFORMANCES / 212 DAYS

PERFORMANCES

63	Melbourne	HIS MAJESTY'S THEATRE September 28 – November 21, 1938
71	Sydney	THEATRE ROYAL November 25, 1938 – January 26, 1939
17	Auckland	HIS MAJESTY'S THEATRE February 1 – 15, 1939
1	Hamilton	THEATRE ROYAL February 16, 1939
1	Palmerston North	OPERA HOUSE February 17, 1939
16	Wellington	GRAND OPERA HOUSE February 18 – March 3, 1939
10	Christchurch	THEATRE ROYAL March 4 – 11, 1939
8	Dunedin	HIS MAJESTY'S THEATRE March 13 – 18, 1939
2	Invercargill	CIVIC THEATRE March 20, 1939
22	Melbourne	HIS MAJESTY'S THEATRE March 29 – April 12, 1939
15	Adelaide	THEATRE ROYAL April 13 – 27, 1939
1	Sydney	THEATRE ROYAL Midnight Gala (before boarding ship) April 27, 1939

Toumanova and Danilova were not with the company, so Baronova and Riabouchinska had to take over their roles. The company performed a repertoire of twenty-seven ballets including a world premiere of a revival of *Prodigal Son*. The ballets performed were:

Aurora's Wedding, Bolero, Carnaval, Cendrillon, Les Cent Baisers, Choreatium, Le Coq d'Or, La Concurrence, Cotillon, Danses Slaves et Tziganes, Les Dieux Mendiants, Les Femmes de Bonne Humeur, Jeux d'Enfants, Les Papillons, Petrouchka, Les Présages, Prince Igor, Prodigal Son, Protée, Scheherazade, Scuola di Ballo, Le Soleil de Nuit (Midnight Sun), *Le Spectre de la Rose, Les Sylphides, Symphonie Fantastique, Swan Lake,* and *Union Pacific.* They gave 227 performances in 212 days.

HIS MAJESTY'S THEATRE

AUSTRALIAN AND NEW ZEALAND THEATRES LTD.

Managing Directors: FRANK S. TAIT, S. S. CRICK, G. B. DEAN, ERNEST C. ROLLS.
London . J. NEVIN TAIT

Present

J. C. Williamson's Outstanding Theatrical Attraction of the Year

COVENT GARDEN RUSSIAN BALLET

Direct from the Royal Opera, Covent Garden, London.

Including the world-famed prima ballerinas, Mlles.

IRINA BARONOVA TATIANA RIABOUCHINSKA
TAMARA GRIGORIEVA

Together with the following principal artists and soloists (in alphabetical order):
KYRA ABRICOSSOVA, IRINA BONDIREVA, ALEXANDRA DENISSOVA, VANDA GROSSEN, IRINA KOSMOVSKA, RAISA KOUZNETZOVA, LINA LERINA, VERA NELIDOVA, LUDMILA LVOVA, LARA OBIDENNA, SONO OSATO, GALINA RAZOUMOVA, LELIA ROUSSOVA, ANNA ROY, MARIA SANINA, LISA SEROVA, NATASHA SOBINOVA, KYRA STRAKHOVA, TAMARA TCHINAROVA, EDNA TRESAHAR, ANNA VOLKOVA, IRINA WASSILIEVA, BETTY WOLSKA, and CORPS DE BALLET.

And the Celebrated Principal Male Dancers,

ANTON DOLIN DAVID LICHINE
YUREK SHABELEVSKY PAUL PETROFF ROMAN JASINSKY

Together with the following principal artists and soloists (in alphabetical order):
GRISHA ALEXANDROFF, H. ALGERANOFF, LAURENT ANDAHAZY, ALBERTO ALONSO, BORIS BELSKY, EDWARD BOROVANSKY, SERGE BOUSLOFF, EDUARD DZIKOWSKY, SERGE ISMAILOFF, VALENTINE GEGLOVSKY, MARIAN LADRE, YURA LAZOWSKY, NARZIS MATOUCHEVSKY, BORISLAV RUNANINE, DIMITRI ROSTOFF, GEORGE SHAEVSKY, EDUARD SOBISHEVSKY, OLEG TUPINE, and CORPS DE BALLET.

Ballets by MICHEL FOKINE under his personal supervision.

Choreographer: **DAVID LICHINE.**
Regisseur-General: **SERGE GRIGORIEFF.**
Assistant-Regisseur: **JAN HOYER.**

SYMPHONY ORCHESTRA OF FIFTY PLAYERS
Principal Conductor: ANTAL DORATI
Assistant-Conductor: VLADIMIR LAUNITZ.

E. B. LIMITED { Chairman and Director of Company: VICTOR DANDRE.
{ Managing Director: G. SEVASTIANOV.

"Gerry instantly made himself three years younger. There was no way he could have known what the consequences of this would be."

Possibly because the validity of their elopement could be questioned since my mother was underage, Gerry decided that he wanted a proper Russian Orthodox wedding, performed by a priest, and arranged for this in Sydney. Victor Dandre and Anton Dolin were the best men who held crowns over the bride's and groom's heads during the ceremony. Dandre was holding a crown over my mother's head when he suddenly got hiccups. The crown bounced off her head, more hiccups, another bounce, giggles erupted, and Dandre had to be escorted out, his duties taken over by Dolin's friend, Otis Pearce. A day later, Dandre was still hiccupping, and he left by hydroplane for England to see his own doctor.

During the company's time in Sydney, Gerry's Yugoslavian passport needed renewing. It had always been a sore point for him that he was fifteen years older than my mother, so now Gerry took the opportunity to explain to the young man at the consulate that the birthdate on his old passport was a mistake: he was a Russian refugee, with papers issued by a foreign country, a mistake had been made that he didn't notice until later, could the mistake be rectified now? The young man behind the desk obliged, and Gerry instantly made himself three years younger. There was no way he could have known what the consequences of this would be.

Irina and Gerry at breakfast Photo: Hugh P. Hall / National Library of Australia

Photo: Andrews (New Zealand)

"The interviewer said, on the contrary, they adore you — they just don't want to disturb you by clapping. It's a sign of respect to be silent."

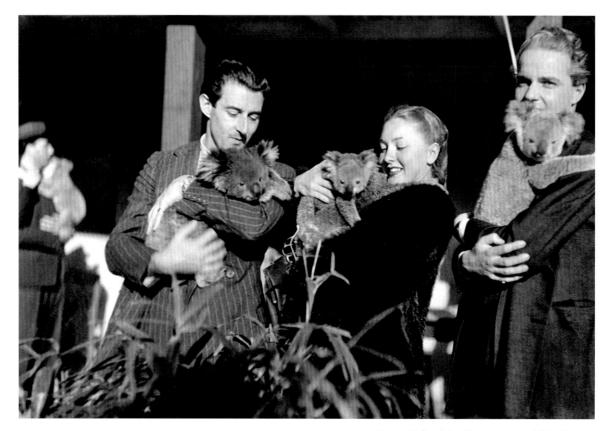

Anton Dolin, Irina Baronova, and Otis Pearce

When we got to New Zealand, two performances went by with not a clap. Silence. A radio station asked Dolin and myself to do an interview, and we said on the radio that we were heartbroken because nobody liked us. The interviewer said, on the contrary, they adore you — they just don't want to disturb you by clapping. It's a sign of respect to be silent. Dolin immediately said, "Whoever is listening . . . for God's sake, clap!" After that, they never stopped applauding. I could hardly hear the orchestra. The audiences clapped in all the right places, all the wrong places, it was too much already!

Photo: Andrews (New Zealand)

From the *Sydney Herald*, November 18, 1938:

The greatest season of Russian Ballet ever presented in Australia and one of the most important events in Australian theatrical history is about to end at Her Majesty's Theatre. . . . Baronova has two of her best roles in Swan Lake *and* Aurora's Wedding *in both of which she is able to show the dazzling brilliance of a great and wonderfully controlled technique.*

At the end of the tour, April 1939, eight members of the company decided to stay in Australia. Fearing a war in Europe, some of the Jewish dancers preferred not to return, and others stayed to marry Australians. Among them were Tamara Tchinarova, Edouard Borovansky and his wife, Zenia, and Kira Abricossova and her husband, Serge Bousloff. They remained and rebuilt their lives Down Under. The Borovanskys started a ballet school in Melbourne, and then a company, which in time became the Australian Ballet, helped by Tchinarova, who was one of their leading dancers. Abricossova started a ballet school in Perth and then founded

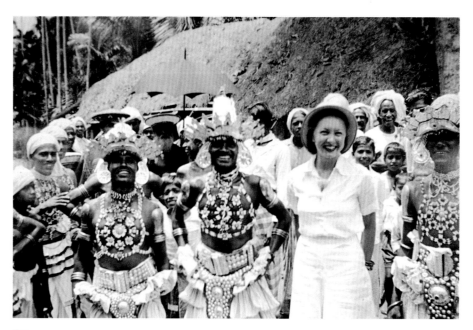

Fiji

the West Australian Ballet, which is still going strong. The Ballet Russe de Monte Carlo tour was an important event in the cultural growth of Australia and firmly established ballet as an art form across the country.

Dolin came up with a plan to make some extra money by giving recitals in Fiji, Samoa, and Honolulu on the way back to England. He proposed this to Baronova, Lichine, and Riabouchinska, who thought it was a great idea. There was a ship going to Los Angeles taking that route and from there they could fly on to New York and take another ship to England. There weren't any venues in Fiji or Samoa, but two nights were booked in Honolulu at the McKinley High School auditorium with the Honolulu Symphony Orchestra. They persuaded one of their conductors, Antal Dorati, to go with them, and another dancer for back-up, and the venture was sold out.

The particular beauty of the Australian landscape, and the enormous warmth and friendship given to her over this six-month tour made a lifelong impression on my mother. Fifty years later, after several rewarding working visits, she returned to live in Australia for good.

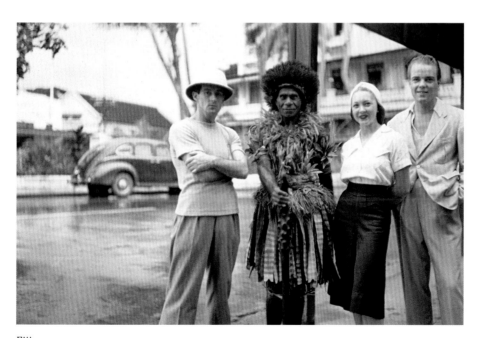

Fiji

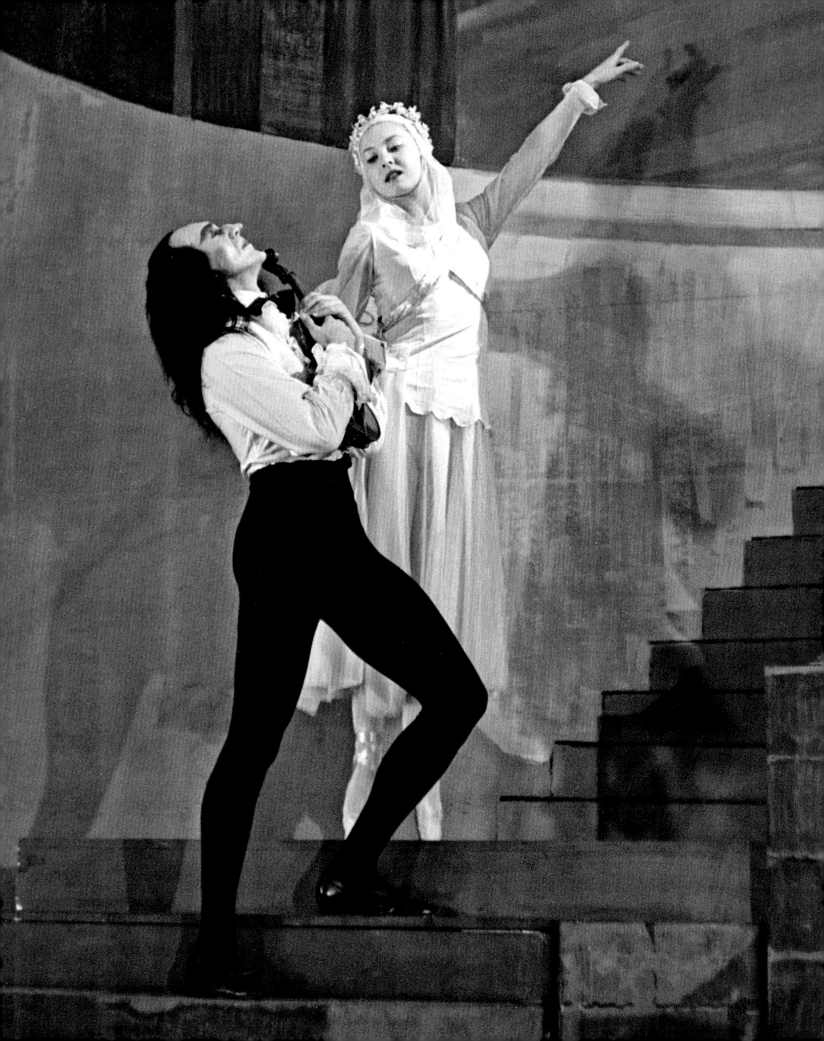

Goodbye Home, 1939
World War II

JUNE 10 – JULY 29 1939: COVENT GARDEN

After their eight-month tour of Australia, the company sailed back to London. This turned out to be their last season at the Opera House. War was imminent. Many of the Russian dancers, my mother among them, were refugees without proper passports, travelling on Nansen papers. These worked in peacetime, when de Basil could pull strings to get visas and work permits, but they would not be adequate to travel in Europe if war were declared.

Ballets new to the English audience were *Prodigal Son,* which had its London premiere, and a world premiere of Fokine's ballet *Paganini,* which the King and Queen attended and all the loyal balletomanes. On the last night of the season, the company performed *Swan Lake, Paganini, Protée,* and *Aurora's Wedding.* The audience erupted, clapping and shouting "Bravo." The stage was filled with bouquets of flowers; the curtain calls went on and on. The applause didn't stop. The stagehands finally had enough: they wanted to dismantle the scenery, load it onto the trucks, and go home; they complained to Papa Grigoriev, who then ordered them to lower the fire curtain, which would signal to the audience that the evening was over. No one in the auditorium moved; the audience stayed in their seats stamping their feet

PAGANINI

Choreography by Mikhail Fokine

Libretto by Sergei Rachmaninoff and Mikhail Fokine

Set and costumes by Serge Soudeikine

Music by Sergei Rachmaninoff

First night June 30, 1939

Irina Baronova as the Divine Genius with Dmitri Rostov

Photo: Baron / Hulton Archive / Getty Images

"No one in the auditorium moved; the audience stayed in their seats stamping their feet and started shouting, 'Baronova! Baronova!'"

and started shouting, "Baronova! Baronova!" Papa Grigoriev rushed to the dressing rooms, where the dancers had already taken their costumes off, and told my mother that she had to come back. Throwing her old dressing gown on, she was hurried back to the stage. Since the fire curtain was down, she had to step out into the stalls and make a speech for the first time in her twenty-year-old life. In her heavy Russian accent, she thanked the audience on behalf of the whole company. The next morning, the papers called the evening "one of the most remarkable scenes that the century-old theatre at Covent Garden has ever witnessed."

Irina and Gerry on the last night
of Covent Garden, August 9, 1939
Photo: NYPL Jerome Robbins Dance Division

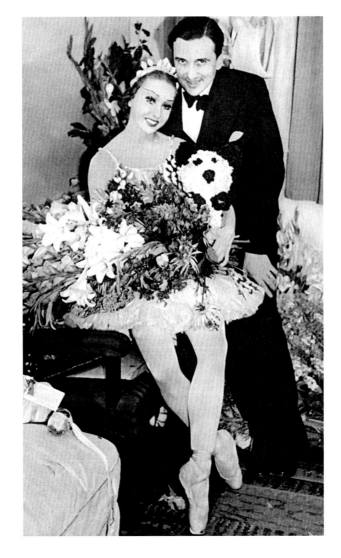

"The next morning the papers called the evening 'one of the most remarkable scenes that the century-old theatre at Covent Garden has ever witnessed.'"

The next engagement was in Berlin. Concerned for the well-being of the Jewish members of the company, Gerry asked Goebbels to guarantee their safety. Goebbels replied that as far as he was concerned, all the members of the Ballets Russes were non-Jewish. Suddenly the engagement was postponed, and a week later it was cancelled. The company didn't know what was going to happen; people started dispersing. Germany invaded Poland, and on September 3, England declared war.

Irina Baronova
Photo: Gordon Anthony
©Victoria and Albert Museum

An American ship, the SS *Washington,* was making a last crossing to New York, and all the dancers stranded in England were found places on it. The ship was packed; cabins were divided into Women and Men. My mother shared a cabin with Danilova and Alicia Markova. It took eleven days to reach New York, zigzagging to evade German submarines. At night, no one was permitted on deck, and all the portholes were blacked out. When the dancers reached New York, they found out that some of the company were in Canada, some were still in Paris, and Riabouchinska and Lichine were in Italy. The American tour had been cancelled. There was talk of going back to Australia. Gerry decided that he and my mother would stay in New York until the war was over. Having experienced the Russian Revolution, he was staying as far away from the conflict as possible. He resigned as de Basil's managing director and went to work for Hurok. At this moment, an offer arrived via Hurok's office for my mother to appear in an MGM film, *Florian*. Reluctantly, she was persuaded to take it.

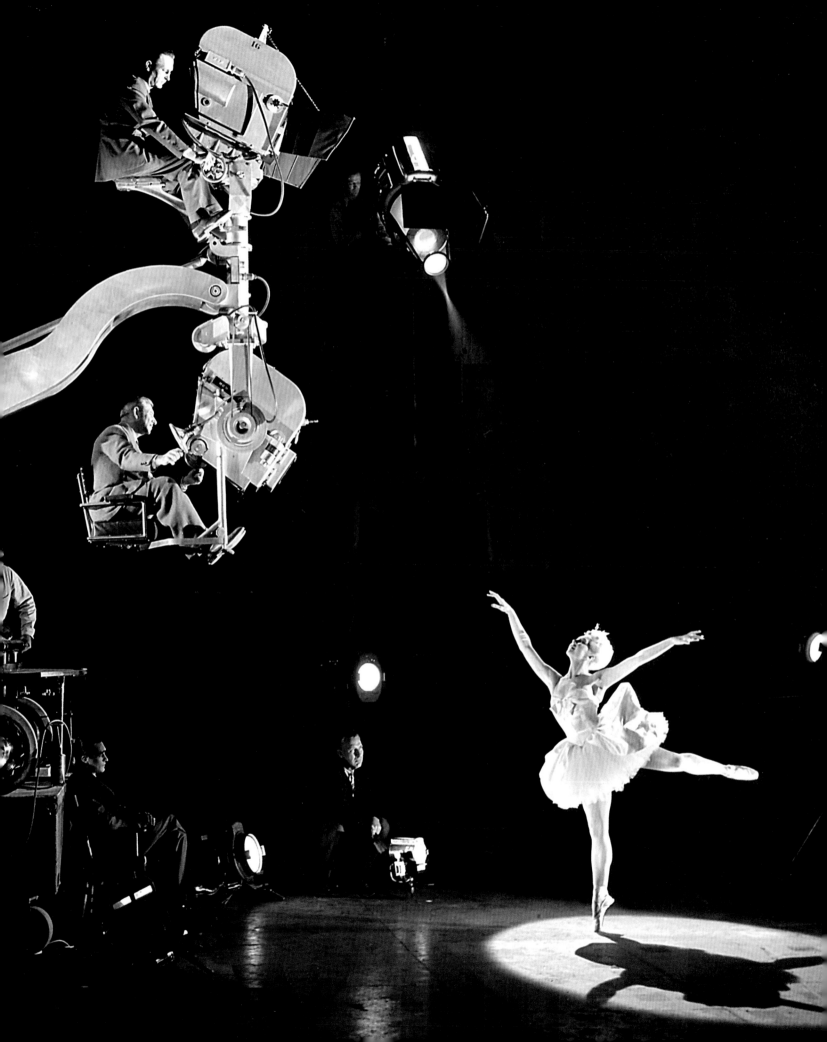

CHAPTER NINE
Hollywood and South America 1940–1941
MGM, Massine, and de Basil

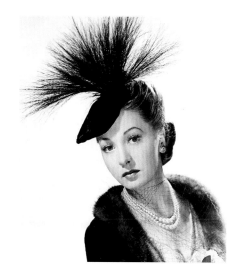

My mother arrived in Hollywood in the spring of 1940. The studio rented her a house on Roxbury Drive from Gracie Fields's mother, and a brand new, pale green Pontiac appeared in the garage. My mother didn't care about any of it. She was only making a film because the ballet company was in disarray and Gerry thought it was a good idea. When de Basil called to ask her to join him for another tour to Australia and Gerry had already signed her contract with MGM, she cried for the rest of the day.

The producer of the film was married to a famous Viennese opera singer who, in her youth, had been given a pair of white Lipizzaner horses by Emperor Franz Josef I. These horses now lived on the producer's ranch, and his wife had suggested that he make a film with them. A writer was hired, and in the story he came up with, in Vienna in 1880, a prince was betrothed to a princess. But he was in love with a ballerina and the princess was in love with a stableman. This was what my mother had to say about it:

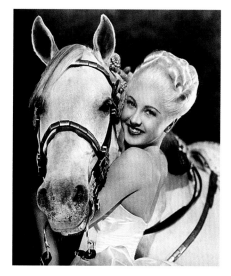

FLORIAN
MGM, 1940
Produced by Winnie Sheehan
Directed by Edwin L. Marin
Starring Robert Young, Irina Baronova, and Lee Bowman

Far left:
Irina Baronova filming *Florian*
Photo: Herbert Gehr / Getty Images

Oh, it was all baloney. The best thing in it was the horse!

As soon as the filming was over, my mother packed up the Pontiac and drove back to New York. She had just turned twenty-one and for the first time was able to sign her own contracts. Sol Hurok offered to represent her as her personal manager, and that was the first contract she signed. De Basil was still in Australia and Europe was engulfed in war, but René Blum and Massine's company, Ballet Russe de Monte Carlo, with Danilova and Markova, was going to tour South America, and Massine was asking for Baronova to dance *Les Sylphides, Swan Lake,* and a new role, *Coppélia.* Hurok and Gerry recommended that she go.

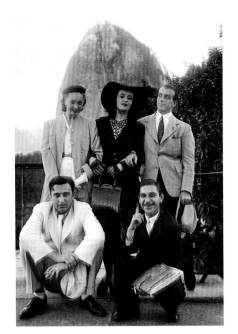

Rio de Janeiro
Standing: Baronova, Orlova, and Massine
Seated: Gerry and unknown man

Irina Baronova

MASSINE'S BALLET RUSSE DE MONTE CARLO
JUNE – AUGUST 1940
Rio de Janeiro and São Paulo, Brazil
Montevideo, Uruguay; and Buenos Aires, Argentina

Arriving in Rio de Janeiro, my mother joined the other ballerinas in Massine's company, Danilova and Markova, whom she knew well, and Mia Slavenska, whom she hadn't yet met. Massine asked Danilova to teach my mother the role of Swanhilda in *Coppélia,* and Danilova refused. It was a role that Danilova particularly liked, and she was already sharing it with Slavenska. Very generously, Slavenska offered to teach my mother the role, and they became good friends. Working with Slavenska and Igor Youskevitch, my mother was ready to dance Swanhilda by the time they got to São Paulo. This is what my mother says in her book:

Igor Youskevitch [was] one of the outstanding leading artists and a brilliant partner. I learned the role quickly [and I] loved it. On the day I was to perform, Slavenska hardly spoke to me and I could not think what was the matter. In the evening, a beautiful bouquet of flowers was delivered to my dressing room. The card read, "Don't pay any attention to my mood today. I'm jealous. It will pass. Good luck for tonight. Love Mia."

My mother got such rave reviews that Massine declared the role exclusively hers for the rest of the tour. Danilova took this badly and wouldn't talk to her for a long time.

COPPELIA
Choreography by Massine after Lev Ivanov and Louis Merante
Libretto by Arthur Saint-Léon, adapted by Charles Nuitter (archivist of the Paris Opera)
taken from "Der Sandmann" by E. T. A. Hoffmann
Set and costumes by Pierre Roy; costumes executed by Karinska
Music by Leo Delibes

Originally performed with Arthur Saint-Léon choreography by Paris Opera Ballet
Théâtre Imperiale de l'Opéra, Paris, May 25, 1870
New choreography by Petipa for the Imperial Ballet of St. Petersburg, 1884
Petipa's choreography revised by Lev Ivanov and Enrico Cecchetti, 1894
(Baronova's first performance São Paulo, Brazil)
Irina Baronova as Swanhilda, Igor Youskevitch as Franz, and Simon Semenoff as Dr. Coppelius

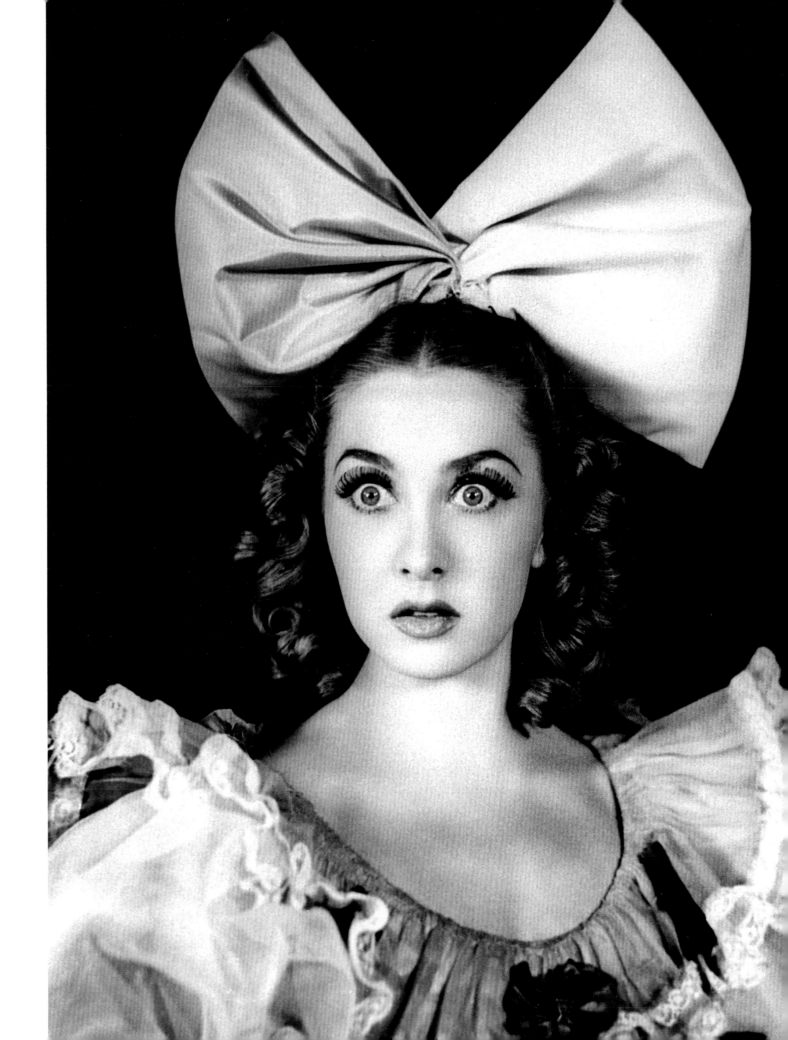

Léonide Massine and Sol Hurok
Photo: NYPL Jerome Robbins Dance Division

On the ship *Argentina*: Massine and his ballerinas, from the top of the table clockwise: Irina Baronova, Tania Orlova (Massine's third wife), Alexandra Danilova, Mia Slavenska, and Alicia Markova

On the ship *Argentina*: the Captain on Fancy Dress Night with Sol Hurok in eyepatch

I found a photograph of my mother in costume, labeled on the back, *Ghost Town*, but I couldn't find any reference to my mother dancing that ballet, in either her book or any other book. I called a ballet friend to see if she knew anything about it, and although she didn't, we agreed that it would be odd for my mother to have been photographed in the costume if she had never danced in the ballet. I hung up and looked at an e-mail from Dan Geller and Dayna Goldfine, who had directed the wonderful documentary film *Ballets Russes*: there was an address and telephone number for Frederic Franklin with a note mentioning his age, ninety-eight years old. I picked up the phone and called the number:

"Hello?"

"Freddie, it's Victoria Tennant, Irina Baronova's daughter."

"My Darling! How lovely to hear from you."

I told him that I was making a photo book about my mother, and I was trying to determine which ballets she had danced in. I wanted to ask him if he knew if she had ever danced in *Ghost Town*.

"My Darling! I partnered her in it!"

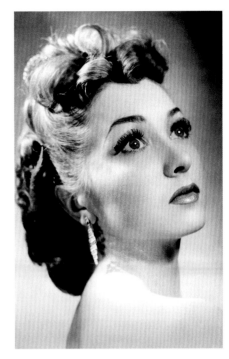

Irina Baronova in *Ghost Town*

Quote from my mother:

I admired Freddie's dancing enormously. He danced a lot with Danilova. Very, very nice person, adorable young man. We were great friends, he is really a nice chap.

GHOST TOWN
Choreography by Marc Platt
Libretto by Richard Rodgers
Set and costumes by Raoul Pène du Bois; costumes executed by Karinska
Music by Richard Rodgers
First night Metropolitan Opera House, New York, November 12, 1939
Irina Baronova as Eilley Orum, with Frederic Franklin as Ralston

Baronova danced this one-act American folk ballet on the South American tour of Massine's company. It was the only ballet Marc Platt choreographed. The research for the libretto was done by Gerald Murphy, who had lent his early American recording collection to Massine and MacLeish when they were creating *Union Pacific* in 1934. In this ballet, two hikers meet an old man in a deserted old mining town in the desert, and he tells them the story of the town.

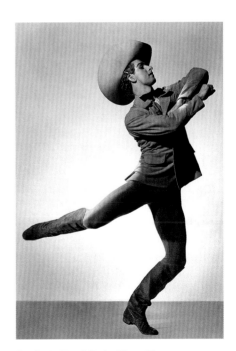

Frederic Franklin in *Ghost Town*
Photo: Maurice Seymour

"Granny begged my mother to consider the new company and stay near them in America. If she rejoined de Basil she would be working so far away."

Back in New York, there was good news from Sol Hurok: de Basil and his company were returning to America from Australia and would arrive by ship in Los Angeles shortly. My mother was to join them for their Los Angeles and New York engagements. When my mother said that she wanted to rejoin them for good, Hurok told her that he was working on big plans for a new ballet company, Ballet Theatre, and for now he had agreed with de Basil that she would dance with his company in just those two cities. My mother went to talk to Dolin, who was not only a trusted friend but experienced in the business of ballet. He confirmed that talks were underway about a new company to be based in New York that was being created by Richard Pleasant with seed money from Lucia Chase, a wealthy woman who was a dancer in her own right. Dolin told my mother that he was helping Hurok in the venture and that inquiries were being made to all the international leading dancers. He urged her to join him. Before leaving for Los Angeles, my mother went to stay with her parents in Sea Cliff and discussed the situation with them. She very much wanted to rejoin de Basil's company; it was her home, her tribe. Grandpa understood her feelings perfectly but pointed out that with the war in Europe, if Hurok were going to throw his support behind this new company and book into all the American theatres, that left only South America and Australia for de Basil. It would be hard going for him with such greatly reduced venues. Granny begged my mother to consider the new company and stay near them in America. If she rejoined de Basil she would be working so far away. All this advice was for change, when all my mother wanted was for things to stay the same.

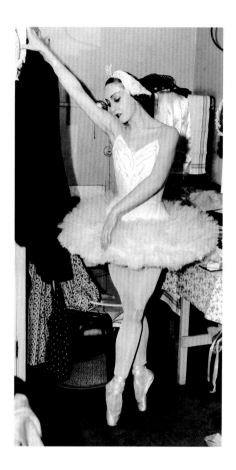

DE BASIL ORIGINAL BALLET RUSSE
October – November 1940
Philharmonic Auditorium, Los Angeles

My mother arrived in Los Angeles overjoyed to be reunited with her company again. From my mother's book:

It was as if time had not passed. I felt at home from the first class, the first rehearsal, and I performed my old roles as if I had never stopped doing so.

In Los Angeles, de Basil reunited nearly all of his Ballets Russes principal dancers from 1933, including the three Baby Ballerinas. All the dancers took their original roles, and rave reviews praised the maturity, richness, and individuality of the performances. One evening, during a performance of *Les Présages*, dancers suddenly started falling on the stage . . .

. . . first Nina Verchinina, bang, then everyone. We couldn't understand what was happening. It was like we were on ice, it was disastrous. When the curtain went down, Grigoriev and everybody rushed onstage and started looking at the floor. André Eglevsky had taken a candle and rubbed a lot of wax on the bottom of one shoe so it would be slippery. He was turning like mad that night, he was doing twenty pirouettes, but the wax remained on the floor on every spot where he turned. Oh, we could have killed him!

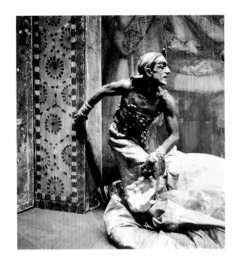

Yurek Shabelevsky in *Scheherazade*

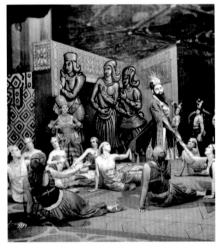

Scheherazade

Among the piles of photographs I found a letter from Disney. The Disney studio was making its third animated film, made up of eight segments set to pieces of classical music, seven of which were performed by the Philadelphia Orchestra conducted by Leopold Stokowski. The film was called *Fantasia*, and it was the first film with stereophonic sound recorded on multiple tracks. This pioneering music system, developed for the film, was called Fantasound. The segment called "Dance of the Hours" was assigned to the animator John Hench, who didn't know much about ballet, so Disney bought him a season ticket to the Ballet Russe and got him a backstage pass. He based the character of the ballerina ostrich Madame Upanova on my mother, Hyacinth Hippo on Riabouchinska, and Ben Ali Gator on Lichine. The film opened in late 1940 in a few theatres specially equipped with the new sound equipment and ran for fifty-seven weeks in New York, thirty-nine weeks in Los Angeles (beating the record set by *Gone with the Wind*), and thirty-two weeks in San Francisco. *Dance Magazine* gave the film its lead article and said, "The most extraordinary thing about *Fantasia* is, to a dancer or balletomane, not the miraculous musical recording . . . but quite simply the perfection of its dancing."

DE BASIL ORIGINAL BALLET RUSSE
November 1940 – February 1941
51st Street Theatre, New York

Balanchine arrived to rehearse *Cotillon* and to present a new ballet, *Balustrade*, with music by Stravinsky and with Toumanova in the principal role. It was not successful. Yes, Mama Toumanova was put out because my mother had reappeared to share or reclaim the roles that her daughter had danced in Australia, but other than that, everything was going splendidly.

In Serge Grigoriev's black notebooks in the archives of the New York Public Library's Dance Division, I read the lists that he

made from year to year of the male and female dancers in their order of ranking. Initially, Balanchine had favored Toumanova; then when he left to start his own company and she went with him, my mother took first place, with Riabouchinska after her. When Danilova arrived, my mother moved to number two. When Danilova left, my mother was back to number one. When Toumanova came back, she moved into third place behind my mother and Riabouchinska, fourth place if Danilova was there. The rivalries between the ballerinas, usually friendly, were brought out into the open during this tour.

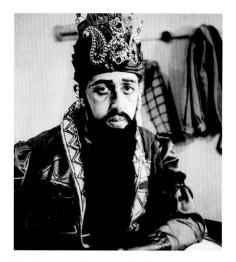

Yurek Lazowsky in *Scheherazade*

On opening night at the Metropolitan Opera House in December 1940, I was going to dance the Firebird. I alternated in the part with Toumanova and my turn happened to fall that night. Mama Toumanova wasn't happy about this at all. Right at the beginning of the ballet the Firebird crosses the stage with three grands jetés, disappears, and crosses again on the other side. As I started the second set of jumps the right strap holding up my bodice snapped. The audience gasped. On the third set of jumps the left strap snapped and my bodice fell down, exposing my breasts. Bigger gasps. A very long pas de deux was next and no way to get off the stage. Paul Petroff was my partner that night, and he caught me, and held my costume up by holding me across the chest instead of around my waist. He whispered, "Oh my god, I'll hold it up, I'll hide you!"

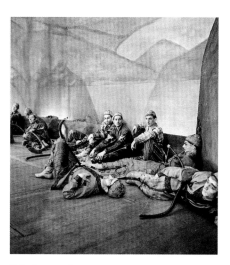

Scheherazade

The audience was goggle-eyed, waiting to see if it would happen again. It didn't, and the pas de deux ended to an ovation. Backstage, the costume was examined and the shoulder straps were discovered to have been cut almost all the way through. The attempted sabotage of my mother's opening night had entirely the opposite effect: it created a sensation and the newspapers were full of the story the next day. It was never proven who the culprit was.

Lubov Tchernicheva (the Ballet Russe de Monte Carlo ballet mistress) took me under her wing. She liked me and was wonderful in developing my artistic sense of how to do things — arms, expressions, make-up, she'd come and fix my hair for different ballets, trying out different styles to see which would suit the character and style best. She'd go through certain variations with me, talking, showing, getting more out of it. She taught me *Scheherazade,* which was her role, and I used a false nose with a little bump on it, which I also did for *Prodigal Son.* She taught me all the mime, and explained the gestures, the abandonment when the slave enters, the sexuality of it. She told me that in the last scene when Zobeide kills herself, she shouldn't be just a simple girl who got caught with her lover. Because she is the Queen, the favorite; she is proud. It's not begging for your life but asking with dignity, and then, when the King won't give that, all right, I'll kill myself. It's all those details that she taught me in between morning class and rehearsal.

SCHEHERAZADE
Choreography by Mikhail Fokine
Libretto by Fokine and Alexandre Benois
Set and costumes by Léon Bakst;
costumes executed by Karinska
(Diaghilev assigned Léon Bakst the credit in
the program because he said he needed to
give Bakst a credit for something, and Benois
already had *Le Pavillon d'Armide*)
Music by Rimsky-Korsakov
First performance Théâtre National de l'Opéra
Paris, June 4, 1910

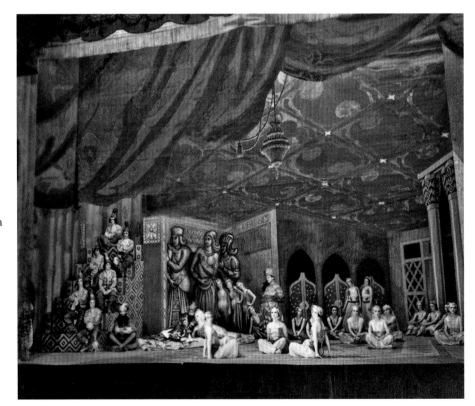

Baronova as Queen Zobeide in *Scheherazade*
Photo: NYPL Jerome Robbins Dance Division

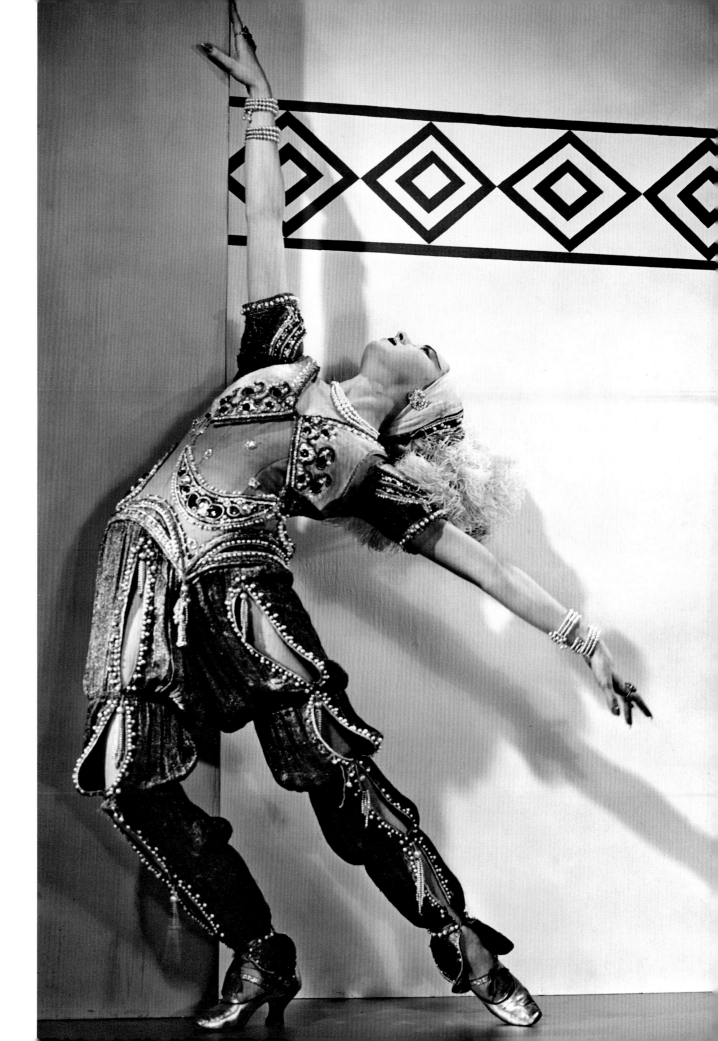

"Hurok had had enough of de Basil's wheeler-dealer style of doing business."

In New York, the company gave seventy-nine performances to full houses and glowing reviews. Lichine's ballets *Prodigal Son* and *Graduation Ball* were presented to great acclaim. Hurok's predictions of hard times for de Basil seemed incredible to my mother; the company was the most famous company in the world, clearly stronger than Massine's company and the newly formed Ballet Theatre. But Hurok had had enough of de Basil's wheeler-dealer style of doing business; since Gerry's departure as managing director, de Basil had been operating without any restraining influence. Hurok wanted to keep the lucrative business of ballet in America firmly in his control.

At the end of the New York season, de Basil's company departed for Canada, New England, and Mexico City before the start of a long South American tour. My mother remained in New York. Ten days later, Hurok asked my mother to join de Basil in Mexico City and Cuba as a guest artist, because Toumanova was not staying for the South American Tour but leaving to join Massine. My mother would dance *Aurora's Wedding, Scheherazade* and the Black Swan pas de deux from *Swan Lake*. Accompanied by Gerry, she rejoined the company in Mexico a month after she had said goodbye to them in New York, then flew to Havana while the rest of the company travelled by ship. On the ship the dancers threatened to strike in retaliation for cuts to their salaries. What they didn't know was that Hurok had withheld money he was contractually obligated to pay to de Basil, who was thus unable to pay his dancers.

MARCH 20, 1941
Teatro Auditorio – Havana, Cuba

When the company arrived in Havana, they were in a desperate situation. The dancers didn't have enough money to buy themselves food and were mistakenly blaming de Basil. What ensued was a power struggle between Hurok and de Basil for control of the Ballets Russes company. Gerry, as Hurok's representative, asked my mother to go on strike with nineteen of the other dancers and she refused. While Gerry was advising the striking dancers to hold firm, he was quietly negotiating with a few of them to join Ballet Theatre. My mother continued to perform, and de Basil filed a lawsuit charging Hurok and Gerry with conspiracy and sabotage. Hurok immediately instructed Gerry to leave Cuba and dispatched his assistant, Mae Froman, to ensure that his orders were followed. Returning to the hotel after taking a class, my mother discovered her suitcases already packed and a taxi waiting at the side door. She found herself with Gerry and Mae on the afternoon boat to Miami.

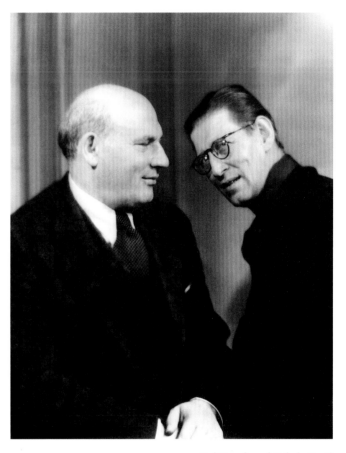

Sol Hurok and Col. de Basil
Photo: Maurice Goldberg /
NYPL Jerome Robbins Dance Division

By late spring, events had played out to Hurok's advantage. Ballet Theatre had opened for an inaugural three-week season on January 11, 1940, at Center Theatre in New York and played to great reviews and half-empty houses at a loss of over $200,000. The company then appeared with the Chicago Opera Company, providing dances for the opera season and getting the theatre for an additional eleven evenings to perform ballet. Ballet Theatre was contracted for a guaranteed weekly fee for the opera nights and a 50/50 share of the profits or losses for the ballet nights, which the opera refused to honor when fewer than 500 people a night showed up

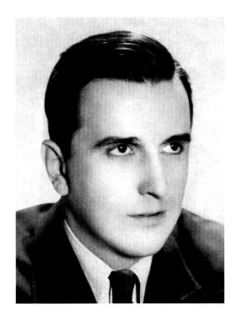

G. W. Sevastianov, Managing Director
Photo: NYPL Jerome Robbins Dance
Division

to see ballet. Ballet Theatre then performed for four weeks in February 1941 at the Majestic Theatre in New York, but sold only twenty percent of the tickets, and at the end of the last performance, Richard Pleasant had to announce to the company that they, and he, were dismissed. His great vision of an American ballet company had been undone by a lack of managerial skill. Hurok now made his move.

Gerry was proposed to the Ballet Theatre Board by Dolin and engaged by them to be the new managing director. He was highly experienced, knew all the dancers, was liked by the choreographers, and above all, he was a businessman who would bring order to the chaotic company finances and restore faith to its creditors and investors, principally Lucia Chase. Gerry knew that Ballet Theatre would have to appeal to a nationwide audience in order to remain in business. Apart from Dolin, none of the internationally famous dancers initially contacted by Pleasant had been available. Those managed by Hurok had been held back until he decided which company to support. In Hurok and Gerry's view, Ballet Theatre needed big names, star names to bring the audiences in, and in 1940, none of those names were American. They were Russian. The immense tours undertaken by de Basil's company in the 1930s had made Americans believe that great ballet had to be Russian.

Hurok arranged a dinner meeting for my mother with Lucia Chase, at Lucia's Park Avenue apartment. Gerry and Dolin went too. Lucia Chase told my mother that Fokine and Nijinska were going to start work on two new productions for Ballet Theatre. Her passionate commitment was apparent, and her straightforward, modest manner was right up my mother's alley. That dinner was the beginning of a great friendship between the two women and a new chapter for Ballet Theatre.

Irina Baronova and Lucia Chase

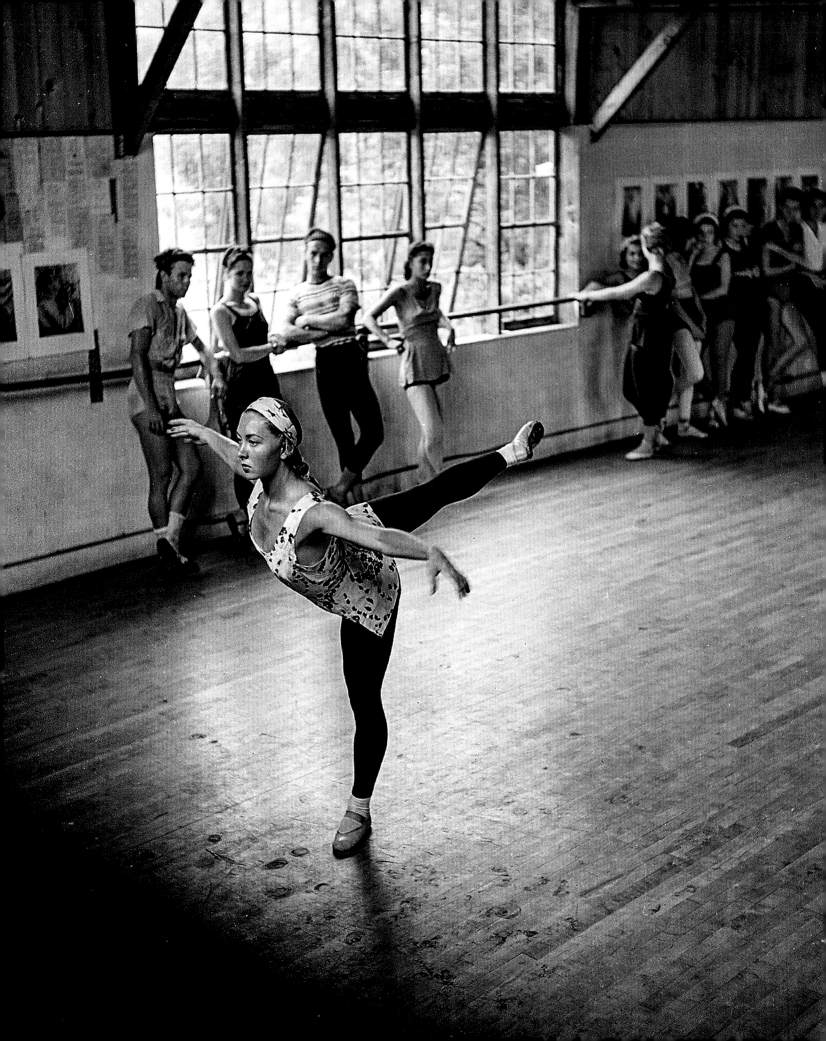

Ballet Theatre, 1941–1943
The Birth of American Ballet Theatre

Soon after the meeting with Lucia Chase, my mother left for Jacob's Pillow, in Massachusetts, to join Dolin and meet the rest of the Ballet Theatre company. Among the American and English dancers she didn't yet know were Karen Conrad, Jerome Robbins, Nora Kaye, Donald Saddler, Annabelle Lyon, Charles Dickson, and Hugh Laing. Among the former Ballet Russe dancers were Yura Skibine, Yurek Lazowsky, Ian Gibson, André Eglevsky, Sono Osato, Nina Popova, Rosella Hightower, and Simon Semenoff. Alicia Markova, who had come to be the company's other star ballerina, she knew well, and of course, Lucia Chase, who was the fourth-ranked female dancer after Baronova/Markova (or Markova/Baronova) and Karen Conrad. The choreographers were Dolin (*Princess Aurora, Capriccioso,* and *Pas de Quatre*), Vania Psota (*Slavonika*), Agnes de Mille (*Three Virgins and a Devil*), Antony Tudor (*Gala Performance* and *The Lilac Garden*), Mikhail Mordkin (*Voices of Spring*), Adolph Bolm (*Peter and the Wolf*), and Nijinska (*Beloved* and *La Fille Mal Gardée* a.k.a. *Naughty Lisette*). Fokine was making a new ballet, *Bluebeard,* for the company but preferred to work out his ideas at his home in Riverdale.

The compound of wooden buildings and rustic cabins, surrounded by forests and fields, had been rented from a dance company called Men Dancers for a few months, and there the Ballet Theatre company lived as a commune, sharing the chores and rehearsing.

Baronova, Markova, Kaye
Photo: Hans Knopf / Jacob's Pillow Archives

Photo: Hans Knopf / Jacob's Pillow Archives

Irina Baronova at rehearsal
Photo: Hans Knopf / Jacob's Pillow Archives

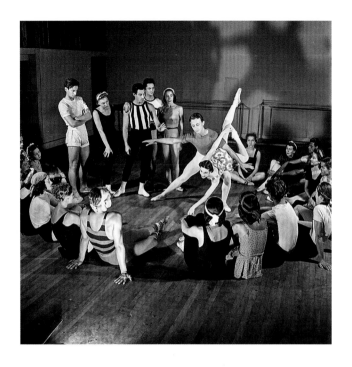

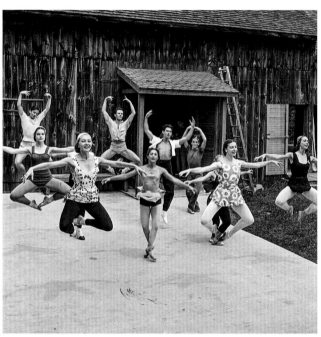

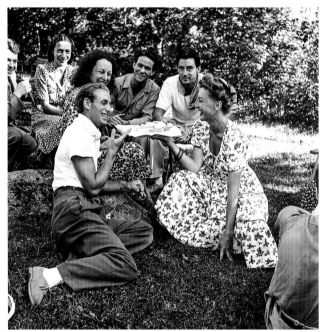

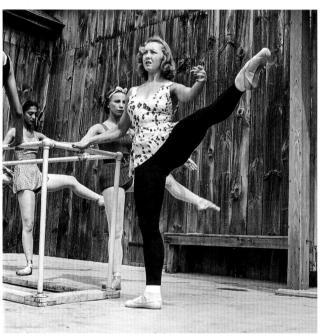

All photos: Hans Knopf / Jacob's Pillow Archives

"I found my American colleagues friendly, full of fun, and easy to live and work with."

Nijinska and her husband were staying at a hotel in the nearby town of Becket and were driven to work every day. Several dancers, including my mother, were billeted at Mother Derby's farmhouse, close enough for them to bicycle. At Mother Derby's, my mother had her own room, which she cleaned herself, a shared bathroom, and the use of a toilet in the garden shed.

From my mother's book:

There was much laughter and I found my American colleagues friendly, full of fun, and easy to live and work with. . . . [They] were vibrant, versatile and talented — some exceptionally so. . . . I had a lovely little room with chintz curtains and a view of the fields beyond.

Photo: Hans Knopf / Jacob's Pillow Archives

Photo: Hans Knopf / Jacob's Pillow Archives

My mother rehearsed with Nijinska on a new role, Lise, in a reworking of the old ballet *La Fille Mal Gardée*; with Dolin, learning his new version of the *Pas de Quatre* and working on a new ballet, *Princess Aurora,* a restoration of Petipa's choreography for parts of *Sleeping Beauty*; with Psota on a new ballet, *Slavonika*; with Mordkin on *Voices of Spring*, and with Antony Tudor on *Gala Performance*, in which he partnered her.

Photo: Hans Knopf / Jacob's Pillow Archives Photo: Hans Knopf / Jacob's Pillow Archives

Photo: Hans Knopf / Jacob's Pillow Archives

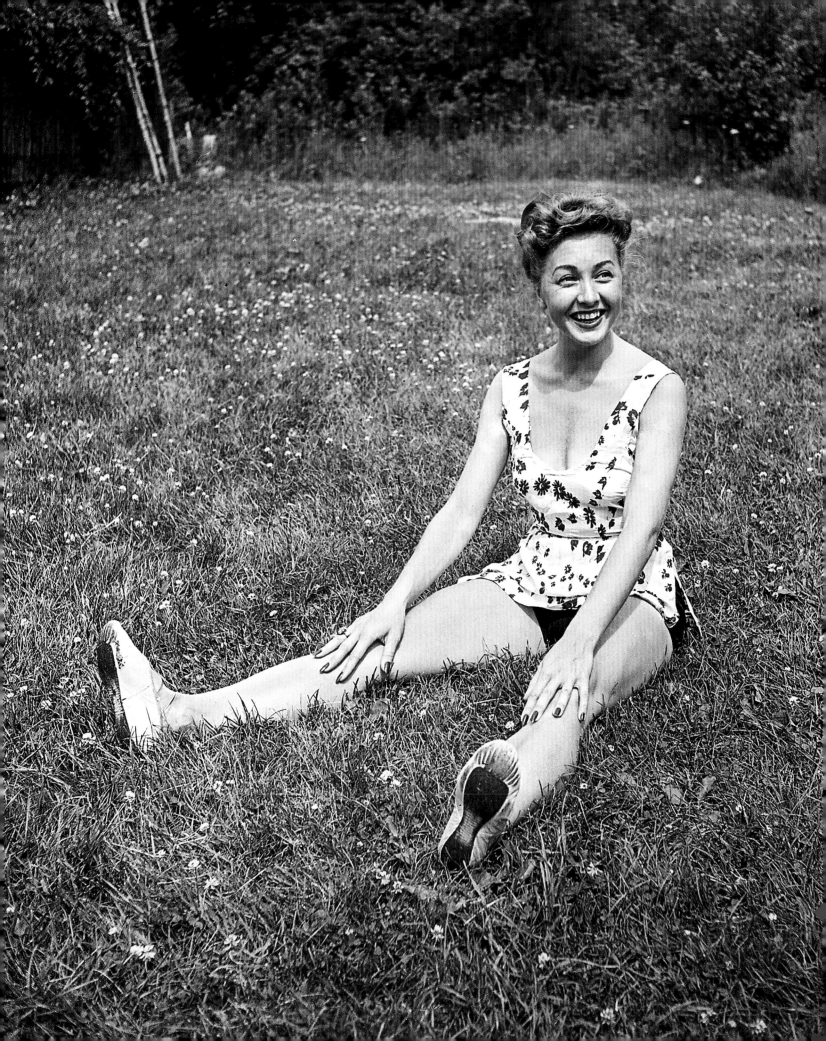

BALLET THEATRE

ARTISTS

Alicia Markova Irina Baronova Anton Dolin

Karen Conrad	Yura Lazowsky	Lucia Chase	Annabelle Lyon
George Skibine	Ian Gibson	Nora Kaye	Hugh Laing
Dimitri Romanoff	Simon Semenoff	Maria Karniloff	Rosella Hightower
Sono Osato	Jeanette Lauret	Jerome Robbins	Borislav Runanine

Miriam Golden, Nina Popova, Galina Razoumova, Muriel Bentley, Jean Hunt, Albia Kavan, Jean Davidson, Mimi Gomber, Roszika Sabo, Virginia Wilcox, Billie Wynn, Margaret Banks, Barbara Fallis Shirley Eckl

David Nillo, Nicolas Orloff, Charles Dickson, Donald Saddler, Richard Reed, John Kriza, Hubert Bland, Frank Hobi, Wallace Seibert, Alpheus Koon, Jr., John Duane, Duncan Nobl

CHOREOGRAPHERS

Michel Fokine Leonide Massine Anton Dolin Antony Tudor
Bronislava Nijinska Michail Mordkin Agnes Demille
Eugene Loring Simon Semenoff David Nillo

All ballets by Michel Fokine were staged under his personal supervision

Artistic collaboration by HENRY CLIFFORD

Ballet classes conducted by ANTONY TUDOR

Musical Director: Antal Dorati
Conductor: Mois Zlatin
Associate Conductor: Jos Ives Limantour
Regisseur General: Yura Lazowsky
Stage Manager: Serge Sokoloff

Managing Director: G. W. Sevastianov
Executive Manager: Charles Payne
Executive Assistant: Michel Delaroff
Executive Secretary: Jane Fish

Photos by FOTO-SEMO, Mexico City

WORLDWIDE MANAGEMENT: HUROK ATTRACTIONS, INC.
675 FIFTH AVENUE, NEW YORK, N. Y.

There was a court hearing in New York. De Basil was suing Hurok, Gerry, and Ballet Theatre. De Basil lost on a technicality: he wasn't there. He was still in South America trying to salvage his tour. Hurok had refused to pay any salaries for the last four performances in Havana or to pay for any transportation back to America, so de Basil's entire company was stranded in Cuba for five months (except for the dancers who had agreed to join Gerry and Ballet Theatre during their strike; they were brought back to New York). It took de Basil until August to get his company back to America under the new management of Fortune Gallo. He had an unsuccessful American tour and went back to South America, as my grandfather had predicted.

Gerry had hired a dozen dancers from the Russian companies. He had also hired de Basil's conductors, stage manager, and wardrobe mistress. Hurok got the theatre owners across America to book Ballet Theatre in place of de Basil's company, and the 1941–1942 season was in place.

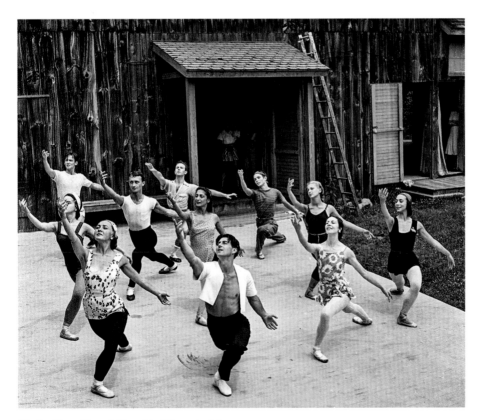

Photo: Hans Knopf / Jacob's Pillow Archives

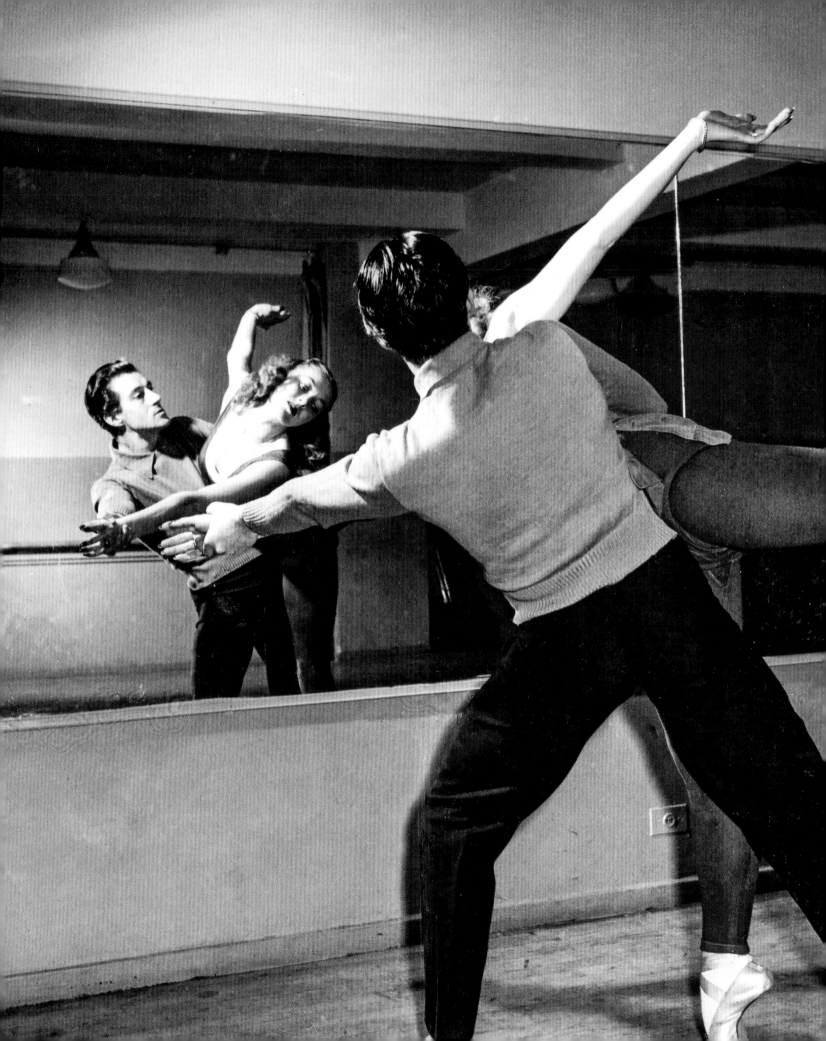

The whole company moved to New York for rehearsals August 25–October 14. It was a short rehearsal period for *Bluebeard*, which was a big production, but Fokine had worked with the conductor, Antal Dorati, before (Ballet Russe de Monte Carlo), they had chosen and timed the music together, and, as usual, the choreography was all in Fokine's head, down to the last detail, ready to show the dancers. He asked my mother to come to his home to discuss her role before rehearsals started.

From my mother's book:

Boulotte, Bluebeard's last wife, had to be high-spirited, mischievous and funny. In the pas de deux with Dolin there would be roughhousing; I would be thrown around, slide on the ground and roll to the footlights. "Pat and I will have such fun doing that!" I exclaimed, excitedly.
"Vera Petrovna [Madame Fokine] pointed out to me that you might get bruised."
Fokine's challenging look, so familiar to me by now, clearly asked, "Are you going to complain?"
"Bruised?" I hastened to reply, "You can break me into little pieces and I'll love it!"
He burst into laughter; for the first time ever, I saw and heard his laugh. Next day we started rehearsals.

On October 15, the Ballet Theatre company travelled to Mexico City, where they were going to present their new ballets before bringing them to New York. The Fokines went, too, and so did Marcel Vertes to supervise the lighting of his scenery designs for *Bluebeard.* Sol Hurok also went to oversee the start of this new venture.

Irina Baronova and Anton Dolin rehearsing *Bluebeard*

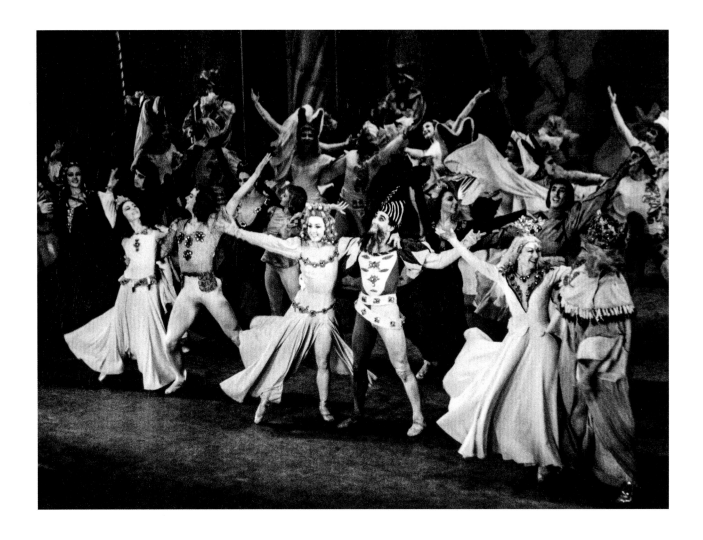

BLUEBEARD
Choreography by Mikhail Fokine
Libretto by Fokine based on the Offenbach opera *Barbe-Bleue*
Set and costumes by Marcel Vertes; costumes executed by Karinska
Music by Jacques Offenbach
First night Palacio de las Bellas Artes, Mexico City, October 27, 1941, and
44th St. Theatre, New York, November 12, 1941

Irina Baronova as Boulotte, with Anton Dolin as Baron Bluebeard, Antony Tudor as the King,
Lucia Chase as Queen Clementine, Yura Skibine as Prince Sapphire, Simon Semenoff as the
Alchemist Popolani, Alicia Markova as Fioretta, Yurek Lazowsky as Orlando, Jerome Robbins
as Alfonso, Donald Saddler as Armando, and Nora Kaye, Rosella Hightower, Jeanette Lauret,
Maria Karnilova, and Miriam Golden as the Wives of Bluebeard.

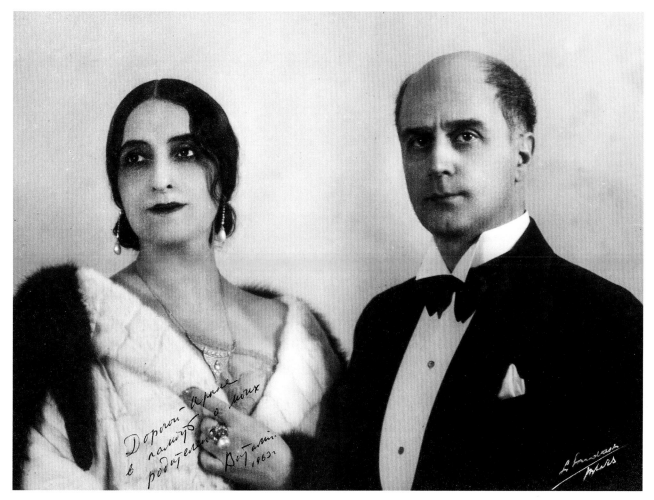

Vera Petrovna and Mikhail Fokine

Photo: Lazaro Sudak (Buenos Aires)

Bluebeard was a big production in the grand manner. It was a huge success with the audiences and the critics and was part of Ballet Theatre's repertoire for many years. Boulotte was one of Baronova's favorite roles.

From my mother's book:

When the curtain came down at the premiere of *Bluebeard* [the audience] went wild. The ballet was all we had hoped for and more. Fokine had produced, yet again, a superb work.

On one occasion in *Les Sylphides* Fokine didn't like what one of the other dancers was doing. She was making arm movements that were not his, putting something into it that wasn't Fokine; he walked out onto the stage, grabbed her by the hand, and pulled her into the wings in front of the whole audience. He wouldn't allow her to dance in the ballet again. It was a cruel thing to do in front of everybody. I suppose one must excuse a genius.

Les Sylphides Photo: André Kertész, 1941

When Dolin brought you on the stage, no matter how you felt, you might be sick, maybe you had a fever and felt ghastly, maybe you had a fight with your husband or lover and were in tears, he brought you on and he made you feel like you were the most beautiful woman on earth. You were the queen. He was a gentleman and a completely unselfish partner. The human body is not a machine, there are days when you feel better, there are days when you don't feel so good, sometimes your balance is perfect, other times, not so. Dolin, with one little tap of his finger would put you right. Never let you fall, never let the audience see that something's gone wrong. He was with you, helping you, for you. And, at the same time, putting over his own personality because he was a very good showman indeed.

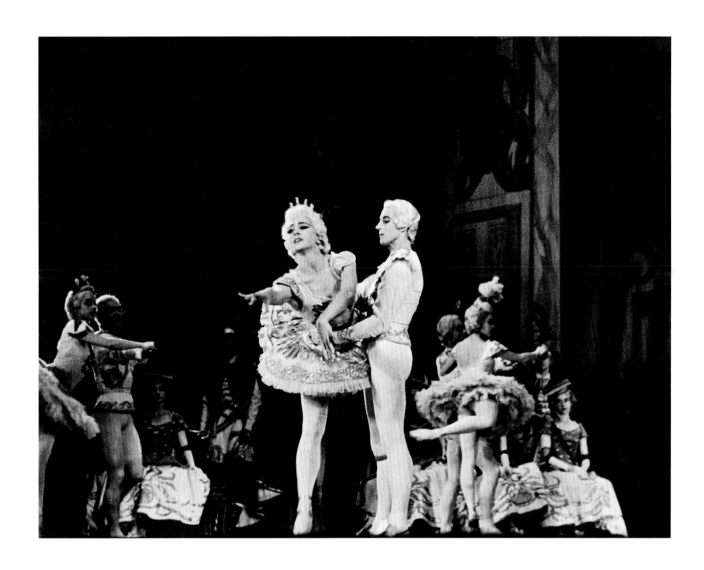

PRINCESS AURORA

Choreography by Anton Dolin after Petipa, with

Dance for Three Ivans by Bronislava Nijinska

Set and costumes by Mikhail Baronov after Léon Bakst; costumes executed by Karinska

First night Palacio de las Bellas Artes, Mexico City, October 23, 1941, and

44th St. Theatre, New York, November 26, 1941

Irina Baronova as Princess Aurora, with Anton Dolin as Prince Charming

Dolin made this ballet out of dances from the first and third acts of *Sleeping Beauty*. The Rose Adagio (Princess Aurora and the Four Princes) in particular was Petipa's original choreography, reinstated by Dolin based on the Diaghilev London production of 1921, which Dolin danced in.

SLAVONIKA

Choreography by Vania Psota

Libretto by Vania Psota

Set and costumes by Alvin Colt; costumes executed by Karinska

Music by Antonín Dvořák

First night Palacio de las Bellas Artes, Mexico City, October 24, 1941, and

44th St. Theatre, New York, November 21, 1941

Irina Baronova as Slavonika, with Yura Skibine as Jan

Photo: Maurice Seymour

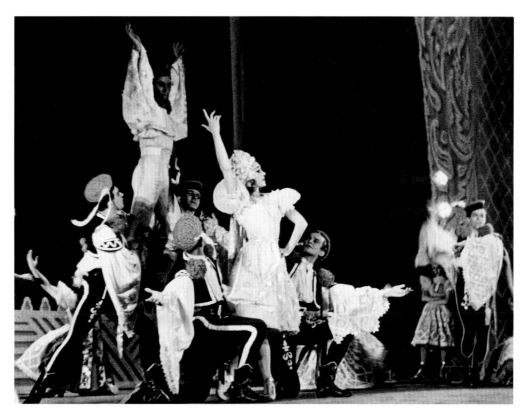

Irina Baronova warming up

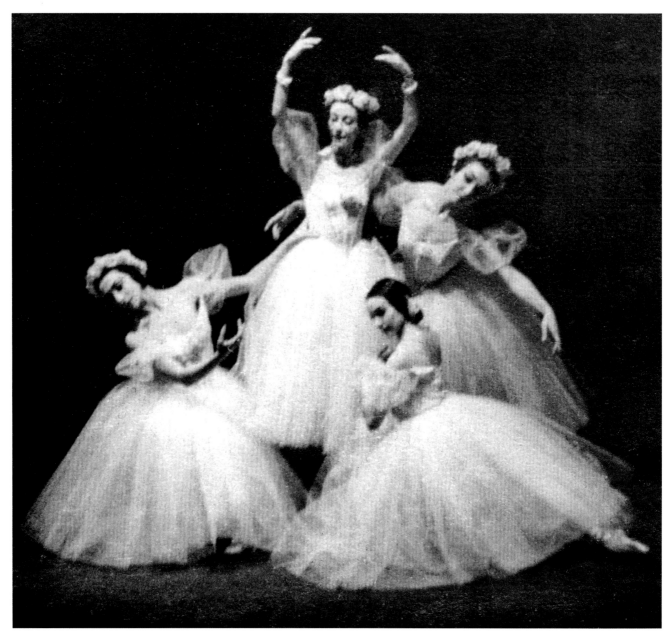

PAS DE QUATRE

Choreography by Anton Dolin

Costumes after 1845 *Pas de Quatre* lithograph by Chalon and Maguire

Music by Cesare Pugni transcribed by Leighton Lucas

First performance Her Majesty's Theatre, London, July 12, 1845, with choreography by Jules-Joseph Perrot

Ballet Theatre first night New York, February 16, 1941,

Palacio de las Bellas Artes, Mexico City, November 3, 1941, and

44th St. Theatre, New York, November 28, 1941

Alicia Markova as Marie Taglioni, Irina Baronova as Lucile Grahn, Nora Kaye as Carlotta Grisi, Annabelle Lyon as Fanny Cerrito

Taglioni, Grahn, Grisi, and Cerrito were the four ballerinas who danced this ballet on July 12, 1845. They gave their names to the roles in Dolin's version of the ballet.

Photo: NYPL Jerome Robbins Dance Division

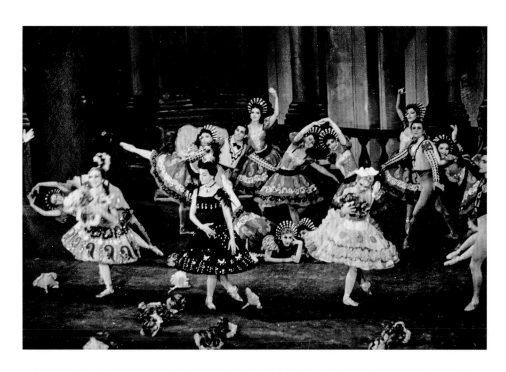

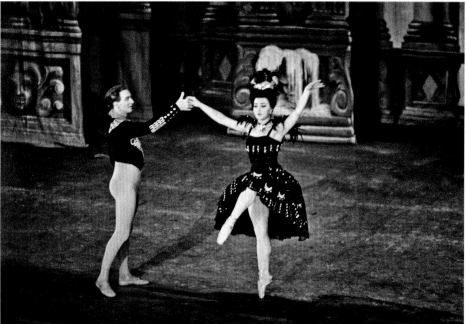

GALA PERFORMANCE

Choreography by Antony Tudor

Set and costumes by Nicolas de Molas; costumes executed by Karinska

Music by Sergei Prokofiev

First performance London Ballet, Toynbee Hall Theatre, London, December 5, 1938

First night Ballet Theatre, Majestic Theatre, New York, February 11, 1941,

Palacio de las Bellas Artes, Mexico, November 3, 1941, and

44th St. Theatre, New York, November 12, 1941

Irina Baronova as Italian Ballerina, with Antony Tudor as her Cavalier; Nora Kaye as Russian

Ballerina, with Hugh Laing as her Cavalier; and Karen Conrad as French Ballerina

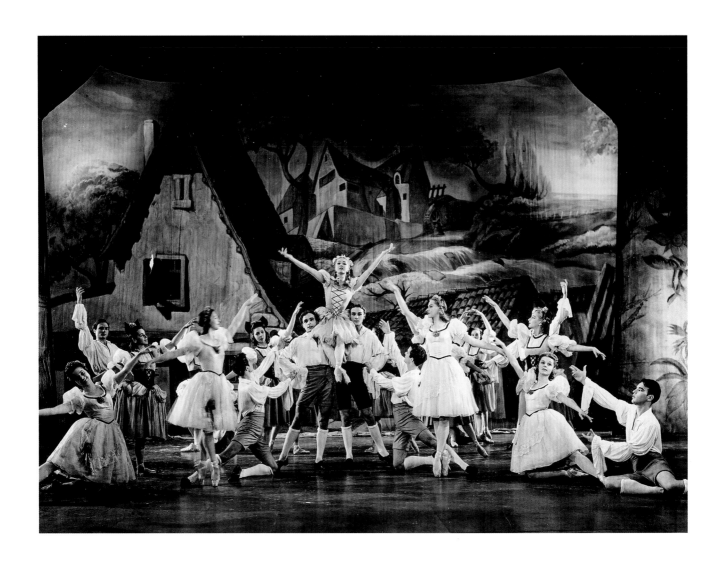

LA FILLE MAL GARDEE a.k.a. NAUGHTY LISETTE

Choreography by Bronislava Nijinska

Set and costumes by Serge Soudeikine

Music by Peter Ludwig Hertel

First night Ballet Theatre, Center Theatre, New York, January 29, 1940, with Patricia Bowman and Yurek Shabelevsky;

Palacio de las Bellas Artes, Mexico City, October 29, 1941; and Boston, January 24, 1942, with Irina Baronova as Lise,

and with Anton Dolin, Ian Gibson, and Simon Semenoff

My mother had her last rehearsals with Nijinska for *La Fille Mal Gardée* and began to get very nervous because she wanted to please her famously difficult choreographer so much. On opening night, as my mother was warming up on the dimly lit, empty stage, Nijinska appeared out of the shadows, gently stroked her cheek and made the sign of the cross over her.

From my mother's book:

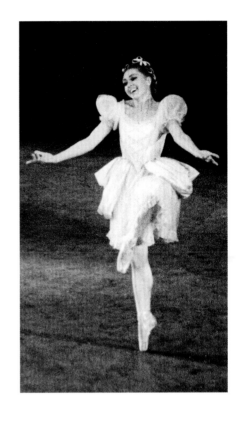

As I stood in the wings waiting for . . . my first entrance, an extraordinary feeling took hold of me, a sensation I had never experienced before . . . utter inner joy possessed my entire being . . . my dancing just happened all by itself . . . with an ease I'd never felt before. I was not pretending to be Lise; I was Lise . . . and hugely enjoying being alive. The curtain came down . . . the sound of tumultuous, prolonged applause gradually penetrated my consciousness. It was as if I had been rudely awoken from a dream. . . . For some reason I felt embarrassed and painfully shy about acknowledging the audience's ovation.

Our *Fille Mal Gardée* was endearingly funny. [Ian] Gibson as the half-wit fiancé was absolutely marvelous. [He played him as a] real moron with this colossal jump. Simon Semenoff was a marvelous mime. I suited the part with my round face and the pigtails . . . I looked like a 14-year-old. It was really comic . . . and touching. The pantomime scenes were the original Maryinsky version but the pas de deuxs and my variations were all pure Nijinska. It was warm and it was human.

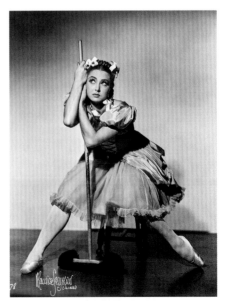

Interesting, don't you think? The choreography my mother describes as endearing, warm, touching, human, was made by a woman who was sarcastic, cutting, difficult, and intimidating, who only touched dancers wearing white gloves. And yet, she stroked my mother's cheek.

Photo: Maurice Seymour

Irina with news reporter

Irina Baronova

Irina Baronova and Lucia Chase

THE BALLET THEATRE
FIRST TRANSCONTINENTAL TOUR, 1941 – 1942

Jan 13	Baltimore
14–15	Washington D.C.
16	Princeton
17	New Rochelle
19	New Haven
20	Springfield
21–24	Boston
26	Providence
27	Travel to Ottawa
28	Ottawa
29	Three Rivers
30	Quebec
31	OFF
Feb 1	Travel to Montreal
2	OFF
3–8	Montreal
8	After performance travel to Toronto
9–14	Toronto
15	OFF
16	Travel to Hamilton
17	London
18	Travel to Montreal
19	OFF
20	Montreal
20	After performance travel to Toronto
21	Toronto
22	Travel to Chicago
23–25	Rehearse in Chicago
24	Milwaukee
Feb 26–Mar 7	Chicago
Mar 8–22	OFF
Mar 23–Apr 4	Rehearse *Petrouchka*, New York
Apr 6–26	Metropolitan Opera House, New York
Apr 27–May 1	OFF
May 2	Travel to Mexico
May 8–11	Rehearse Mexico City
May 11–22	Mexico City
May 23–28	OFF
May 29–Jun 6	Mexico City
Jun 7–10	OFF
Jun 11–Aug 27	Mexico City

The *Novedades* critic wrote, "*Swan Lake* opened the new season with a new Baronova in sensitive non-pyrotechnical perfection."

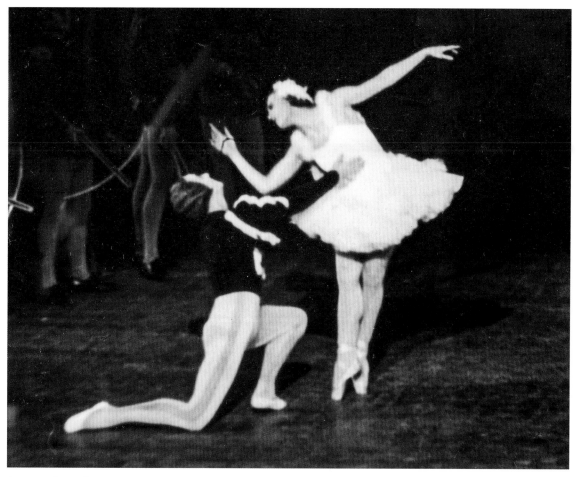

Anton Dolin and Irina Baronova

Photo: Hugh P. Hall / National Library of Australia

MEXICO CITY

The Mexico City season opened with *Swan Lake, Bluebeard, La Fille Mal Gardée*, and *Slavonika.* The *Novedades* critic wrote "*Swan Lake* opened the new season with a new Baronova in sensitive non-pyrotechnical perfection. Dolin partnered as no one else in the world can partner."

A Mexican producer, Manuel Reachi, approached Lucia Chase and Gerry about my mother and Dolin dancing in a film with the entire Ballet Theatre company. In addition, my mother would play the leading acting role. My mother was initially reluctant, after her Hollywood experience. It was another melodrama and to be shot in Spanish, but everyone else was interested, so because it involved the whole company and she would be working with Dolin, my mother agreed. The ballet sequences were long and complete, and at the time, a rare document of dance on film made to a professional standard. The film was made in Mexico City while Ballet Theatre was performing at the Palacio de las Bellas Artes. The ballet scenes in the film were shot in the theatre using the full Ballet Theatre company with my mother and Dolin in the *Princess Aurora* pas de deux, the *Swan Lake* pas de deux, and some of *La Fille Mal Gardée*. My mother filmed the acting scenes on location during the day and performed with Ballet Theatre at night. Fokine agreed to accommodate her schedule by rehearsing *Helen of Troy* with her from 5 PM to 7 PM every day before her evening performance. Not surprisingly, she was exhausted every morning after three and a half hours sleep, but this time the experience of making a film was a happy one.

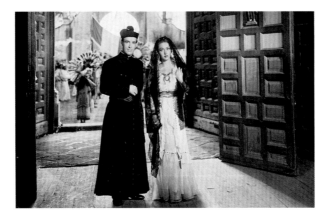

YOLANDA a.k.a. TOAST TO LOVE
Promesa Films, Mexico, 1942
Produced by Manuel Reachi
Directed by Arman Chelieu
Starring David Silva, Irina Baronova, Miguel Arenas

Yolanda Petrova, a Russian ballerina on tour in Mexico, agrees to marry diplomat Don Carlos if he will save her parents from being sent to Siberia, even though she is in love with Julio, a military cadet.

Massine arrived to work on a new ballet, *Aleko* (for Toumanova and Skibine) with his new wife, Tatiana Orlova, and their baby. Marc Chagall came to Mexico City to work on the scenic designs for *Aleko,* and my grandfather arrived to assist Chagall with their execution. Fokine arrived with his wife, Vera, to work on *Helen of Troy* (for my mother and Dolin) in a noticeably mellow mood. While sightseeing in Cuernavaca and Taxco with Lucia Chase and my mother, he bought an outsize sombrero, which he proceeded to wear for the rest of the day. The whole group stayed in a small hotel that had once been a private house.

Mikhail Baronov working with
Marc Chagall on set designs for *Aleko*

Marc Chagall working on *Aleko* designs

Fokine in his new sombrero

Lucia, Irina, Vera, and Fokine

Oh, [Fokine] made me sweat in *Helen of Troy.* Unless you are left-handed, everyone always does turns to the right. Suddenly, in a very difficult technical variation he made everything on the left, all the pirouettes, everything. I asked him if I could please do it on the right and he said to me, "You're supposed to be the ballerina in this company; a ballerina should be able to turn to the left as well as the right." So, in our breaks I stayed in the studio practicing on the left until I got it. It was very difficult, but I was in such a rage that I was going to do it if it killed me. At the dress rehearsal, with the orchestra on the stage, the third act not quite finished because he was still working on it, he turned to me and said, "You can do the whole thing on the right." I replied, "No, no, no, no. Now that we worked it on the left I'm going to do it on the left." And he said, "Your choice." I don't know why he did that; it's hard to say. He would never say, well done, or, I'm pleased with you. It was taken for granted that you should be good; otherwise Fokine would not work with you.

Fokine got very sick in Mexico City and his wife wouldn't let the Mexican doctors touch him, and made him get on a train for New York. Lucia Chase, Gerry, and I went to see them off at the station. He was ill and looked awful. Lucia kissed him and said goodbye, then Gerry, then Fokine said to me, "One moment, I want to say something to you alone. Let them go." So I stayed behind, and he said, "I just want you to know I loved very much working with you." I burst into tears, and did the unthinkable: I hugged him. I will treasure his words forever.

Fokine had developed a thrombosis in his left leg. Although he was in pain, he continued with rehearsals for *Helen of Troy,* having himself carried up the flight of stairs to the studio. His wife insisted that they take a train to New York to see his own doctor. The journey took three days. His doctor immediately sent him to the hospital, where he died of pleurisy and double pneumonia on August 22. When the telegram arrived in Mexico City the same day, my mother was devastated. Fokine had not been able to finish choreographing and polishing *Helen of Troy.* In an attempt to salvage the work, Lazowsky completed the finale, but the ballet was obviously unfinished, and out of respect for Fokine it was retired. To salvage the set and costumes, David Lichine was asked to rechoreograph the ballet, which he did, in a much lighter style, and it opened successfully in New York.

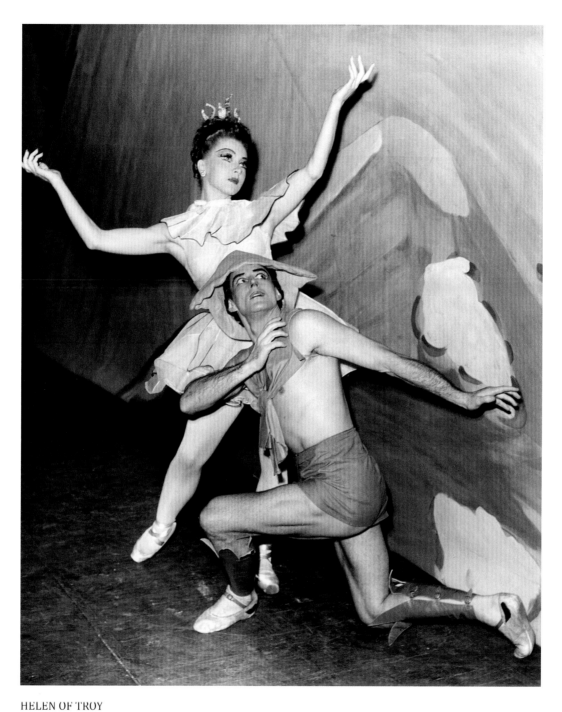

HELEN OF TROY

Choreography by Mikhail Fokine with finale completed by Yurek Lazowsky

Set and costumes by Marcel Vertes; costumes executed by Karinska

First night Palacio de las Bellas Artes, Mexico City, August 27, 1942

Irina Baronova as Helen of Troy, with Anton Dolin as Paris, Simon Semenoff as Calchus,

Lucia Chase as Pallas Athene, Nora Kaye as Aphrodite, Rosella Hightower as Hera, Ian Gibson as

Hermes, Donald Saddler as Menelaus/Zeus, and Jerome Robbins as Hermes

Photo: NYPL Jerome Robbins Dance Division

Grandpa's sketches for the Ballet Theatre production of *Petrouchka*

SEPTEMBER 1 – OCTOBER 31
1942 – 1943 SEASON AT THE METROPOLITAN OPERA HOUSE

Lucia Chase wanted to use the Benois designs for a Ballet Theatre production of *Petrouchka*. At Gerry's suggestion, she asked my grandfather to go to the Avery Memorial Museum in Hartford, where the designs were on exhibition, and copy them. Among all the photographs and letters in my room was a portfolio, and inside it were many costume and scenery designs, among them Grandpa's sketches for the Ballet Theatre production of *Petrouchka.*

Massine returned to Ballet Theatre in New York to stage his *Boutique Fantasque.* My mother had danced in this ballet before, so the rehearsals were familiar and she enjoyed watching Massine at work. My grandparents drove in to New York from Long Island regularly, and often Grandpa would touch his chest, but every time my mother asked him if something was the matter, he said he was fine.

"John Martin wrote in *The New York Times:*
'... Irina Baronova dancing this season with a breathtaking command of her medium.' "

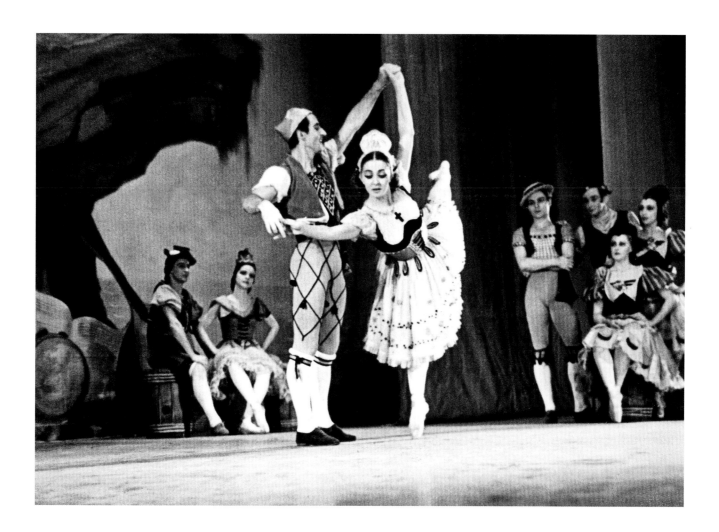

COPPELIA

Choreography by Simon Semenoff after Lev Ivanov and Louis Merante

Libretto by Charles Nuitter and Arthur Saint-Léon after *Les Contes d'Hoffmann*

Set and costumes by Roberto Montenegro

Music by Léo Delibes

First night Palacio de las Bellas Artes, Mexico City, September 1, 1942, and

Metropolitan Opera House, New York, October 22, 1942

Irina Baronova as Swanhilda with Anton Dolin as Franz, and Simon Semenoff as Dr. Coppelius

THE BALLET THEATRE
SECOND TRANSCONTINENTAL TOUR 1942 – 1943

Nov 5	Richmond	16	New Orleans
6	Durham	17	Columbus
7	Augusta	20	Little Rock
9	Raleigh	30	Evansville
11	Newark	31	St. Louis
12	Philadelphia	1943 Jan 4	Omaha
16	Baltimore		Premiere *Boutique Fantasque*
18	Washington D.C.	5	Burlington
20	Cleveland	6	Milwaukee
23	E. Lansing	7	St. Cloud
25	Kalamazoo	8	Minneapolis
26	Battle Creek	11	Aberdeen
28	Detroit	12	Jamestown
30	Columbus	13	Bismarck
Dec 1	Indianapolis	16	Portland
2	Bloomington	18	Victoria, British Columbia
3	Kentucky	23	Seattle
4	Cincinnati	25	Oakland
7	Knoxville	26	San Francisco
8	Atlanta	Feb 1	San Jose
9	Savannah	2	Sacramento
10	Jacksonville	4	Pasadena
11	St. Petersburg	5	Los Angeles
12	Miami	7	San Diego
14	Birmingham	8 –15	Los Angeles

The touring conditions were even worse than the Ballet Russe tours in that there was no private train. The company went from city to city on buses and overcrowded trains, carrying their luggage with them. They slept where they could, wedged together on a bus seat or stretched out on top of their luggage waiting for the bus to arrive. One dancer even slept in the overhead luggage rack. The dancers travelled with their technical crew, their orchestra and conductor, and their wardrobe ladies, and the ballerinas got no special treatment. America was fighting in the war and soldiers were everywhere. Transport was disrupted; many times the company arrived at a theatre after the performance was supposed to start, and Dolin would go onstage in his dressing gown to beg the audience to be patient while the dancers scrambled into their costumes and makeup.

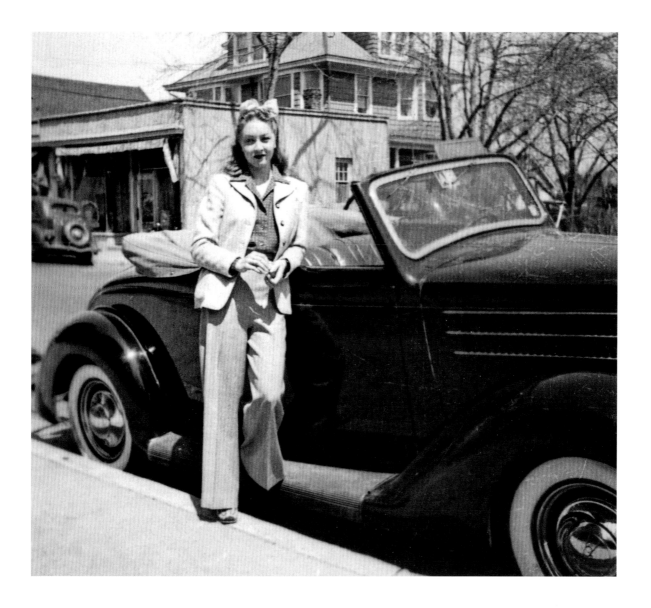

My mother and Gerry had been married for eight years, though the marriage had been gradually coming to an end, and now they decided to separate. They managed to continue working together in the same company because they didn't see that much of each other, once the touring started. Dolin and Lucia Chase were sympathetic to both parties and did everything they could to help keep things friendly, for the company was dependent on both Gerry and my mother at this point.

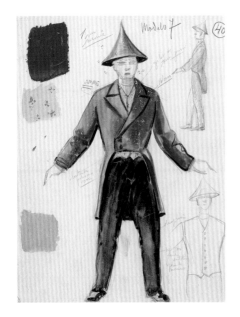

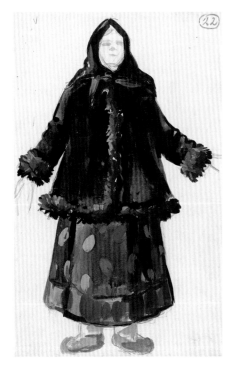

Grandpa's sketches for the Ballet Theatre production of *Petrouchka*

On February 14, 1943, Gerry received a telephone call while on tour in Los Angeles that Grandpa had had a serious heart attack and was in a hospital in New York. He immediately told my mother, who danced the first ballet on the program that night before Gerry drove her to the airport. She was met by a friend of her parents who took her directly to the hospital. Grandpa's face was ashen; the first thing he asked when he saw her was how long could she stay. In that moment, she knew that she couldn't leave until he was well again. Alone with Granny, she reassured her mother that there would be money to live on until her father got better; she had accumulated some savings and even had a bank account and checkbook. She would see them through. February 17 she sent a telegram to Gerry telling him that she wasn't coming back. She moved into her bedroom in the Long Island cottage, and shortly afterwards Grandpa came home from the hospital. When he found out that my mother was giving them money, he was upset, but Granny persuaded him to be sensible and accept it, and really, he didn't have much choice. He started going for short walks and painting again, and my mother, distressed and exhausted, decided to take her own much-needed rest.

In 1949, with American ballet firmly established, Balanchine was offered the City Center theatre and his own company, the Ballet Society company renamed New York City Ballet. For the next twenty-eight years all his costumes were made by Karinska.

René Blum had parted company with de Basil in 1935 over de Basil's adding his name to the Ballet Russe de Monte Carlo which Blum had founded. There had also been disagreements over de Basil's style of doing business. On December 12, 1941, Blum was arrested at his home in Paris and held in Compiègne. From there he was transferred to the Drancy internment camp. On September 23, 1942, he was put on a train with eighty other Jewish intellectuals and sent to Auschwitz, where he was killed. Without him, the Ballet Russe de Monte Carlo would not have come into existence and his death was a tragic loss for the literary, opera, and ballet worlds and the cultural life of France.

BALLET THEATRE
ADDITIONAL PERFORMANCES, 1941 – 1943

VOICES OF SPRING
Choreography by Mikhail Mordkin
Libretto by Mordkin
Set and costumes by Lee Simonson
Music by Johann Strauss arranged by Mois Zlatkin
First performance Mordkin Ballet, Alvin Theatre, New York, November 10, 1938
First night for Irina Baronova, Palacio de las Bellas Artes, Mexico City, October 31, 1941
Irina Baronova as the Flirt

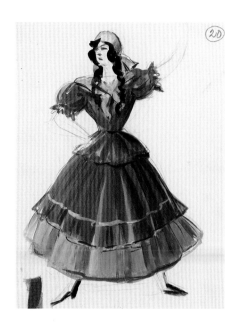

PETROUCHKA
Choreography by Mikhail Fokine
Libretto by Alexandre Benois and Igor Stravinsky
Set and costumes by Alexandre Benois courtesy of Avery Memorial Museum, Hartford
Music by Igor Stravinsky
First night June 13, 1911
First night Palacio de las Bellas Artes, Mexico City, August 27, 1942, and
Metropolitan Opera House, New York, October 8, 1942
Irina Baronova as the Ballerina, with Yurek Lazowsky/Jerome Robbins as Petrouchka,
David Nilo as the Blackamoor, Simon Semenoff as the Charlatan

HELEN OF TROY
Choreography by David Lichine
Libretto by Lichine and Antal Dorati
Set and costumes by Marcel Vertes
First night Metropolitan Opera House, New York, September 10, 1942
Irina Baronova as Helen of Troy, with Anton Dolin as Paris
The new, shorter version of the ballet, choreographed by David Lichine, opened during Ballet
Theatre's first season at the Metropolitan Opera House, which established the new company's status and importance.

BOUTIQUE FANTASQUE
Choreography by Léonide Massine
Set and costumes by Andre Derain
Music by Giacomo Rossini
First performance by Diaghilev's Ballets Russes, Alhambra Theatre, London
June 5, 1919
First night Central High School Auditorium, Omaha, January 4, 1943
Irina Baronova as Can Can Doll with Léonide Massine
Baronova had danced in this ballet in 1934 at Covent Garden but had taken a different role
then, the Tarantella. Danilova had danced the Can Can Doll in 1934, but Baronova had danced
her part a couple of times when she was unwell, so the role was familiar. The ballet was
premiered in Omaha, on tour.

Grandpa's sketches for the Ballet Theatre
production of *Petrouchka*

Massine's Highlights of the Ballet Russe, 1945

Broadway and London, 1946–1949

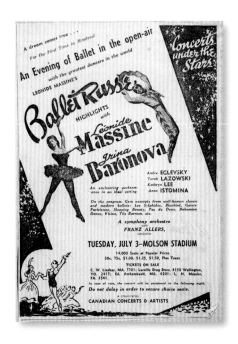

Grandpa was slowly getting better. Every day my mother did long barre exercises on the back porch to stay in shape and thought about what she should do next, as her savings were running out.

Dolin telephoned every week, and one day told my mother that Gerry had gotten his draft papers. He had taken them to the U.S. Army Recruiting Center to explain that it was a mistake, that he was actually three years older than the birthdate on his new American passport, that he was, in actual fact, forty-one years old, not thirty-seven and thus too old to be drafted. The army guy was less obliging than the Yugoslavian Consulate in Sydney. He told Gerry that because he had sworn that all the information in his passport was correct, he now had a choice: join the U.S. Army or go to prison for perjury. On May 18, Gerry joined the Russian Section of Army Intelligence as a translator.

Massine called: he wanted to come over and talk to my mother about a new project. He wanted to come right away; was she free tomorrow? He arrived with a huge bottle of perfume. He was starting a small company. André Eglevsky and Yurek Lazowsky had agreed to join him and Rosella Hightower, Kathryn Lee, and Avdotia Istomina. He had hired a twenty-piece orchestra to tour with them, and their program would consist of short extracts from a classical repertoire, his own ballets, and some new pieces he would choreograph. The company would be called Ballet Russe Highlights and would be managed by Fortune Gallo. They would open in New York and rehearse in the studio adjoining his house in Long Island, starting next week. Would she join him? It seemed too good to be true.

My mother's two-year contract with Hurok had expired during the past months and, unsure of what she wanted to do, she hadn't renewed it. This both made it easier to make an agreement with another management and meant that she had no one to negotiate her terms with Massine. Needing the money for her parents, my mother knew that she had to find an agent quickly, as she herself would accept anything Massine offered, which wasn't likely to be much. She remembered the name of the agent who had negotiated her contract for the MGM movie, Jules Ziegler, and looked him up in the phone book. He was surprised to hear from her but delighted to represent her. She told him why she needed the money and asked him to get her a fair salary. "Don't worry," he told her, "you've come to the right place!" At the end of the day Ziegler called to say the deal was done.

Anna Istomina, Irina Baronova, Léonide Massine, and Kathryn Lee

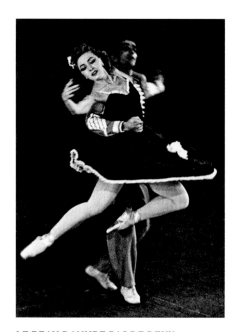

LE BEAU DANUBE PAS DE DEUX
Choreography by Léonide Massine
Irina Baronova with Léonide Massine

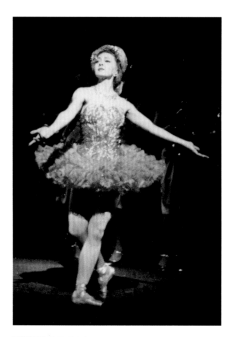

BLUEBIRD PAS DE DEUX
From *Aurora's Wedding*
Choreography by Marius Petipa with
additions by Bronislava Nijinska

FIRST TOUR: NOVEMBER 13, 1944 – MAY 18, 1945
48 cities in six months: Connecticut, New Hampshire, Massachusetts, Canada, Michigan, Indiana, Missouri, Oklahoma, Texas, Arizona, California, Washington, Iowa, Illinois, Georgia, Ohio, Kentucky, Tennessee, South Carolina, North Carolina, Virginia, New Jersey, and Maryland.

SECOND TOUR: JUNE 28, 1945 – JULY 28, 1945
25 performances in ten cities, including the Lewisohn Stadium in New York where 25,000 people attended two performances, and the Robin Hood Dell Stadium in Philadelphia where 15,000 people attended one performance.

These itineraries demonstrate to me how the Ballets Russes de Monte Carlo tours had transformed the state of ballet in America. Back in 1933, the manager of the theatre in New York had remarked to de Basil that he had never seen a ballet, and now in 1944 the names of Massine and Baronova were attracting rock-concert-sized audiences across the continent.

From my mother's book:

The program [Massine] devised was excellent in its variety; the new numbers were beautiful and effective. I loved the Russian peasant number he staged for Lazowsky and myself to the tune of the popular song, "Yablotchko" . . . it was funny, gay and fast, a show-stopper. All in all, there were twenty numbers, with only one intermission; we changed backstage at breakneck speed!"

The tour was a success . . . [Massine] decided to chance another tour. In the last ten days before the end of the second tour, my ankles and insteps started to swell up, as if full of water. I could hardly tie the ribbons of my toe shoes around my ankles, which looked awful . . . "Hold on till the end, don't let me down! Just a few more days!" Massine urged me. As the last curtain came down, he looked at my deformed ankles and shook his head, saying, "As soon as you get home, go to your doctor."

TOUR PERFORMANCES

SPECTRE DE LA ROSE PAS DE DEUX
Choreography by Mikhail Fokine
Irina Baronova with Léonide Massine

SAILOR DANCE
Choreography by Yurek Lazowsky
Irina Baronova with Léonide Massine

IGROUCHKA (RUSSIAN DOLLS)
Choreography after Mikhail Fokine
Music by Nikolai Rimsky-Korsakov
Irina Baronova with André Eglevsky

RUSSIAN DANCE
Choreography by Léonide Massine
To Russian folksong *Yablotchko* (*Little Apple*)
Irina Baronova with Yurek Lazowsky

GAITE PARISIENNE PAS DE DEUX
Choreography by Léonide Massine
Libretto by Count Etienne de Beaumont
Set and costumes by
Count Etienne de Beaumont
Music by Jacques Offenbach
Irina Baronova with Joey Harris a.k.a.
Ivan Demidoff

POLISH MAZURKA
Choreography by Yurek Lazowsky
Music by Leopold Lewandowski
Costumes by Mikhail Baronov
Irina Baronova with Léonide Massine

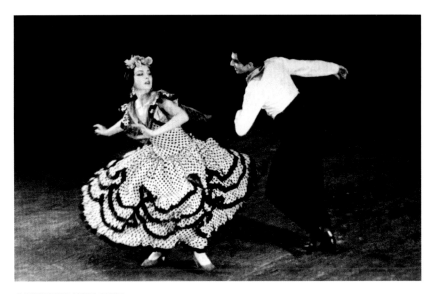

CAPRICCIO ESPAGNOL
Choreography by Léonide Massine, with Argentinita
Libretto by Massine
Set and costumes by Mariano Andreu
(originally for 1937 Fokine ballet *Jota Aragonesa*)
Music by Nikolai Rimsky-Korsakov
Irina Baronova with Léonide Massine

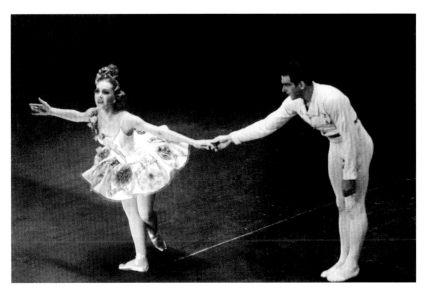

THE NUTCRACKER PAS DE DEUX
Choreography by Marius Petipa and Lev Ivanov
Libretto adapted from E. T. A. Hoffmann's *The Nutcracker and the Mouse King*
Music by Pyotr Ilyich Tchaikovsky
First night Maryinsky Theatre, St. Petersburg, December 18, 1892
Irina Baronova with André Eglevsky

Grandpa called his doctor. There were tests, cardiograms . . . the diagnosis was an enlarged and strained heart. Six months of total rest and no exercise of any kind. To my mother it seemed a death sentence; she was twenty-six. My grandparents were shocked. Granny kept saying it was all de Basil's fault, exploiting and overworking her. My mother kept defending him; there were lots of arguments. Now it was Grandpa's turn to look after my mother, cheering her up when she couldn't stop crying. Thanks to Ziegler, they had money to live on, but my mother decided she had to make sure, while she was still able to work, that her parents would have enough to retire on. She couldn't allow them to suffer the hardships they had endured as refugees ever again.

My mother called Ziegler and made an appointment to see him. She took a train to New York and went to his office to explain to him what was going on. She begged him not to tell anyone that she had health problems. His response was to take her to lunch at Sardi's and propose that she do theatre.

My mother signed on to do a musical for a year at $2,000 a week (a huge sum in 1946, when a soloist in a ballet company was making a union wage of $45 a week and my mother's Ballet Theatre salary had been $150 a week for the first year and $300 a week after that). Her costumes were to be made by Madame Karinska. Ziegler found her an apartment at 23 East 69th and a dresser named Beatrice Winters. He took care of everything. My mother didn't know whether to laugh or cry, and my grandparents were completely at a loss.

FOLLOW THE GIRLS
Shubert Theatre, Broadway 1946
Gertrude Niesen, Frank Parker,
Irina Baronova, and Jackie Gleason

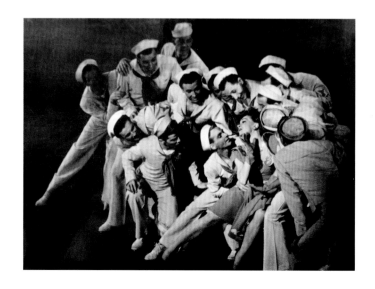

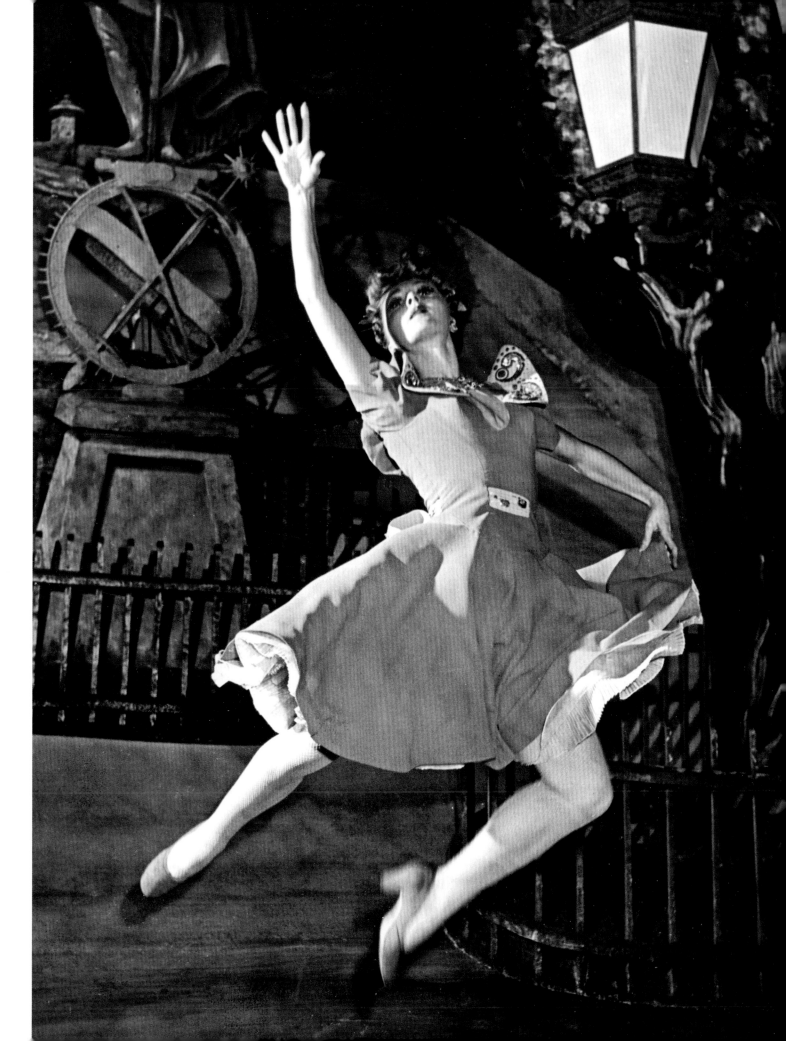

During the run of the show, my mother went several times to visit Mitchel Field Air Force Hospital to talk to the injured, traumatized men, to read to them, and to help wherever she could. Enlisting as a volunteer made her feel that she was doing something to support the boys. When the year's contract ended, my mother had saved enough not to have to sign on for another year and, after her last performance, was taken out to a late dinner by the director, producers, and Zeigler. Next morning she woke up to loud noises outside her window. Horns, shouts . . . peace had been declared. The War in Europe had finally ended, VE day, May 8, 1945. It had lasted six years and upended everybody's lives.

Irina Baronova with a U.S. Army officer

My mother's heart condition had improved and she now had some money saved to look after her parents. As she was deciding what to do next, a telegram arrived asking her to play the lead opposite Massine in a play based on a book based on a ballet company. It was a murder-mystery called *Bullet in the Ballet*. It was to open in London after an English tour. Massine wanted to do it, so my mother said yes. When she arrived in London, she was shocked by the streets in ruins, the bombed houses, the destruction. There was rationing, a black market. The British were getting on with it, but everything had changed.

BULLET IN THE BALLET (UK) 1946
Directed by Charles Goldner
Léonide Massine, Irina Baronova,
and Barry Morse

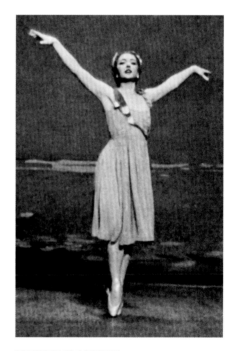

REVERIE CLASSIQUE
Scene in *Bullet in the Ballet*
Choreographed by Léonide Massine
Music by Frédéric Chopin

My mother and Gerry hadn't seen one another during the years he had been with the army in Europe. When he came back, they tried to give the marriage another chance, but it didn't work. In 1946, they parted company for good, and Gerry left America, went back to Europe, and never worked in the ballet world again.

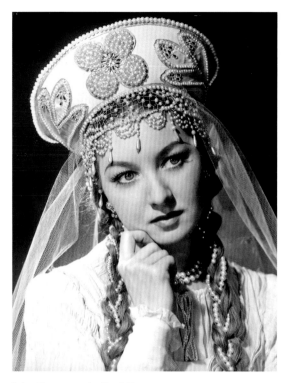
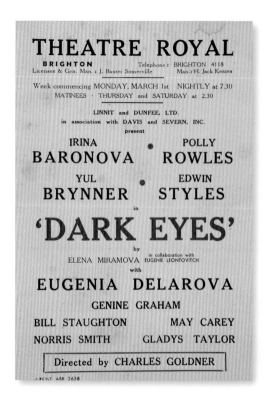

Irina Baronova in *Dark Eyes*

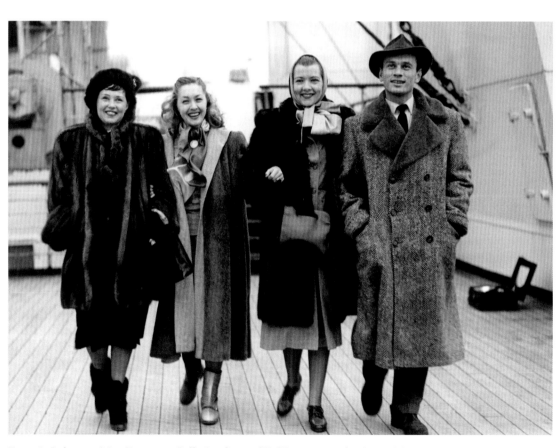

Eugenia Delarova, Irina Baronova, Polly Rowles, and Yul Brynner on the *Queen Mary*, January 2, 1948

Photo: Topfoto / The Image Works

After the play with Massine, my mother did another play in America which transferred to England, *Dark Eyes*, with Uta Hagen on the East Coast and with Polly Rowles and Yul Brynner in London. The third and last film my mother made was an English one. She was in London, packing to return to New York when she got a call from Sir Michael Balcon, the head of Ealing Studios, who asked if she would be interested in doing a film he was producing. While my mother went to spend Christmas with her parents on Long Island, Balcon applied for a work permit for her, and in January, she flew back to London.

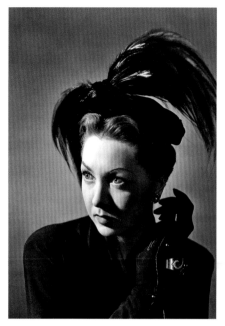

Train of Events, Ealing Studios, 1949

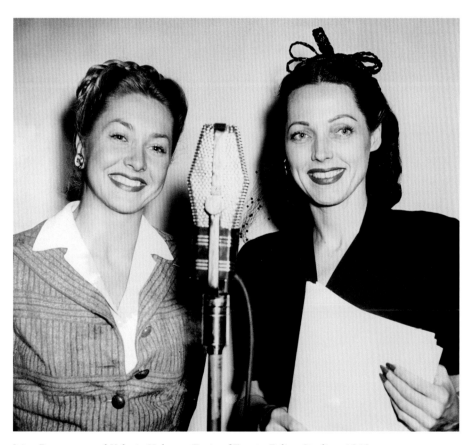

Irina Baronova and Valerie Hobson, *Train of Events*, Ealing Studios, 1949

209

TRAIN OF EVENTS (Ealing Studios) 1949
Produced by Sir Michael Balcon
Directed by Basil Dearden, Charles Crichton, and Sidney Cole
Starring Jack Warner, Joan Dowling, Peter Finch, Irina Baronova, John Clements, and
Valerie Hobson

The film had four storylines that dealt with the aftermath of a train crash. The first story involved the engine driver (Jack Warner) whose daughter's boyfriend was responsible for the crash. The second story was about an actor (Peter Finch) who had planned the perfect murder of his wife and was undone by the crash. (This was Australian actor Peter Finch's first film. He was married to Tamara Tchinarova, one of the Ballets Russes dancers who had remained in Australia after the 1938–1939 tour.) The third story followed a lonely girl (Joan Dowling) who was killed trying to save a fellow passenger. The final story was humorous, following a survivor of the train crash (Valerie Hobson) who sets out to get even with her unfaithful lover (John Clements), a conductor who has taken up with a concert pianist (Irina Baronova).

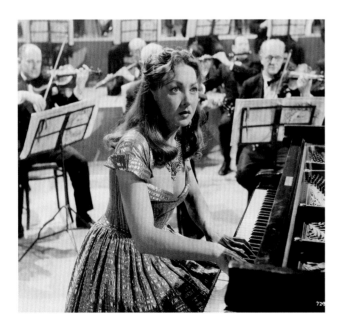 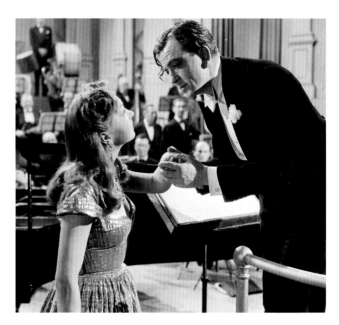

Photo: Denis De Marney / ©Victoria and Albert Museum

Cecil Tennant, Coldstream Guards

When my mother arrived in London to start work, flowers were waiting for her at the hotel. To her surprise, they were not from the studio; they were from Cecil Tennant, the owner of a theatrical agency, who had spent the six war years as a tank commander in the Coldstream Guards. She had only met him once, briefly. When she called his office to thank him, he asked her out to dinner; they had dinner every night that week. He would pick her up from the studio after work take her out to a restaurant, and then they would sit in his parked car talking for hours. The following week, he took her to his sister Helen's for dinner. After the meal, Helen feigned a headache and withdrew, and he promptly asked her to marry him. She thought he was joking, and only realized he was serious when on Sunday he took her to meet his mother. While assuring her how serious he was, he laid out what kind of marriage he was offering. He didn't want her to work; he wanted a mother for his children and a proper home. He asked her to think about it.

211

CHAPTER TWELVE
Family, Teaching, Awards, Autobiography

And so my mother got married to another man she didn't know very well, although she did know what she wanted. I was born in 1950; my sister, Irina, was born in 1952; and our brother, Robert, was born in 1954. Our mother was devoted to us and not exactly like anyone else's mum. No one else's mum did pirouettes in the butcher's.

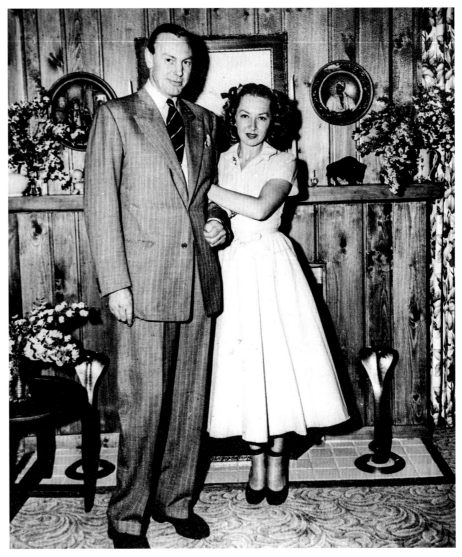

Irina Baronova and Cecil Tennant on their wedding day

When I was a year and a half old, Mum and Dad took me to America to meet her parents. We travelled by ship to New York with my nanny, Nanny Woods, and my godfather, Laurence Olivier. It was the last time Mum saw Grandpa; he died of a heart attack shortly after. Dad insisted that Granny Lydia come to England to live with us. She arrived and decorated her bedroom in purple: purple bed, purple curtains, purple pillows, purple chair, purple everything. Before the Revolution, the Tsarina Alexandra had decorated her boudoir in purple, so purple had been fashionable in St. Petersburg. I didn't know this at the time; I just thought it was odd. Granny Lydia taught me how to read and took me to the local library every week to get books. It is thanks to her that reading has been a lifelong passion. Her English could occasionally be approximate. I remember her announcing that she had met a Danish baroness who was going to be her Bottom Buddy. She meant, of course, Bosom Pal.

Grandparents and Victoria in Sea Cliff

On the ship to New York: Irina Baronova, Victoria, and Laurence Olivier

Victoria's christening: Irina Baronova, Nanny Woods, Cecil Tennant, Helen Tennant, Laurence Olivier, and Lady St. Just

213

Irina Baronova with her children
Irina, Robert, and Victoria, 1959

We lived in the country, and every year at Christmas our driver, Mr. Pearson, would drive Mum and us children into London to see *The Nutcracker* at Covent Garden. We would always sit in the royal box, and after the ballet, we would make our way onto the stage, where the whole company would be introduced to our mother. For several Christmas seasons, Anton Dolin, Uncle Pat to us, did a beautiful show called *Saint George and the Dragon*, so we drove into London to see that too. At the end of each performance, Uncle Pat would ask a child in the audience if they believed in the legend now that they had seen the show. One year he picked on me. He made me stand up and a spotlight hit me.

"Little girl, do you believe in Saint George and the Dragon?"
My voice came out in a mortified squeak, "YES."
"Speak up, little girl!"
I wanted to drop through the floor. I bellowed, "YES."

Uncle Pat beamed at my mother, hugely pleased. Backstage we got to touch the green sequin scales stuck on the Dragon actor's face and have our photo taken.

With Anton Dolin as St. George, 1958

My sister and I were sent to a ballet school where I managed to disappoint everyone. Although I was good academically I wasn't good in the ballet studio, where it mattered. At the end of each summer term there were academic prizes given in a tent, preceded by a ballet show on the big lawn, row after row of children, aged eight to sixteen, performing dance movements in black leotards and tights. One year, during a dress rehearsal for this show, the head ballet mistress made me step forward in front of the entire school so that she could ask me how I could possibly be my mother's daughter. A humiliation I have never forgotten.

Irina Baronova giving school prize to Victoria, 1961

©Royal Academy of Dance / ArenaPAL

In early 1962, a call came from Paris. My mother's teacher, Olga Preobrajenska, had fallen and broken her hip. She was in a hospital, but her finances were not good. Her old ballet students were raising money to help her. My mother and Uncle Pat started a collection, calling all the people they knew as well as all the ballet schools and organizations. The response was huge; an account was opened for Madame Preobrajenska in Paris. Madame Preobrajenska was moved to a nursing home, and my mother went to Paris to help sell her apartment and move her belongings. My mother went to the nursing home and Madame said, "You're the one with that tall, tall husband." (My father was over six foot six.) Then my mother told her how much she loved her and how grateful she was for being given her first chance to make something of herself. Madame listened intently, patted her cheek and said, "You're a good girl." Then spoke no more. A second collection was started and an auction headed by my mother and Serge Lifar raised enough money to look after Madame Preobrajenska until her death later that year in December.

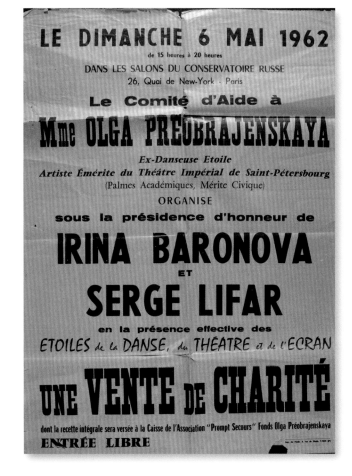

When I was seventeen, Irina fifteen, Rob thirteen, our father was killed in a car crash. Irina and Rob were with Dad dropping a friend home. I was at home with Mum and Granny, waiting for them to get back so we could have dinner. A neighbor came running up the driveway to our house, shouting and crying. We came out to see what the matter was and she screamed something about an accident. Mum and I started running back down the driveway after her and onto our country road where a hundred yards away were two ambulances, police cars, and a small throng of people. Pushing past the policeman, who tried to stop us, we were just in time to see one ambulance drive away. My mother jumped into the back of the second one as the doors were closing, and I was left standing in the road. I walked back to the house and tried to explain to Granny what had happened. But even now, none of us really know. The car suddenly went off the road, struck a tree, veered across the road, struck another tree, and crashed into the ditch. Dad was killed, my sister and brother badly injured. It was June. That winter it snowed; one evening we were all in the sitting room when we heard the crunch of a car coming up the gravel driveway. Our dog jumped up and started barking; we waited for the doorbell to ring. Silence. Mum and I went into the hall and opened the front door. There was no one there. No tracks in the snow.

The next year, I went to a drama school in London. I was still in a fog, struggling with grief. I went home every weekend. One Saturday afternoon Mum said she had something to tell me and she wanted me to come to her bedroom. That sounded serious. We marched upstairs and into her room. She closed the door, then went into her bathroom and beckoned. Christ, it really was serious. I followed her into her bathroom. She shut the door. "I have something to tell you . . . " she started, "I don't know how to say this . . . " I began to feel sick; what could it be? She blurted out, "I've been married before." I stared at her. "That's it?" I asked. Relief washed over me. Life with Mum was like a T.V. drama, Wednesday Night Playhouse I used to call it. Mum was telling me now because Gerry had contacted her; he'd heard about the accident and

wanted to see if he could help. It occurs to me now that the real reason Mum wanted to tell me in her bathroom was that she was afraid Granny would be upset at Gerry's reappearance. Granny took it well, however, and didn't say a word. I met Gerry, and we got on just fine. He still loved Mum, and I was happy that she wouldn't be alone. Gerry said that because they had had the second wedding in Sydney, performed by the Russian Orthodox priest, they had never really been divorced, and in his view were still married. They lived together in Switzerland for five years before he died.

Gerry in Switzerland
Photo: Victoria Tennant

London

Mum lived in Switzerland for ten more years. Then she moved back to London. She did a lot of travelling for the Royal Academy of Dancing (Hong Kong, Sri Lanka, South Africa, Canada, Australia, England). She also gave master classes and lectures (Vassar, Rovinj) and went to Australia and Houston to work with ballet companies reviving Fokine's work. The first time she went somewhere I called her hotel just as she was walking into her room. I asked her how she was and she said that she had been met at the airport with bouquets and suddenly felt bewildered. She said, "I haven't been Irina Baronova for such a long time."

Arriving in Hong Kong

Colombo, Sri Lanka

Pretoria, South Africa 1995

Riabouchinska, Toumanova, and Baronova

Mum went to Los Angeles several times to teach at Tania Riabouchinska's ballet school, the Lichine Academy. When she was there, she always called Tamara and Mama Toumanova, and she told me that on one visit when she called, Mama Toumanova suggested that she come by for a coffee the next morning. Mum said, "But tomorrow's Sunday — won't you be at church?" And Mama Toumanova said, "Oh no, Irinotchka. We don't go to church anymore. Tamara has mink coat, I have mink coat, nothing left to ask for."

Irina Baronova and Tania Riabouchinska

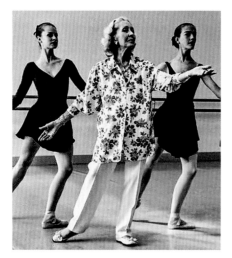

Vassar

With Anton Dolin in Rovinj

Since I was always travelling too, we wrote each other letters. Here is one from Rovinj, Yugoslavia, where there was a summer school for dancers. Mum and Uncle Pat went there to teach for a couple of summers.

On this incredibly hot summer morning I was walking at 8:30 AM through the woods towards the platforms for my first class at 9 AM. I felt a little breeze coming up and thought to myself, "Oh, how good. Maybe it will be more bearable today." The sky was bright blue, and the smell of the pines in the forest to turn your head. Towards the end of my first class, in moments, the blue of the sky evaporated, a grey haze veiled the sun and a mass of dark, heavy clouds enveloped the entire horizon. A sudden hush spread through the forest, the birds and insects disappeared and the leaves on the trees stopped murmuring. And then . . . wham! The lightning, like a red-hot whip. It seemed so near one's face, so incredibly beautiful, that it caught my breath. The air and the earth shook and all the gods' wrath lashed out in that first thunder. The pianist was playing a very tender and romantic melody of Schumann's, it was drowned, and then, like waves, kept rolling into one's hearing and rolling out of it. I felt like dancing. I called to the pianist Nettie, an imperturbable Dutch woman, "Keep playing. Go on, go on!" And suddenly I was alone in the entire universe. I found myself dancing as if I were again 20 years old. The feeling inside me was overflowing, with love, with suffering, with joy, with sadness. So powerful that it had no room in my body, it was overflowing. It was a torment and a tenderness. A feeling I had never experienced before. A torrential rain came down. It ran down my face. A little stream came down behind my ears and ran down my spine. It was dripping off my fingers and my feet were sliding in my soaking shoes. All the students stepped off the platform. I had it all to myself, a platform, in the middle of the forest with the lightening, thunder, rain and Schumann. It was some kind of magic and I was happy in a strange unearthly way. Suddenly, I felt very cold. I saw the dripping pianist bashing away at the piano. A new sound entered my consciousness, a sound from far away, familiar yet lost in the cobwebs and corridors of my memories. It dug at the strings of my heart. It was applause, the applause of my very wet students. I felt confused and silly. An old fool, back on earth facing reality and the steady rain.

Mikhail Baryshnikov, Sono Osato, and Irina Baronova, 1980
Photo: Steven Caras. All rights reserved.

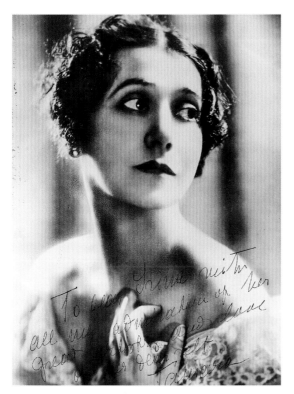

Tamara Karsavina
"To Dear Irina, with all my admiration for your great
artistry and love for your dear self, Tamara"

Irina Baronova with Tamara Karsavina, 1957

Ballets Russes reunion in New Orleans. *Top row, from left*: Roman Jasinsky, (unknown), Frederic Franklin, Anton Dolin, Igor Youskevitch, Paul Petroff. *Bottom row, from left*: Moscelyne Larkin, Nathalie Krassovska, Alicia Markova, Mia Slavenska, Irina Baronova

Ballet Theatre alumni: Herbert Ross, Jerome Robbins, Nora Kaye, Irina Baronova, Sono Osato, and Donald Saddler
Photo: Victoria Tennant

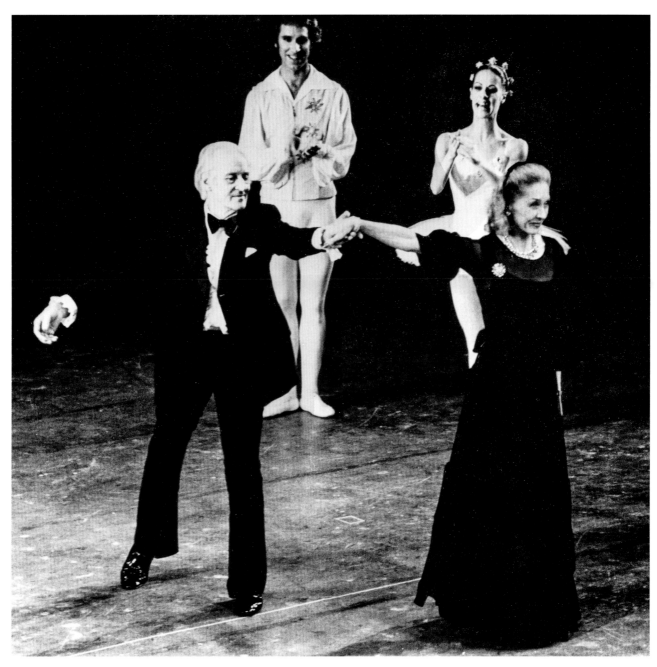

Anton Dolin and Irina Baronova. Fortieth Anniversary of American Ballet Theatre, 1980

If I go to see a ballet, I come home and I can't sleep. I put my face in the pillow and cry, because I miss it. I know that I am extraordinarily lucky to have a family, three beautiful children, my first real home, a wonderful husband, I realize all that, and yet, if I go backstage after a performance, the smell of the stage, of the make-up . . . something inside me still turns, something I never get over.

Honorary doctorate, 1996
North Carolina School of the Arts

Queen Elizabeth II Award with Robert and
his son Hugh

Presentation of the Nijinsky Medal
March 1996, Polish Cultural Institute

In 1992 my mother was invited to visit the Vaganova Academy in St. Petersburg, the great ballet school that had produced Pavlova, Nijinsky, Preobrajenska, Karsavina, Fokine, Balanchine, Nijinska, Nureyev, Baryshnikov, and Makarova. They asked her to come and give talks, to meet their teachers and dancers, to bring them anything of hers that they could put in their ballet museum. When the Iron Curtain came down, all information about Russians in the West had been prohibited. Now that the Iron Curtain had lifted, the ballet world in Russia was hungry for information about the lost years. At the same time, an unexpected letter found its way to my mother. Antal Dorati, the Ballets Russes conductor, was conducting in St. Petersburg when a woman approached him asking him to take a letter to my mother. When he got home, he sent it on with a note saying that this woman had claimed she was a relative. Indeed she was. She was Galia, the daughter of Sergei Baronov, Grandpa's brother.

This is the letter my mother wrote me after her trip to St. Petersburg:

My dearest darling Victoshenka,

Thank you for all your caring calls since I got back from Russia. I shall tell you all about it, starting with my departure from Heathrow: Of course I had a big overweight in my luggage, all the things I was taking over to give Galia . . . When I told the girl at the counter that I am invited, officially, to lecture at the Vaganova Academy, and showed her the letter of invitation, she looked impressed and said that I shall be charged only one third of the overweight. So, that was good. The plane was on time. As I walked into the aircraft I asked the Russian stewardess to direct us to our seats. She waved her arms and said, "Oh, go sit where you want, what's the difference?" There were no more than thirty passengers in all, Russians returning home: technicians from a course in England, and five naval men from Murmansk. After three and a half hours we land in St. Petersburg! It is snowing. The naval men helped me lift the cases off the belt that was moving at about 50 miles an hour. At the Passport Control, a curious, silent glance, a stamp on the declaration to show when I am

leaving, and I am outside in the snow. I am met by two people from the Academy, and we set off in a mini-bus on the long, straight road that brings us to the center of St. Petersburg. My hungry eyes are trying to pierce the dim street lighting further dimmed by falling snow. My heart beats faster . . . this is my city, I was born here. The Academy itself was vast, well kept and clean. Numerous large studios. They have 500 students and the majority live in. Wonderful teachers, students disciplined, polite, all dressed alike in tights, a leotard and a little skirt. The youngest in white, the bigger ones all pink, the oldest in blue. Lovely to see them so neat, to see their legs and bodies properly. All the teachers wanted me to come and watch their classes so I was dashing from one studio to another. I attended three performances at the Maryinsky Theatre. It is the most beautiful theatre I have ever seen! Pale blue velvet, gold and white. Beautiful marble foyer with exquisite crystal chandeliers, gold carvings and sculptures on Art. The draperies over the Royal Box are magnificent. For the 80th birthday of their great ballerina, Natalia Dudinskaya, they gave a Gala at the theatre, and we saw a real STAR. The most wonderful Tatiana Terekhova, breathtaking personality, and brilliant artistry and technique. After the performance I was taken to join the guests for a drink onstage. Big thrill for me. I never had the joy to dance in this great theatre, but at least in my old age I can say that I stood on the stage of the Maryinsky.

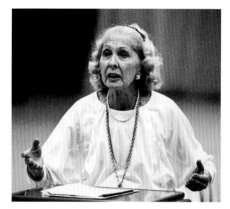

Lecturing at Vassar

Lecturing at the Royal Academy of Dance, London

The first evening after our arrival I was able to go and meet my cousin, Galia. Her daughter, Sasha, came to the Academy to collect me, crying with joy. It is cold and snowing, and I have the big suitcase. I asked Sasha if we could get a taxi, and she waved at cars and one stopped. How much to get to this address? The driver said $50. I told him in Russian not to be silly. Oh, you are Russian . . . then $5. We crossed a bridge over the wide river. Finally we arrive, buildings converted into flats. Galia's calm, deep warmth moves me. Her son, Serge is there. Photo albums come out. I am given my father's Christening spoon with his initials on it, then a book from Galia's father, my uncle, it is inscribed to me, "In case a miracle happens and Galia and you, my darling Irinotchka, meet. I want you to know I loved you. Your Uncle Sergei." I burst into tears.

Lecturing at the Royal Academy of Dance, London

At the age of eighty-one, my mother moved to Byron Bay, New South Wales, Australia. It's the most easterly point of the continent, and one of the most beautiful places in the world. She bought the first house she was shown. It sat on a ridge with incredible views across the hills to the coastline and the sea. There she started to write her autobiography, *Irina: Ballet, Life and Love,* and four years later she finished it. Her days were busy, filled with a constant stream of children, grandchildren, and friends arriving to stay. The Australian ballet world welcomed her with open arms, and she was constantly teaching and lecturing. An Australian painter, Jenny Sages, made a portrait of her, which was runner-up in the 2007 annual portrait competition for the Archibald Prize. It now hangs in the Australian National Portrait Gallery. Letters started arriving from readers who were touched by her book. Not just letters: complete strangers would drop by, having looked her up in the phone book, and my mother would invite them in for a cup of tea and a chat. My mother lived alone, but she wasn't alone very much. Australia was a wonderful home for her refugee soul.

Irina Baronova with David McAllister, head of the Australian Ballet, 2006

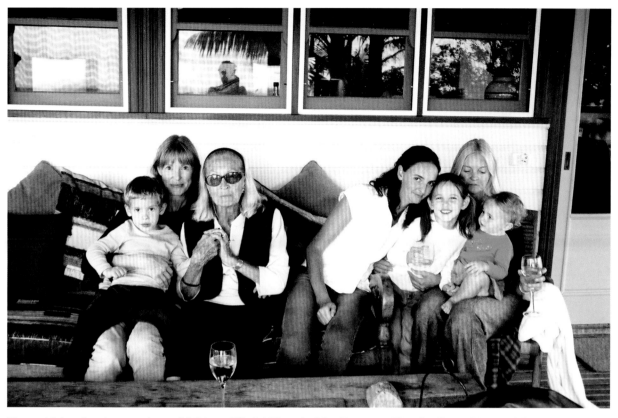

Mum with her daughters and grandchildren: Nikolai, Victoria, Irina Baronova, Natasha, Katya, Irina, and Zoe
Photo: Kirk Stambler

I had come to the end of my work. It had taken me five months. The piles of photographs lined up on the carpet were gone, all sorted and catalogued. I put Antal Dorati's letter into a binder with the rest of my mother's correspondence. There was one last envelope, unsealed; I looked inside it . . . a plastic bag, which seemed to be empty except for some dust or dirt at the bottom. What could that be? What was it? Then I understood, it was earth, Mother Earth, Russian soil.

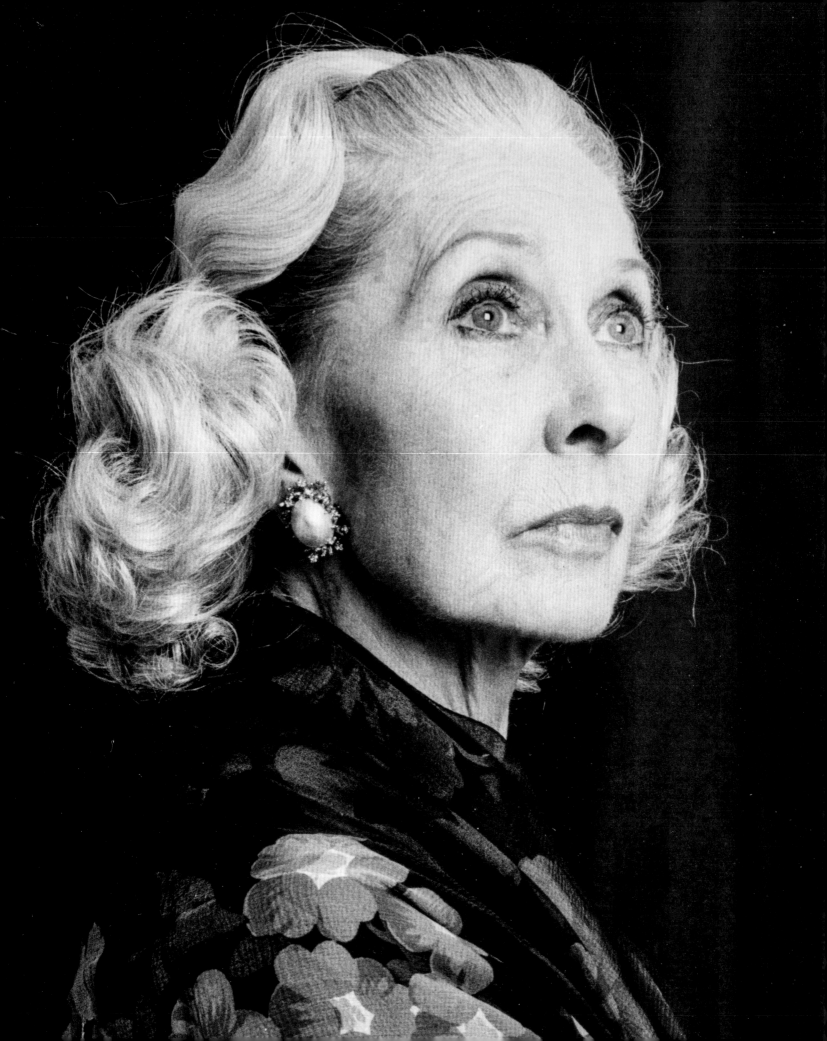

Byron Bay, 2008

Our mother died peacefully in her sleep

June 24, 2008, in Byron Bay, Australia. My sister, Irina, organized a beautiful celebration of our mother in the garden of her favorite restaurant, the Fig Tree. It's a typical Australian house with verandahs on all sides, perched on top of a hill. Mum had gone there with Irina for lunch and a glass of champagne the day before she died. The simple pine coffin stood in the garden, covered with white flowers, two white Tibetan prayer flags planted in the grass on either side. A gigantic Morecambe Bay fig tree arched over it, and behind, the view stretched out across the rolling hills down to the lighthouse and beaches. Classical musicians played violin and cello music while friends and family gathered in the garden. The head of the Australian ballet, David McAllister, spoke first, followed by myself, my sister, and my brother. Then, my husband, Kirk, played his guitar and sang Jackson Browne's *For A Dancer*.

As the musicians played Tchaikovsky's haunting music from the dying swan in *Swan Lake*, all the family picked up Mum's coffin and slowly carried it across the garden to the waiting hearse. Her last journey in a long life of journeys.

Photo: Irina Tennant

"It gives me, personally, a lot of satisfaction
to feel that my work helped introduce audiences to
ballet and made them like it.
So there is a piece of me in all the companies that
have since sprung up.
The work was not in vain.
I achieved something, not just for myself, but for
the Art that I love, and for the future generations of
youngsters coming after me."

IRINA BARONOVA
1919–2008

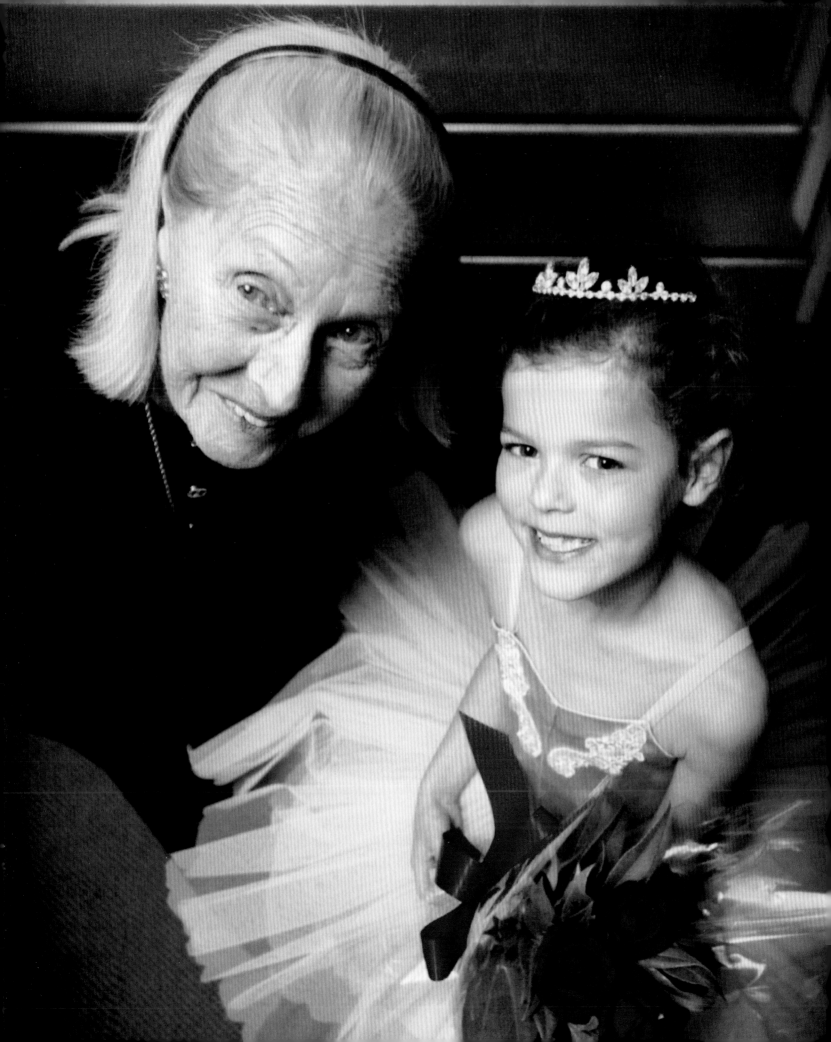

Irina Baronova Repertoire

1931–1932 Ballets Russes de Monte Carlo
Le Bourgeois Gentilhomme (Balanchine)
Cotillon (Balanchine)
Concurrence (Balanchine)
Jeux d'Enfants (Massine)
*Le Spectre de la Rose** (Fokine)
Les Créatures de Prométhée (Lifar)
*Les Sylphides** (Solo Waltz) (Fokine)

1933 *Les Présages* (Massine)
Le Beau Danube (Massine)
Beach (Massine)
Scuola di Ballo (Massine)
Nocturne (Lichine)
Choreatium (Massine)
*Swan Lake** (Petipa — Fokine)

1934 *Petrouchka** (Fokine)
Union Pacific (Massine)
*Aurora's Wedding**
 (Petipa with additions by Nijinska)
*Le Soleil de Nuit** a.k.a. *Midnight Sun*
 (Massine)
*Les Noces** (Nijinska)
*Firebird** (Fokine)
*La Boutique Fantasque**
 (Massine — Tarantella)

1935 *Thamar** (Fokine)
Les Cent Baisers (Nijinska)

1936 *Le Pavillon* (Lichine)
Danses Slaves et Tziganes (Nijinska)

1937 *Le Coq d'Or* (Fokine)
Symphonie Fantastique (Massine)
Orphée et Eurydice (Lichine)
*Les Sylphides** (Fokine)
*Les Papillons** (Fokine)

1938 *Prodigal Son** (Balanchine)
*Les Femmes de Bonne Humeur** (Massine)

1939 *Paganini* (Fokine)
*Scheherazade** (Fokine)

1940 Massine's Company
Coppélia (Massine)
Ghost Town (Platt)

1940-1941 De Basil's Original Ballet Russe
Swan Lake (Petipa)

1941 Ballet Theatre
Bluebeard (Fokine)
*Princess Aurora** (Dolin)
Slavonika (Psota)
Voices of Spring (Mordkin)
Gala Performance (Tudor)
Pas de Quatre (Dolin)
La Fille Mal Gardée a.k.a. *Naughty Lisette*
 (Nijinska)

1942 *Helen of Troy* (Fokine)
Coppélia (Semenoff)
*Petrouchka** (Fokine)
Helen of Troy (Lichine)
*Les Sylphides** (Fokine)

1943 *Boutique Fantasque** (Massine — Can Can Doll)

1945-1946 Massine's Highlights of the Ballets Russes
Capriccio Espagnol (Massine with Argentinita)
Russian Dance (Massine)
Polish Mazurka (Lazowsky)
Gaîté Parisienne (Massine)
Bluebird Pas de Deux (Petipa)
Nutcracker Pas de Deux (Petipa)
Le Beau Danube Pas de Deux (Massine)
Le Spectre de la Rose (Fokine)
Igrouchka a.k.a. *Russian Dolls* (after Fokine)
Sailor Dance (Lazowsky)

*Diaghilev revivals

SWAN LAKE
Photo: Maurice Seymour

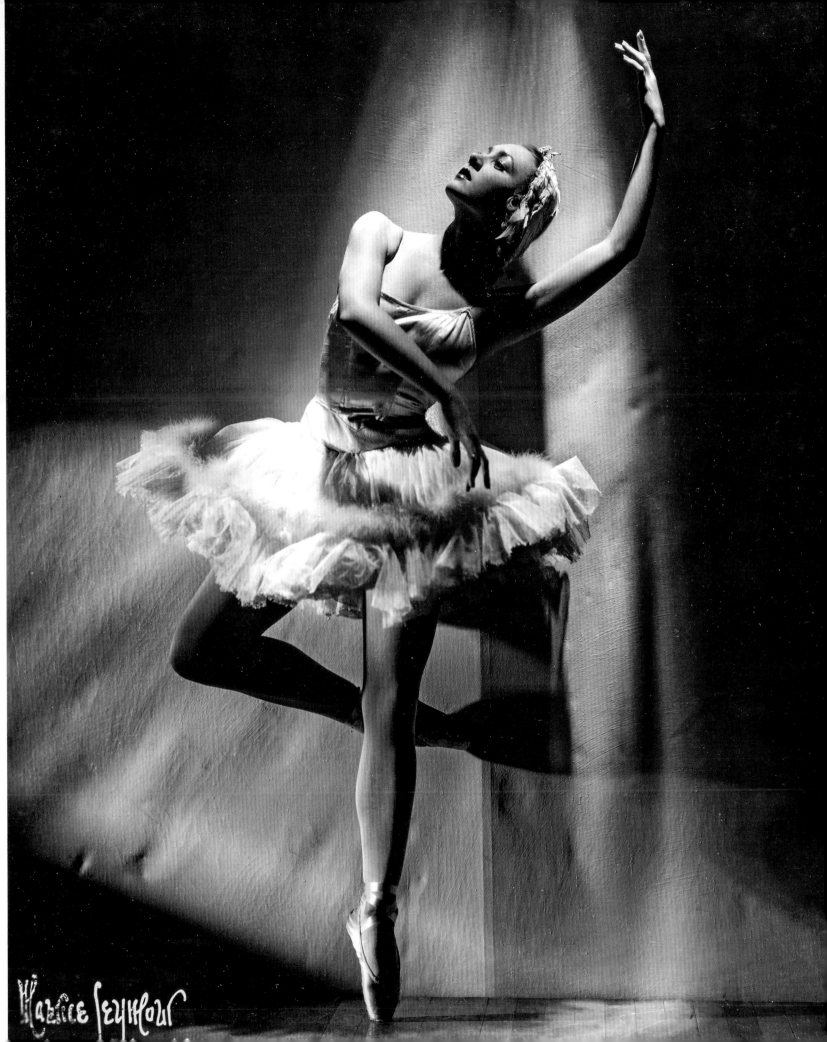

Postscript

At the beginning of chapter 1, I mentioned a CD my brother, Robert, had made of a conversation he had with Granny. She told him the address of her parents' house in St. Petersburg, the house she had grown up in, and I wrote it down. In the summer of 2012, I went to St. Petersburg with my husband and children for the first time. We looked for Granny's house, and we found it, on an embankment across from the Mikhailovsky Palace and the Summer Garden. I stood outside the house and imagined Granny's life as a young girl, the carriage taking her to school just a few blocks away. We found the school too.

And the toe shoes that I found when I began this journey, I gave them to the Vaganova Academy, to go in the Vaganova Museum. Irina Baronova never got to dance in St. Petersburg, but her toe shoes are there.

— **Victoria Tennant**

Photo: Kirk Stambler

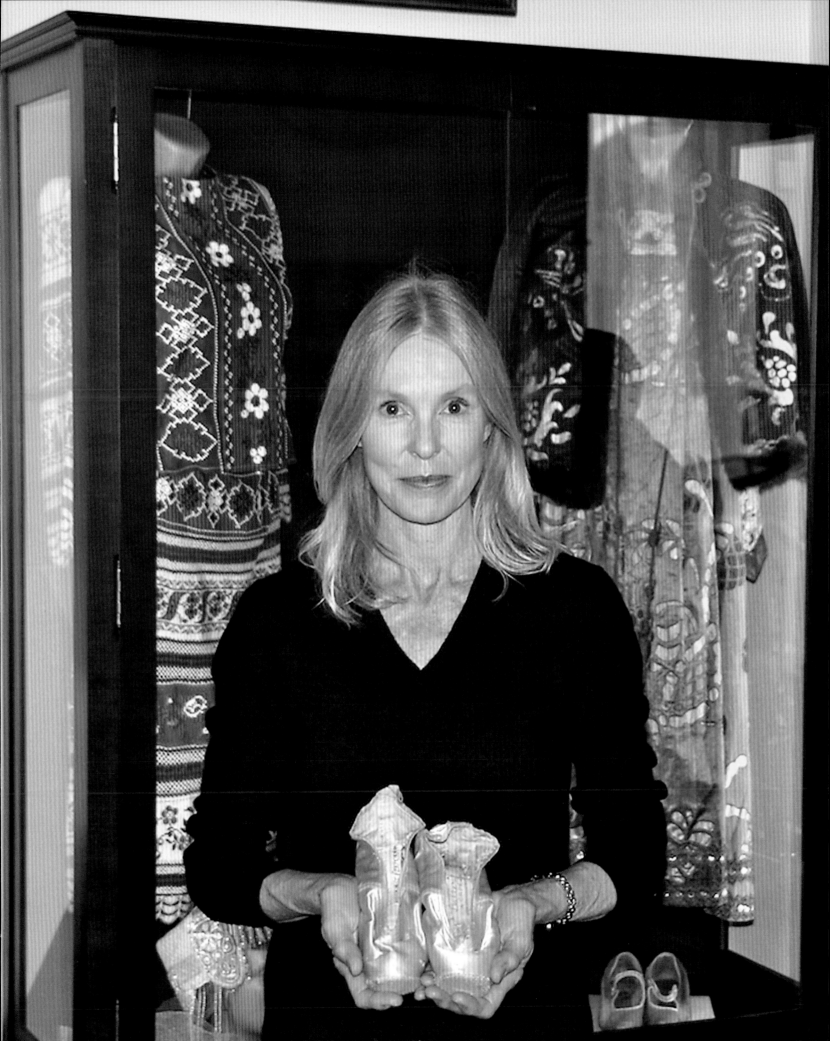

Credits and Sources

Photography Credits

CHAPTER 2: PARIS, 1928–1931

14 Irina Baronova, age 10
Photo by Studio Iris (Paris)

17 Irina Baronova, age 10
Photo by Studio Iris (Paris)

20 George Balanchine ps_dan_cd46_671.tif
New York Public Library
Jerome Robbins Dance Division

CHAPTER 3: MONTE CARLO, 1931–1932

22 Irina Baronova in *Les Sylphides*
Photo by Studio Batlles (Barcelona)

23 René Blum psnypl_dan_1844.tif
New York Public Library
Jerome Robbins Dance Division

24 Joan Miró and Tatiana Riabouchinska
Monte Carlo, 1932
David Lichine and Tatiana Riabouchinska Papers
(s)*MGZMD 267 box 22
New York Public Library
Jerome Robbins Dance Division

24 Balanchine and Baronova, 1932, rehearsing
La Concurrence
Photo by Boris Lipnitzki
©Roger Viollet / The Image Works

25 Irina Baronova in *La Concurrence*, 1932, age 12
©Roger Viollet / The Image Works

26 Irina Baronova in satin tunic
Photo by Raoul Barba

27 Irina Baronova in *Jeux d'Enfants*
Photo by Maurice Goldberg

28 Irina Baronova in *Cotillon*
Photo by Gordon Anthony
©Victoria and Albert Museum

29 Irina Baronova in *La Concurrence*
Photo by Gordon Anthony
©Victoria and Albert Museum

31 Irina Baronova in *Spectre de la Rose*
Photo by Fritz Henle
©Fritz Henle Estate

32 Irina Baronova in *Spectre de la Rose*
Photo by Studio Batlles (Barcelona)

33 Irina Baronova and Serge Lifar in
Les Créatures de Prométhée
Photo by Studio Iris (Paris)

36 Tania Riabouchinska and David Lichine on
the beach
David Lichine and Tatiana Riabouchinska Papers
(s)*MGZMD 267 box 22
New York Public Library
Jerome Robbins Dance Division

CHAPTER 4: LONDON, 1933

38 Irina Baronova in *Le Beau Danube*
Photo by Studio Batlles (Barcelona)

39 Irina Baronova and Yurek Shabelevsky in
Le Beau Danube
Photo by Maurice Goldberg
*MGZB Ballets Russes de Monte Carlo (de Basil)
Souvenir Program, 1934
New York Public Library
Jerome Robbins Dance Division

40 Irina Baronova and male dancer in *Scuola di Ballo*
Photo by Boris Lipnitzki
*MGZB Ballets Russes de Monte Carlo (de Basil)
Souvenir Program, 1933–34
New York Public Library
Jerome Robbins Dance Division

41 Ballet Russe de Monte Carlo dancers posing behind
their tour bus, 1933
David Lichine and Tatiana Riabouchinska Papers
*MGZMD 267 box 22
New York Public Library
Jerome Robbins Dance Division

42 Irina Baronova in *Les Présages*
Photo by Studio Iris (Paris)

43 Irina Baronova and David Lichine in *Les Présages*
Photo by Studio Batlles (Barcelona)

45 David Lichine choreographing *Nocturne*
David Lichine and Tatiana Riabouchinska Papers
*MGZMD 267 box 18
New York Public Library
Jerome Robbins Dance Division

45 Irina Baronova, Tatiana Riabouchinska, and
André Eglevsky rehearsing *Nocturne* with
David Lichine x 2 (as above)

46 Irina Baronova in *Beach*
*MGZRC box 58 Ballet Russe de Monte Carlo
(clippings)
New York Public Library
Jerome Robbins Dance Division

55 Irina Baronova and Anton Dolin in *Swan Lake*
National Library of Australia
nla.ms-ms8495-23-1-s.7-a1-v

CHAPTER 5: AMERICA AND CANADA, 1933–1938

57 Ballerinas on board the *Lafayette*, 1933
*MGZEA Ballet Russe de Monte Carlo, #94
New York Public Library
Jerome Robbins Dance Division

58 "The Man with Seven Mothers"
David Lichine and Tatiana Riabouchinska Papers
(s)*MGZMD 267 box 10 f. 3
New York Public Library
Jerome Robbins Dance Division

59 Irina Baronova
Photo by Du Bois

60 Dancers posing on stairs
*MGZEA Ballets Russes (de Basil) #8
New York Public Library
Jerome Robbins Dance Division

65 Irina Baronova in *Union Pacific*
Photo by Spencer Shier
With permission from National Library of Australia

Other than the two images from Getty Images, the two images from the Image Works, the eight images from the National Library of Australia, the fourteen images from the Jacob's Pillow Archives, and the thirty images from the New York Public Library, Jerome Robbins Dance Division, the remaining two hundred seventy-nine photographs in this book are from my mother's own collection, now in the New York Public Library ((s)*MGZMD 276, 19 boxes), and my own photo albums. I have made every effort to identify the photographers of these mostly unmarked photographs, but if I have inadvertently failed to acknowledge someone's work, please let me know.

Sources

All my mother's quotes in brown type are from:
*MGZMT 5-595
Irina Baronova, *Interview with Irina Baronova*, 1977
Conducted by Dale Harris for the Oral History Project,
New York Public Library, Jerome Robbins Dance Division
Astor, Lenox and Tilden Foundations
With permission from the Dance Division

All my mother's quotes from her autobiography, *Irina: Ballet, Life, and Love*, published in Australia by Penguin and in the United States by Florida University Press, are with permission from my niece, Natasha Cali

Ballets Russes de Monte Carlo records in Serge Grigoriev black notebooks:
*MGZMB Grigoriev, Black Exercise Books v. 1–4, 5–8
New York Public Library, Jerome Robbins Dance Division

Ballet Theatre records:
(s)MGZMD 49 American Ballet Theatre Records boxes 1, 7, 14, 19, 24, 25.
New York Public Library, Jerome Robbins Dance Division

Descriptions of Diaghilev ballets:
Diaghilev and the Ballets Russes, by Boris Kochno

Chapter 2 — Paris
The Ballets Russes Companies, pages 19–21
From *The Ballets Russes*, by Vicente Garcia Marquez
and *George Balanchine: The Ballet Maker*
by Robert Gottlieb, page 62

Chapter 4 — London
Page 41, Last paragraph redacted from my mother's biography, *Irina: Ballet, Life, and Love*, pages 85–87
Page 47, Information about Massine's training and influences from *The Ballets Russes*, by Vicente Garcia Marquez, pages 78–81
From my mother's autobiography, *Irina: Ballet, Life, and Love*:
Page 42, Description of *Les Présages*, from page 62
Page 50, Description of Anton Dolin from page 106
Page 51, Meeting Karsavina from page 105

Chapter 5 — America and Canada
From *The Ballets Russes* by Vicente Garcia Marquez:
Quote on page 64 taken from page 106
Description of the ballet *Union Pacific* from pages 99–107
Quote by Agnes de Mille from page 136
Box office figures for De Basil and Diaghilev from page 158

Chapter 6 — Covent Garden
Description of royal gala dinner on page 106 from my mother's autobiography, *Irina: Ballet, Life, and Love*, page 142

Chapter 7 — Australia and New Zealand
Description of ship on page 131 and description of audience on page 137 from my mother's autobiography, *Irina: Ballet, Life, and Love*, pages 272–281
Tour itinerary on page 138 from *The Ballets Russes in Australia and Beyond* edited by Mark Carroll.
Page 144, Quote from *The Herald*, November 18, 1938:
(s)*MGZMD 267 box 12
David Lichine and Tatiana Riabouchinska Papers
New York Public Library, Jerome Robbins Dance Division

Chapter 8 — Last Season Covent Garden
Page 147, Description of last performance of the season from my mother's autobiography, *Irina: Ballet, Life, and Love*, page 301

Chapter 9 — Hollywood and South America
Page 159, Description of costume straps breaking from my mother's autobiography, *Irina: Ballet, Life, and Love*, page 242

Chapter 10 — Ballet Theatre
Page 189, Quote by the *Novedades* critic, Mexico City from:
*MGZRA Ballet Theatre Press Clippings
New York Public Library, Jerome Robbins Dance Division
Descriptions of Ballet Theatre tours in the early days:
American Ballet Theatre text and commentary by
Charles Payne and *Bravura, Lucia Chase and the American Ballet Theatre* by Alexander Ewing

Chapter 11 — Massine's Highlights
Massine Tour Records:
(s) *MGZMD33 Léonide Massine Papers 1932–1968
Folders 174–213, Series III Folders 214–215,
Series V Folders 247–254
New York Public Library, Jerome Robbins Dance Division

Index

243